AMERICAN **CHARACTER**

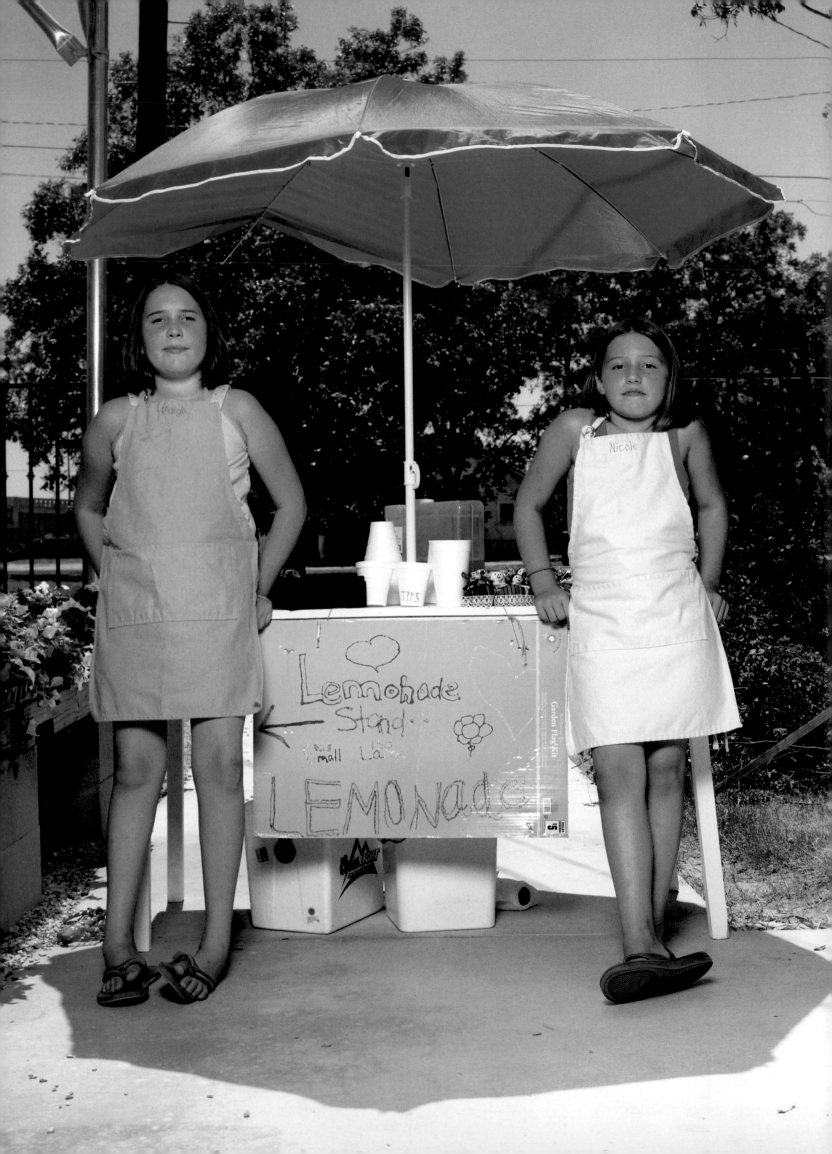

Photographs by

Dawoud Bey

Anna Mia Davidson

Jeff Dunas

David Eustace

Joe Fornabaio

Mary Ellen Mark

Eric McNatt

Eric Ogden

Sylvia Plachy

Richard Renaldi

Marla Rutherford

AMERICAN **CHARACTER**
A PHOTOGRAPHIC JOURNEY

Foreword by **Tom Brokaw**

CHRONICLE BOOKS

SAN FRANCISCO

characters welcome.

usa

Page 2:
ERIC McNATT,
Paigh and **Nicole Hunter,**
Brownwood, Texas

Page 6:
ANNA MIA DAVIDSON,
Nate in the wheat field,
Frog's Song Farm,
Skagit Valley, Washington

Library of Congress Cataloging-in-Publication
Data available.

ISBN: 978-0-8118-6899-0

Manufactured in the United States of America.

Design by Empire Design Studio.
This book has been set in Gotham.

10 9 8 7 6 5 4 3 2 1

Chronicle Books LLC
680 Second Street
San Francisco, California 94107

www.chroniclebooks.com

Contents

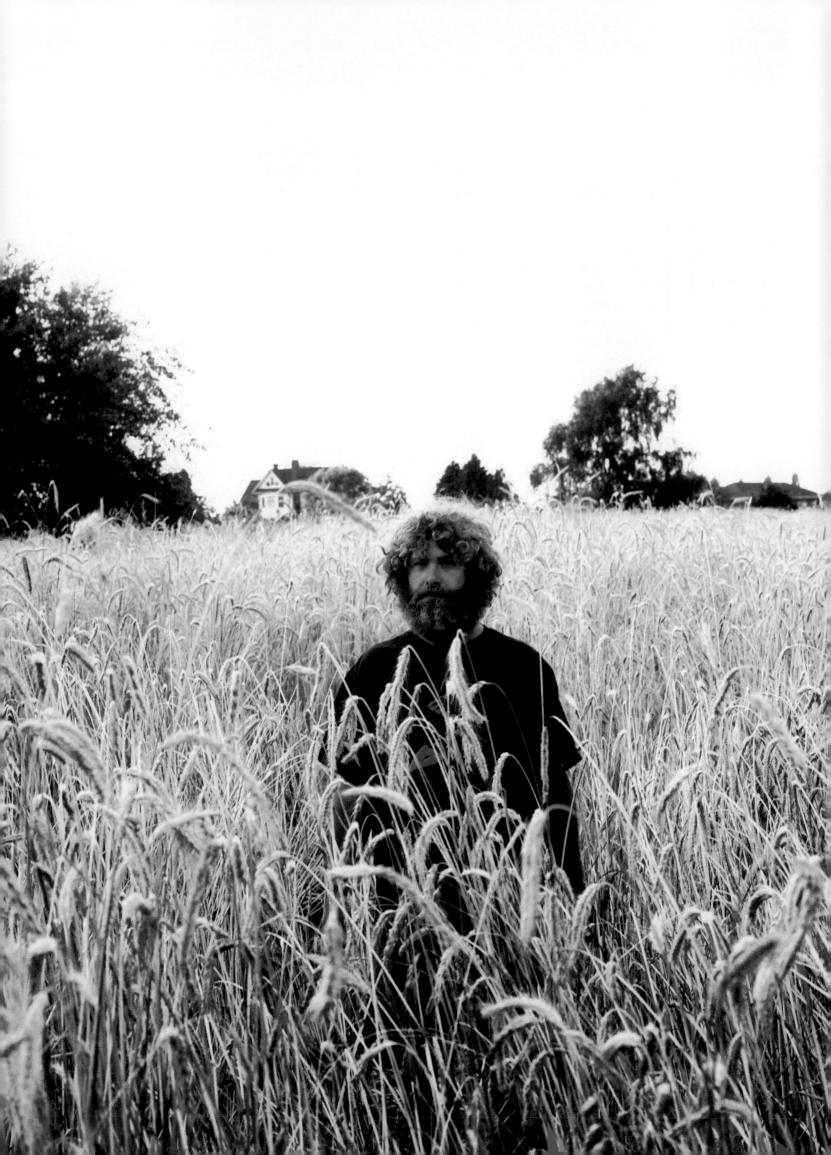

Foreword by **Tom Brokaw**

THE COMMON THEME of this memorable collection of photographs is *character*. It's a muscular word that makes you sit up a little straighter when you hear it. When someone is described as having *character*, it is somehow reassuring even when we may know nothing more about them. It is not an easy trait to define, and others may have their own version, but here's mine: a seamless fabric of honesty, modesty, and the kind of confidence that comes with quiet courage.

The DNA of the American character is unique. It evolved from our common heritage as immigrants, the many strands of humankind that made their way to this majestic landscape over the last five centuries and formed a common chord of democracy, opportunity, generosity, and sacrifice.

It wasn't perfect, this shaping of the American character. There was the shameful legacy of slavery and the brutal oppression of Native Americans. We went to war with each other at a terrible price, but the union held thanks to the man from Illinois, Mr. Lincoln, who endures as the essence of American character.

We emerged stronger at the broken places and roared into the twentieth century to be tested again, first by a Great Depression and then by the greatest war in the history of mankind, World War II, followed by smaller hot wars and a dangerous cold war in which nothing less than survival was at stake.

Now, at the beginning of a new century, we rely once again on the American character to carry us through. We're reminded that this immigrant nation has a rich tapestry of faces, many of whom you will meet in this collection of portraits by some of today's most gifted photographers.

David Eustace travels Highway 50 from the California coast to the industrial Midwest. You'll meet a mop-topped young man with sad eyes and big dreams, who wants to set foot on all seven continents. Yes! That's the American spirit. Never stop looking over the horizon, wondering what's out there, and going to find out for yourself. After all, that's how America came to be settled in the first place, when other young men and women set out to find what was over the next hill or beyond the next ocean. Those first settlers worked the land without benefit of commercial fertilizers and pesticides. You can see their heritage in Anna Mia Davidson's new generation of American farmers, who give fresh meaning to the old ways. This time it is celebrated as organic farming.

When I came to the photographs of Mary Ellen Mark and Jeff Dunas capturing that grand American tradition, the summer festival, I felt I knew each and every subject. We're a festival-happy country. I've been to celebrations of salt in East Texas, tributes to Czech heritage in South Dakota, sheep festivals in Montana, Cinco de Mayo in east Los Angeles; I've eaten a pork chop on a stick at the Iowa State Fair and boiled peanuts in Georgia. If it's a part of our neighborhood, wherever we live in this country, we think it's worth celebrating.

Coaches like to say football builds character, and in Eric McNatt's portraits of the Brownwood, Texas, high school team, young men come of age with that hard-won character. You also see demure beauty in the portrait of Miss Heart of Texas, a girl becoming a woman in small town America where some rituals never go out of fashion.

Skateboarders, hairstylists, rappers, country musicians, the tattooed and the unadorned, kids in costume and cocky young men with attitude. They're all here and they do make us realize we're all richer for our many parts.

There is also, in this study of all that makes us strong, Sylvia Plachy's moving portrait of Sarah Henderson, an African American woman from Greenwood, Mississippi, in a quiet, contemplative moment before she serves lunch at a senior citizens' center. What burdens has she borne? What must she think now that a young man with an African father is president of the United States? What new hope she must have in her heart.

As a nation, we're much more of an ethnic mosaic today than at any time in our history. These pages are tribute to that new reality, and in these photographs you see the changing face of a nation against familiar backdrops.

We are the American family, a vast tribe with deep character.

Highway 50

DAVID
EUSTACE

PHOTOGRAPHY has afforded me many luxuries in life, but probably none more valuable than the excuse it has given me to approach complete strangers whom I find interesting and ask if they would allow me to take their portraits, and while doing so, tell me a little about their lives. Most of these encounters last for a relatively short time; the memories, however, surpass what is caught either digitally or on film.

For Character Project, my intention was straightforward enough: I wanted to explore the diversity of people connected by a single road and create a body of work comprised primarily of portraits juxtaposed against varied landscapes. I chose to follow Highway 50, an artery that stretches over three thousand miles and connects the Pacific to the Atlantic Ocean. It is often referred to as "The Loneliest Road in America" or "The Backbone of America." This old road cuts through twelve states and four state capitals, rarely intersecting with newer freeways as it stretches from coast to coast. It winds across the deserts, mountains, plains, and forests, and it bears witness to both the old and the new United States.

The trip was deliberately very loose in the planning, as I wanted it to serve also as an exploratory trial run for future trips. The only criterion, due to prior work commitments, was that I had to arrange, produce, and complete the project in less than three weeks. Taking one assistant, I would drive an SUV from San Francisco to Ocean City, Maryland. We would drive with the hope of meeting people who I felt had the charisma, character, or individuality to stand out, and who were willing to let me take their photograph.

At the Museum of the Mountain West in Colorado, I met the owner and founder, a retired archaeologist who, among many other things, had carried out excavations at the site of Little Big Horn, where General George Custer and 220 of his cavalrymen died at the hands of Sioux and Cheyenne Indians in 1876. He knew men who had known Billy the Kid and Buffalo Bill.

I met a man who was born in Texas and grew up on a cattle ranch in Idaho before moving out to Carmel, California, where he worked for and later became "a very close friend" of Ansel Adams and his wife. He told me stories of sitting in the Hog's Breath Inn and sharing a beer with the owner, Clint Eastwood.

I came across a wonderful old lady who told me about her life as a girl in Winchester, Virginia, and how she grew up "at 604 and Patsy [Cline] grew up right next door in 605."

I shared a beer and a laugh with the lady who owns the oldest bar in Fallon, Nevada—a bar that hasn't changed much since the likes of Butch Cassidy and Teddy Roosevelt used to sit there.

I was also fortunate enough to photograph Bob Cassilly, the pioneering artist responsible for the City Museum in St. Louis. While in the Utah desert, I encountered a man who had just driven over two thousand miles to rescue four dogs from abandoned dog kennels.

I met a young student in Ohio who dreamed of "setting foot on all seven continents." And I came across a man who, with three of his colleagues, had formed the Chicago Four, a group that successfully took the American Medical Association to the Supreme Court to have chiropractors recognized as qualified doctors and practitioners.

In the final days of this project, I came across a sign that read: "Faith makes things possible, not easy." It made me smile as I realized how true this statement was with my three-thousand-mile journey almost complete. I had left it all to faith, chance, luck—call it what you will—but my adventure had allowed me to photograph fifty people I had not known only three short weeks before. Even though I was a total stranger, every last person I approached agreed to take part in my project. I met some incredibly honest, simple, straightforward, unpretentious, friendly, and memorable American characters along the way. And each and every one of them made me feel so very welcome.

Judd Redfield, friend and former
employee of Ansel Adams,
Montrose, Colorado

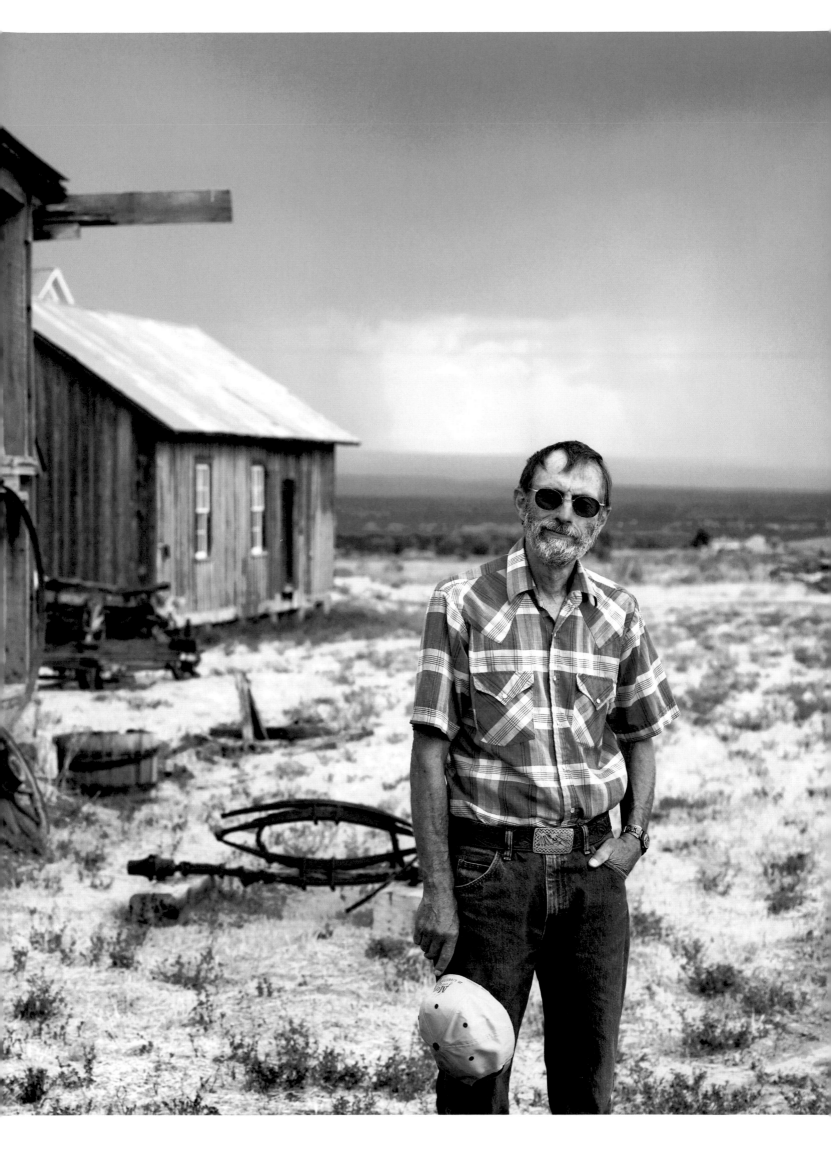

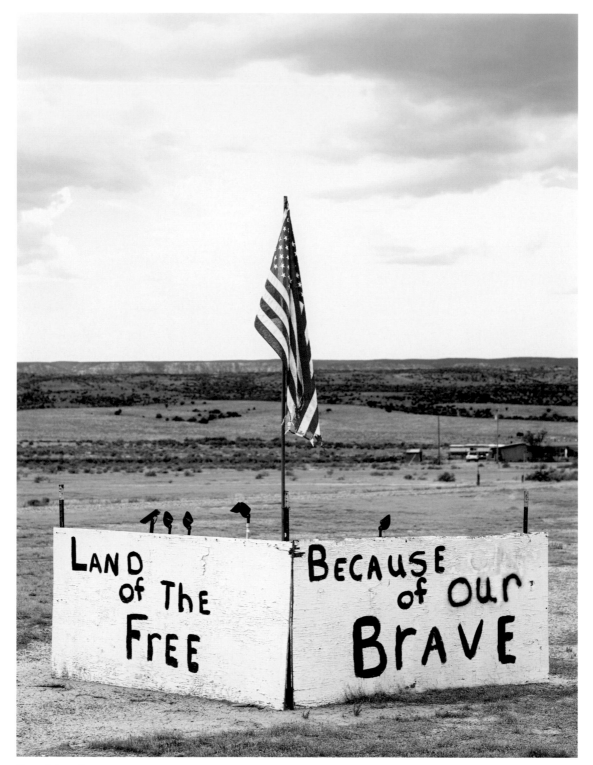

Grand Junction,
Colorado

Sandra Alayon,
San Francisco

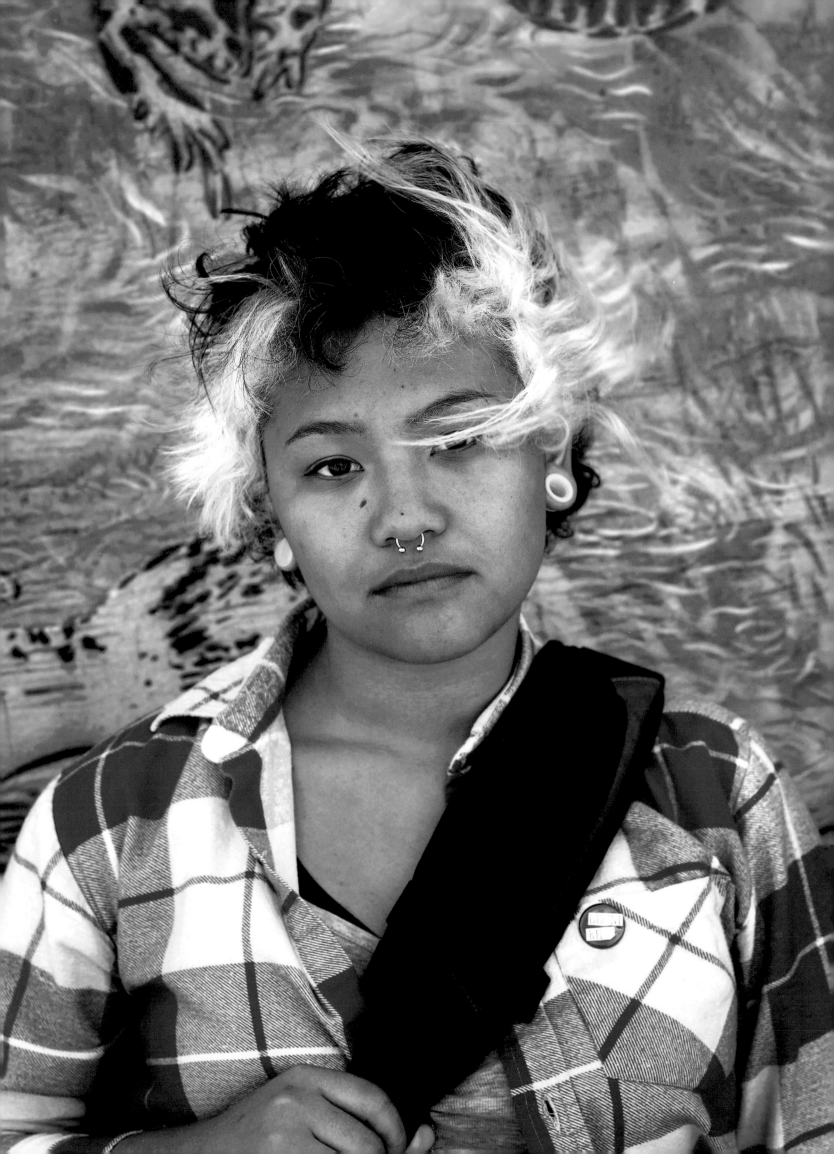

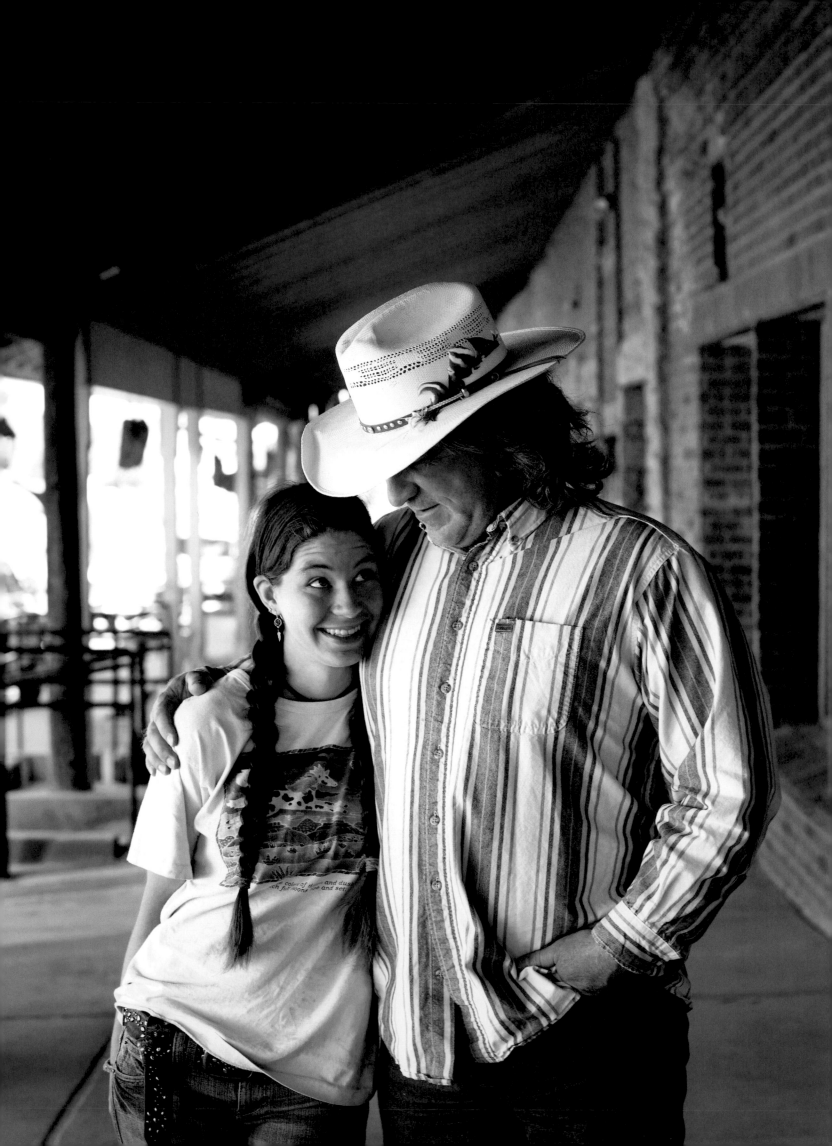

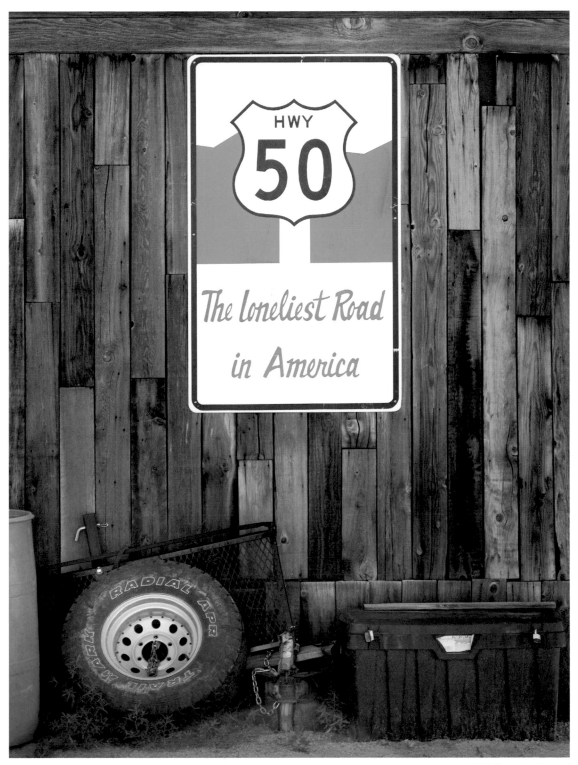

Middlegate, Nevada

Steve and **Holly Pierson,**
father and daughter,
Eureka, Nevada

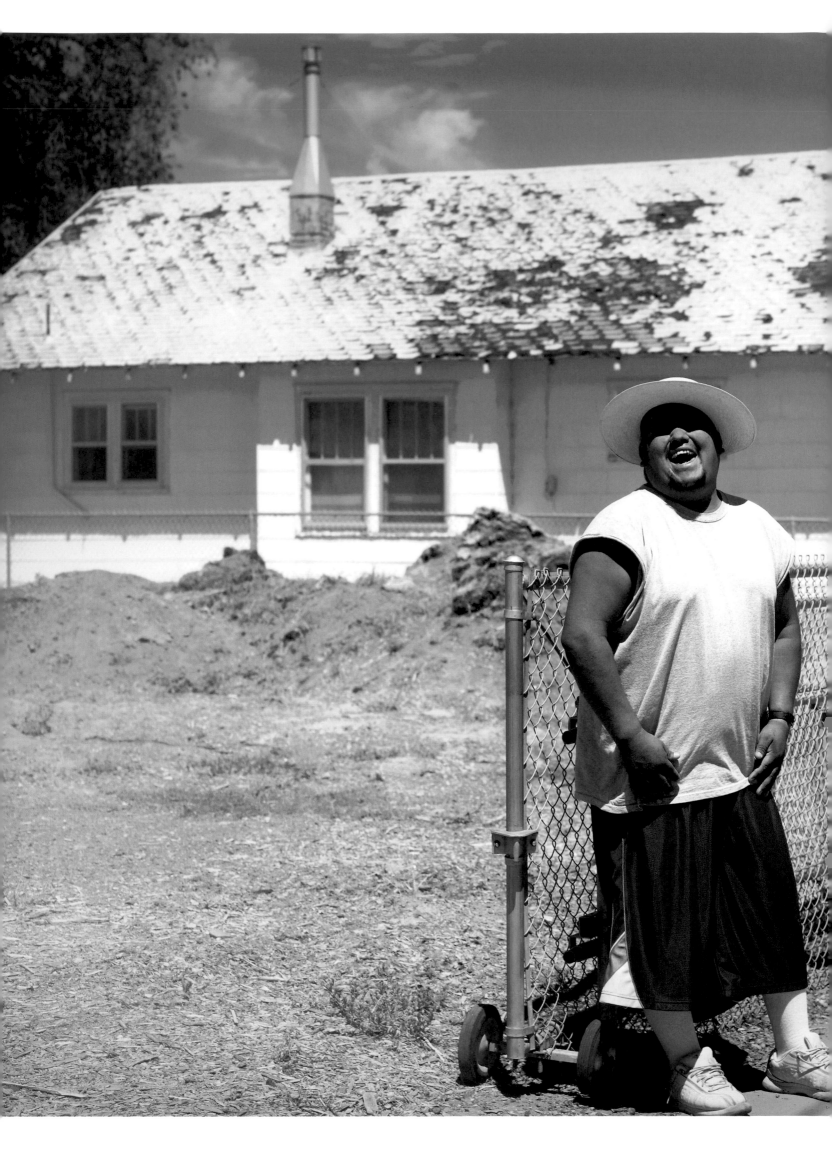

Michael Smith, calls himself
a "cowboy, buckaroo-style,"
Fallon, Nevada

Colorado

Richard E. Fike, retired archaeologist; owner and founder of the Museum of the American West, Montrose, Colorado

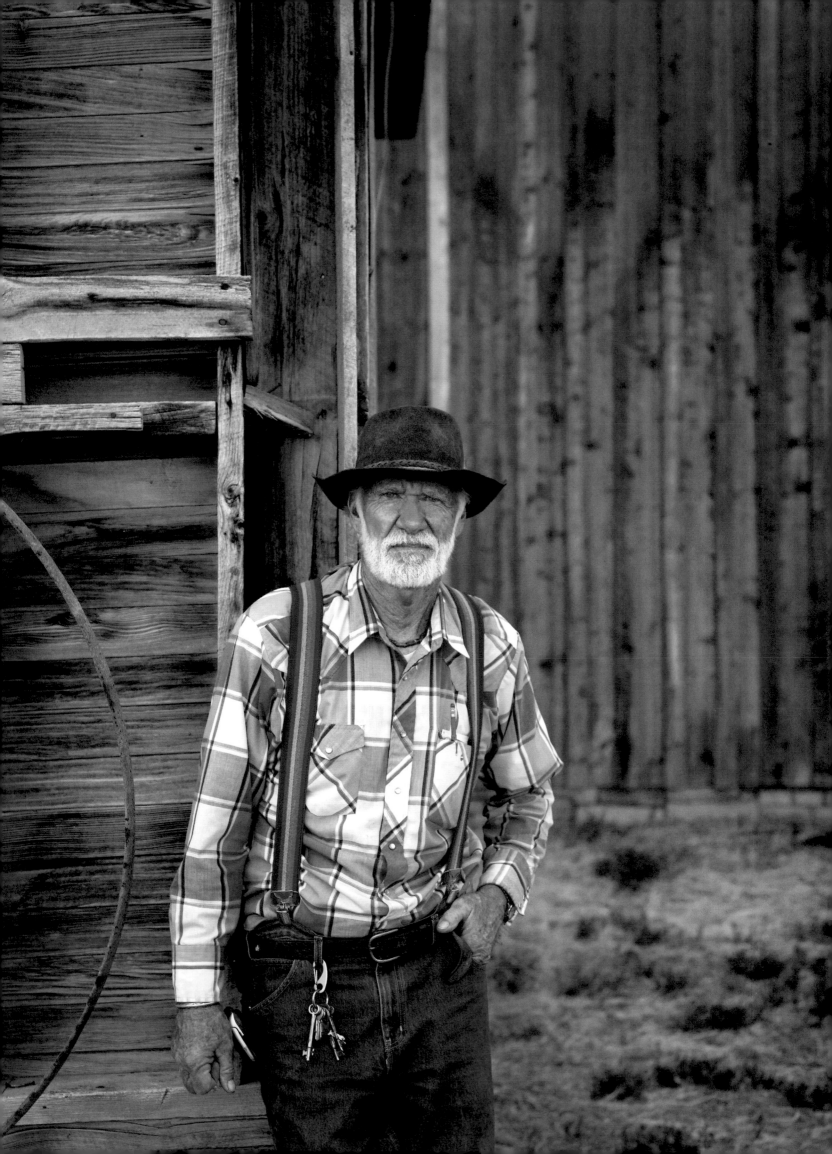

Dylan Souder,
Eureka, Nevada

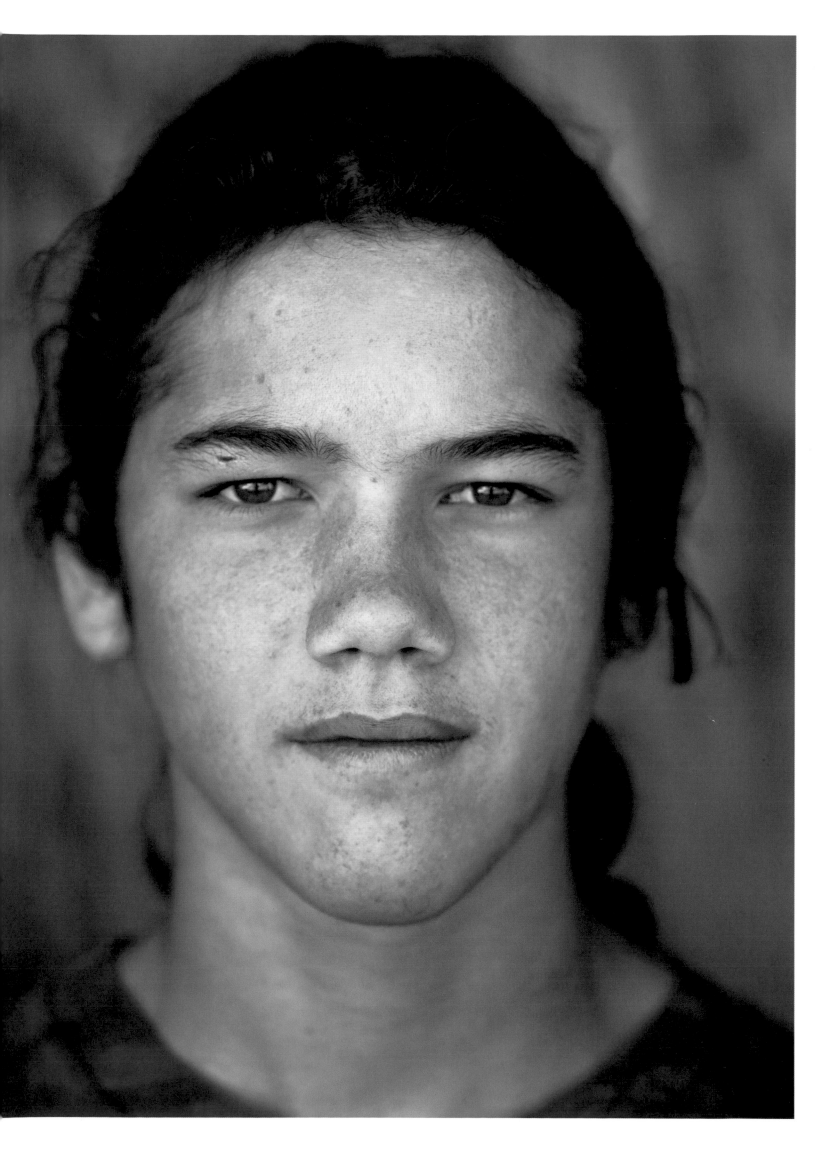

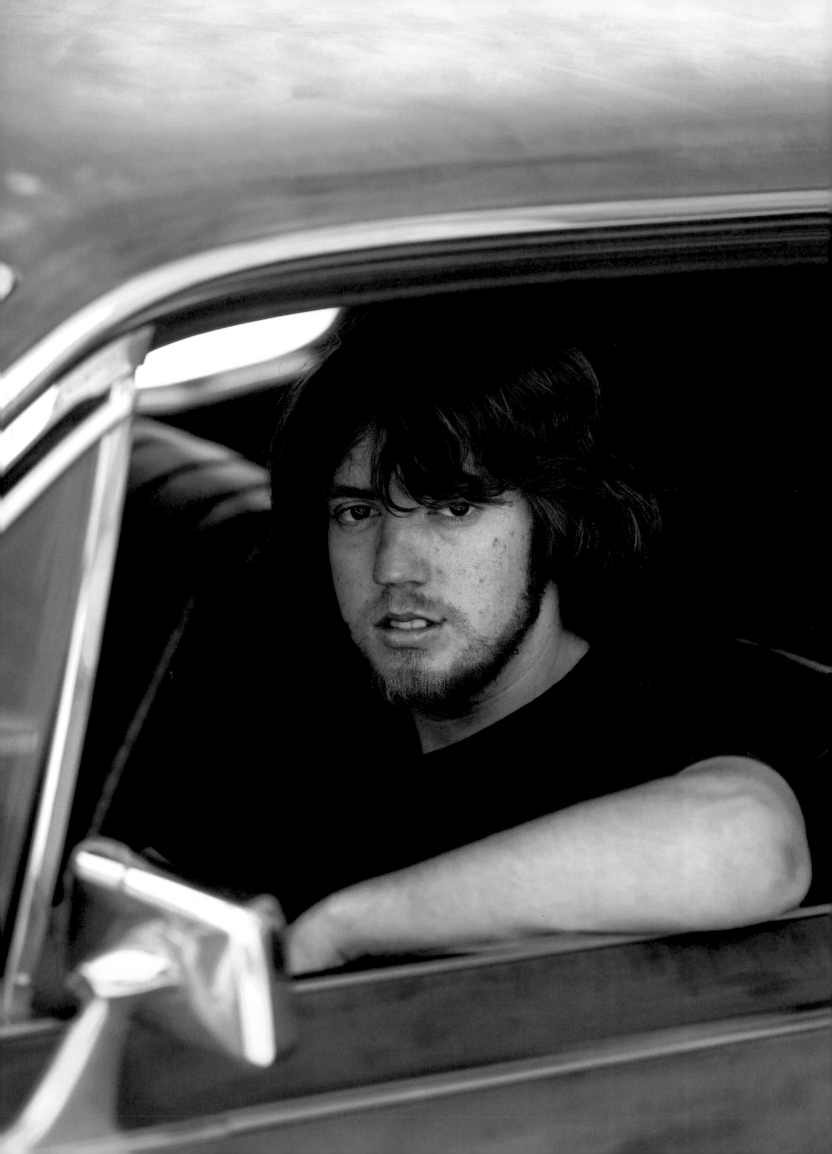

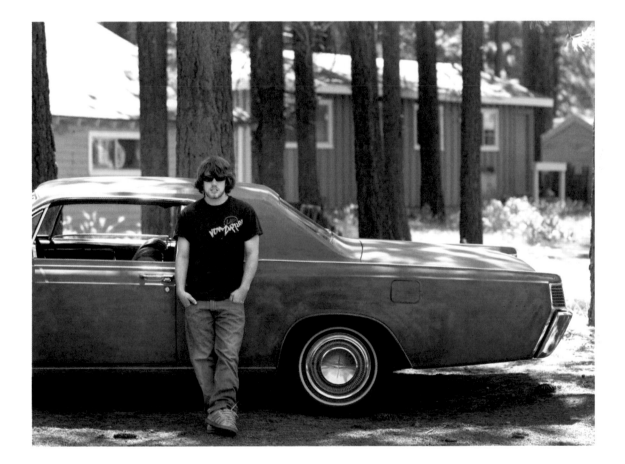

Tony Allison, U.S. Forestry
Service firefighter and snowboard
instructor, Lake Tahoe, California

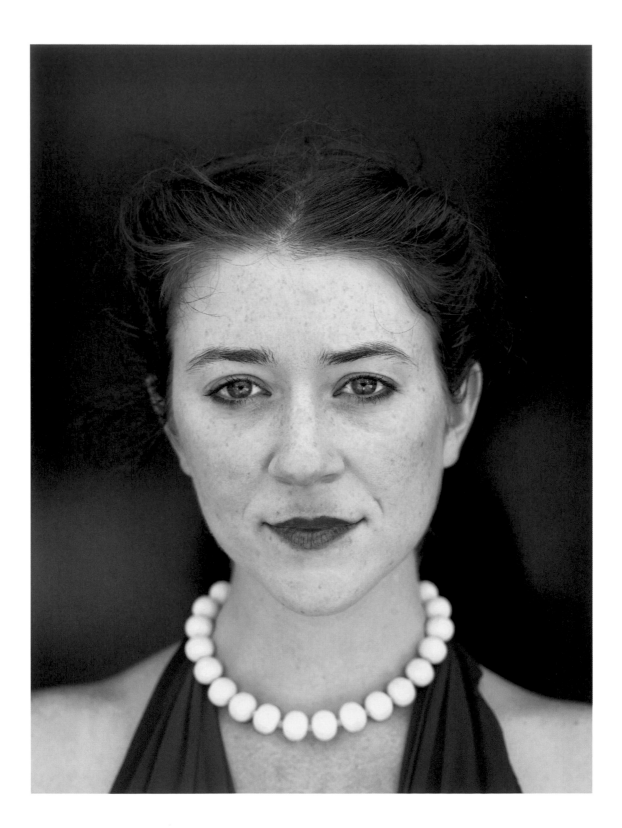

Lindsay Benner, performer
at Pier 39, Fisherman's Wharf,
San Francisco

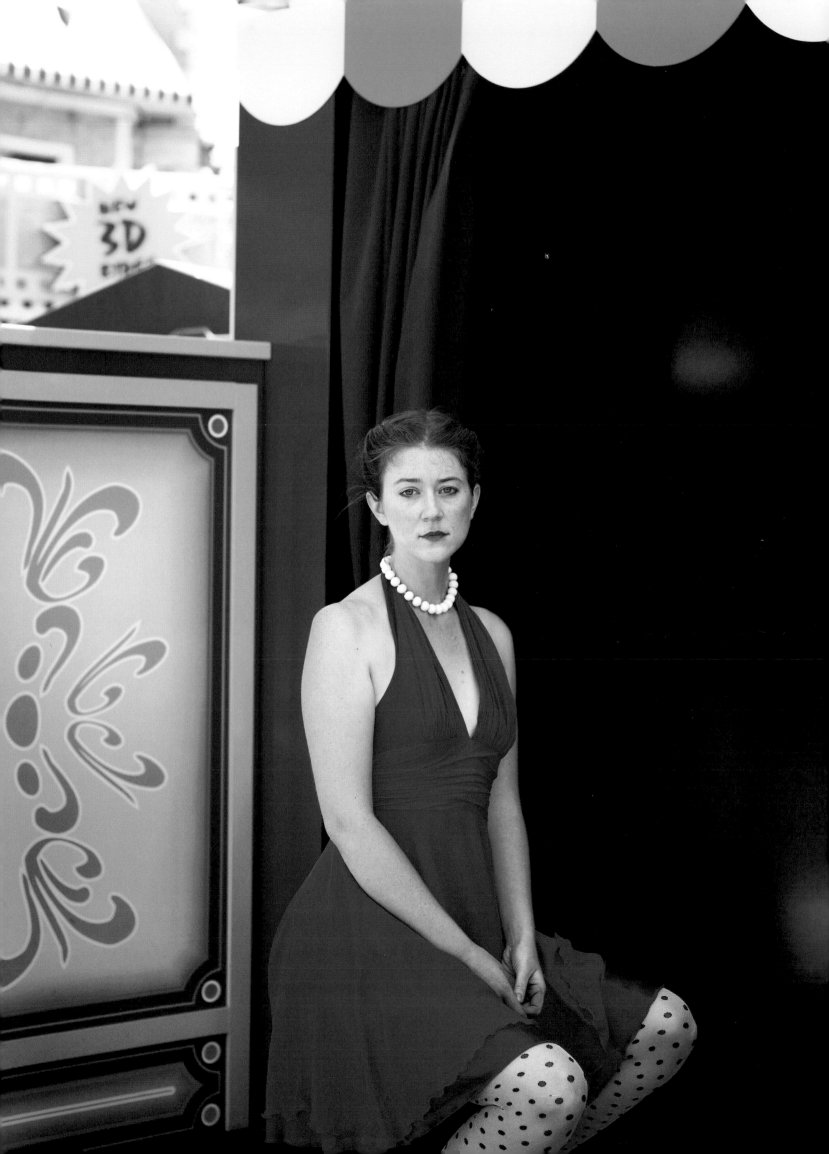

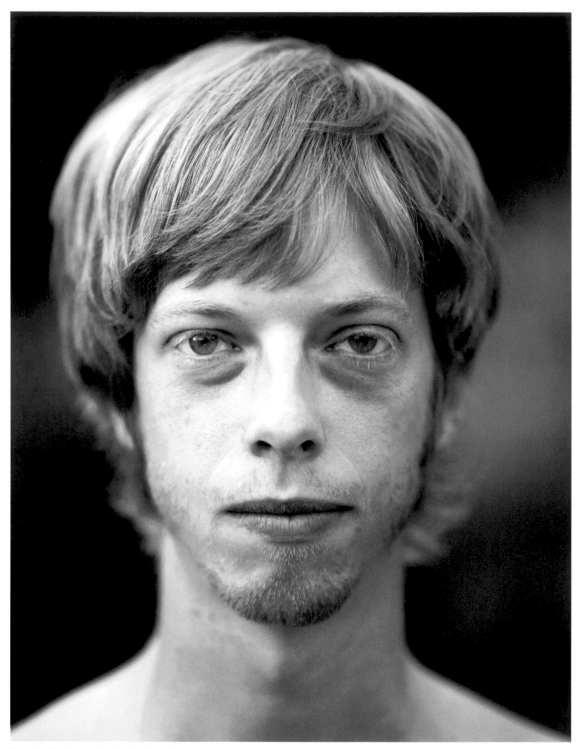

Dustin Meckes, student who dreams
of setting foot on all seven continents,
Athens, Ohio

Joseph Daniel Clipper,
Washington, D.C.

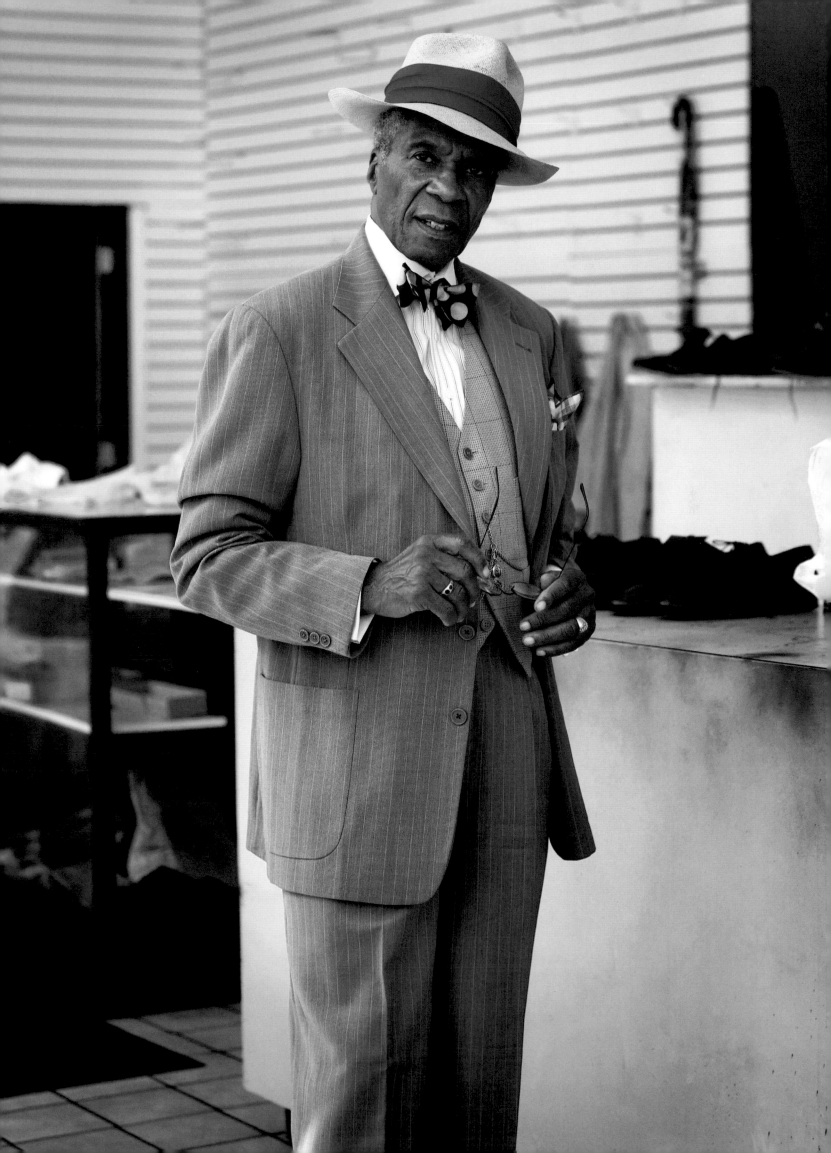

Brady Wilson, devoted BMX
rider, Emporia, Kansas

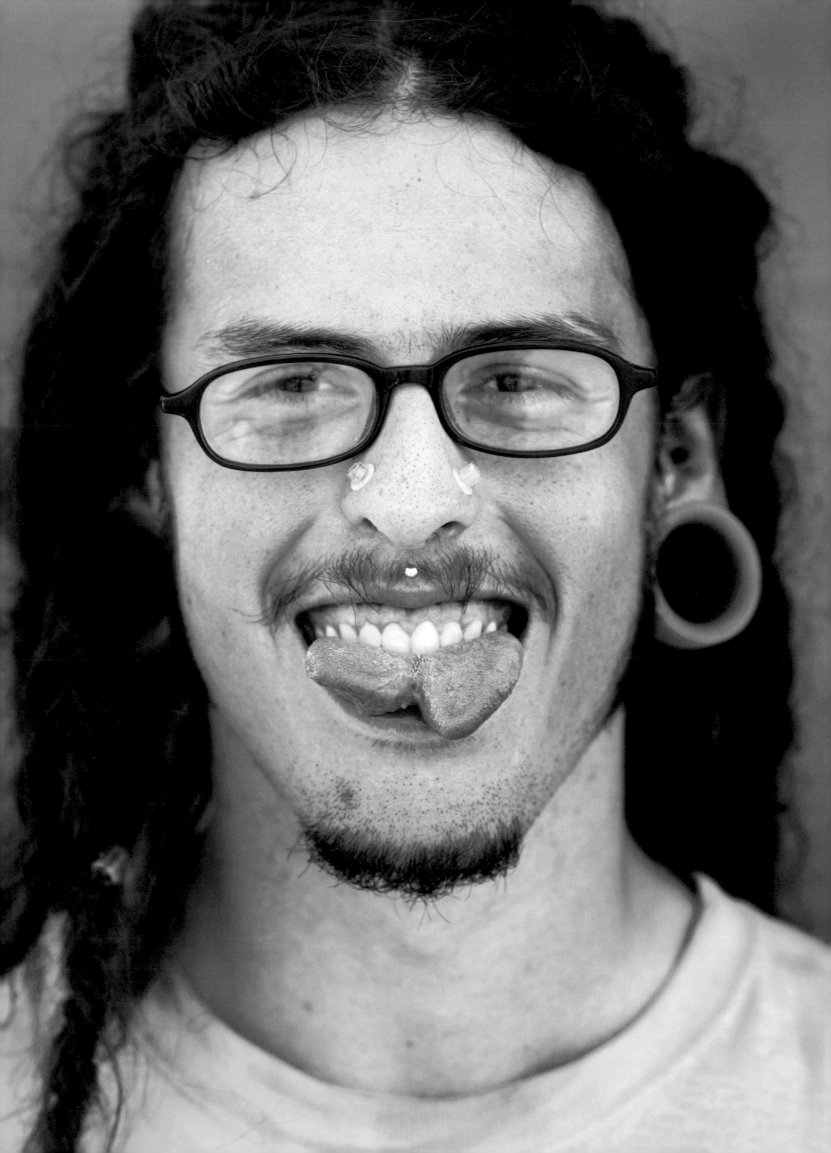

Nevada

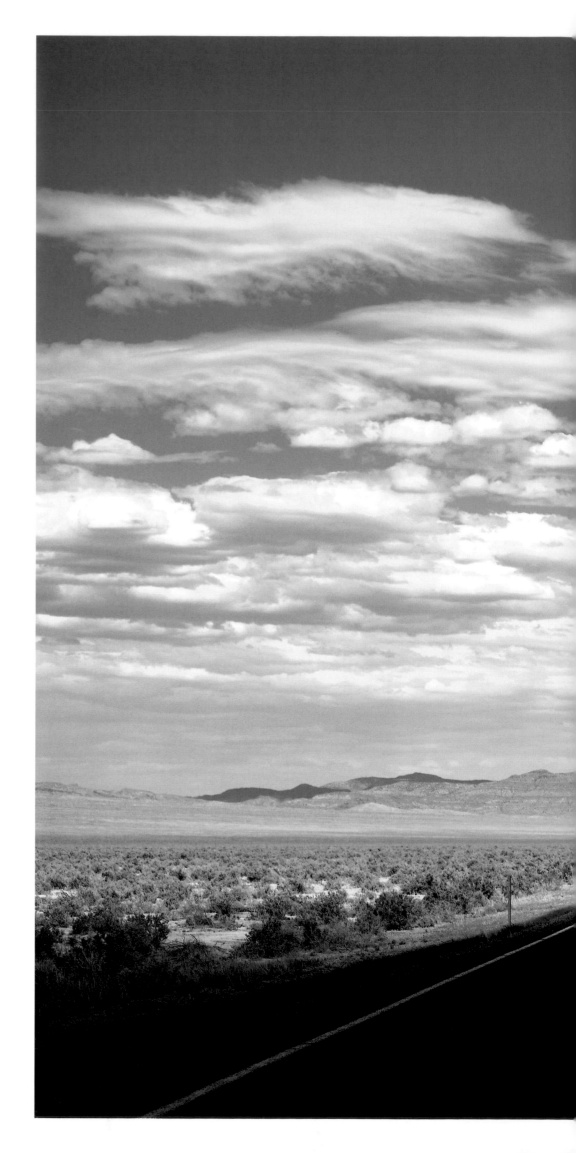

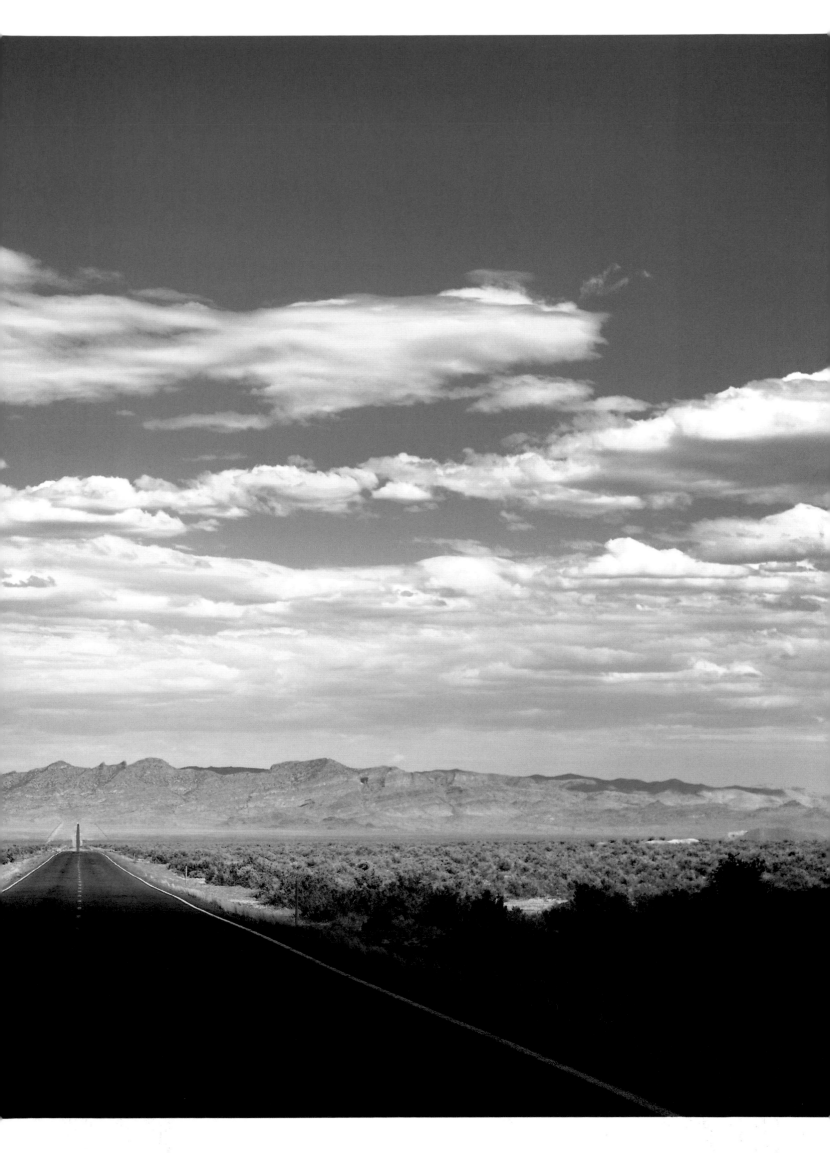

Young Chicagoans

DAWOUD
BEY

I HAVE BEEN making photographs of people for some thirty-three years, beginning with a group of photographs I made in Harlem, New York. The way the camera can make a representation that contains enough of an emotional and psychological charge to momentarily connect the viewer to another human being, a stranger, continues to engage me. Because I use a large-format camera mounted on a tripod, there is an inherent need to set things up in front of the lens, to pose the subject. How to do this in a way that still results in a credible sense of individual character, emotion, and psychology is my ongoing challenge and the thing that motivates my work.

The photographs for Character Project were all made in a single location over several weeks. Using the slightly distressed side of a construction shed as my backdrop, I set up a kind of "studio of the streets" on busy Michigan Avenue, the main downtown thoroughfare in Chicago. The shed allowed me to create a quiet space in the midst of the busy urban environment, a space in which I could take a closer look at the individuals I chose to photograph. All of the subjects are students at Chicago's Columbia College, where I have taught now for ten years. Setting up my camera in this same location each day, I proceeded to look for those young people who I thought exuded either a strong or subtle sense of character, something I thought I could describe interestingly through my lens. By capturing their individual gesture, dress, and comportment, I hoped to represent the rich diversity of young people who inhabit this modern American city.

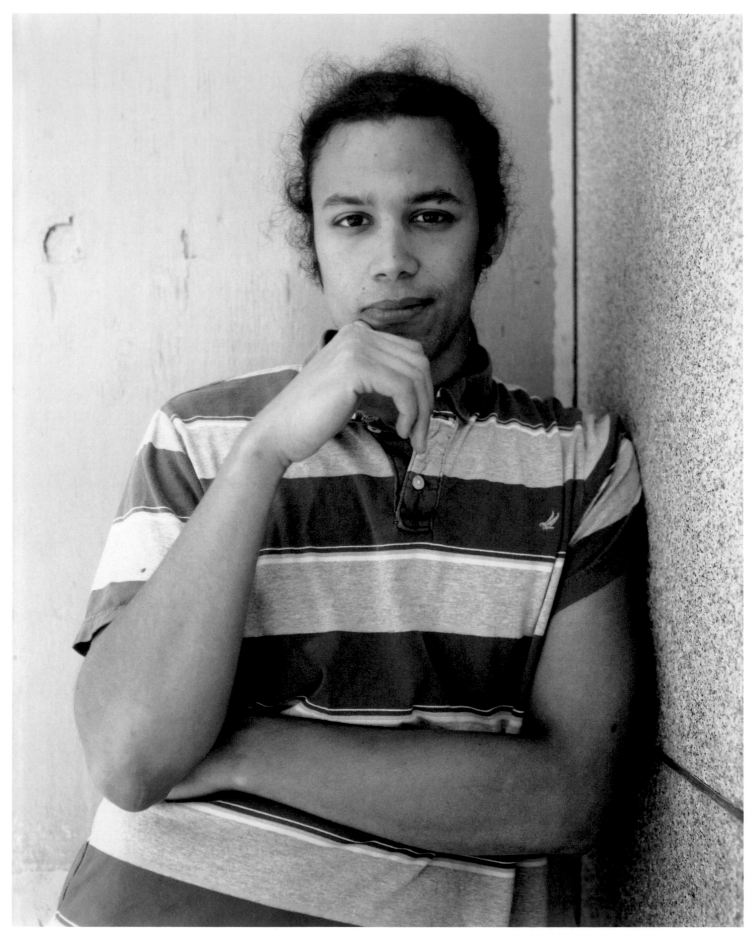

Zach, Chicago

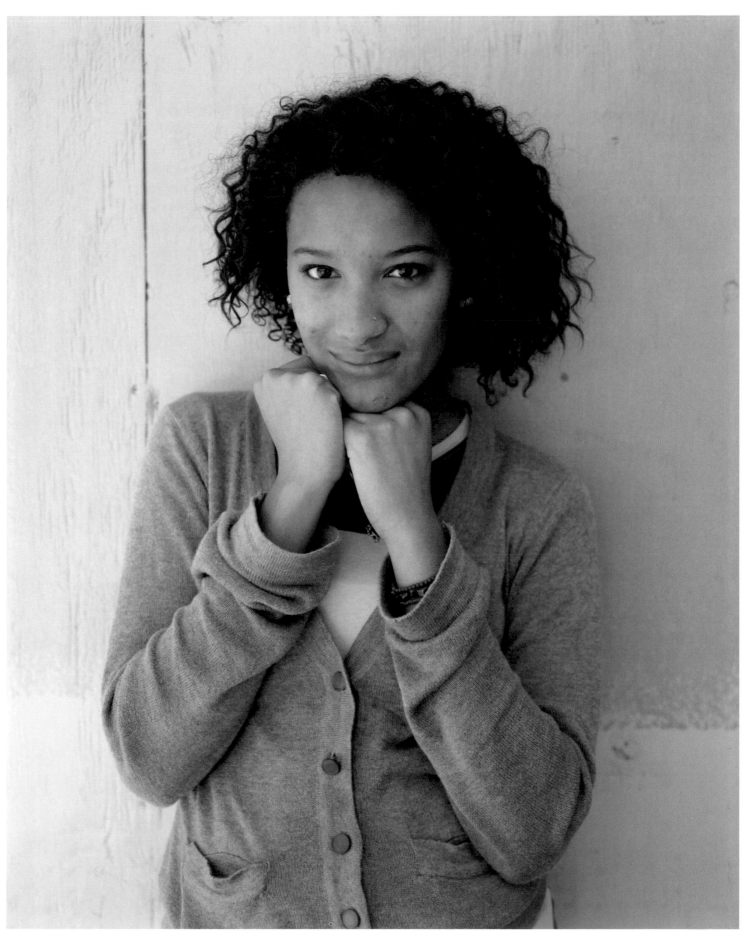

Lalese, Chicago

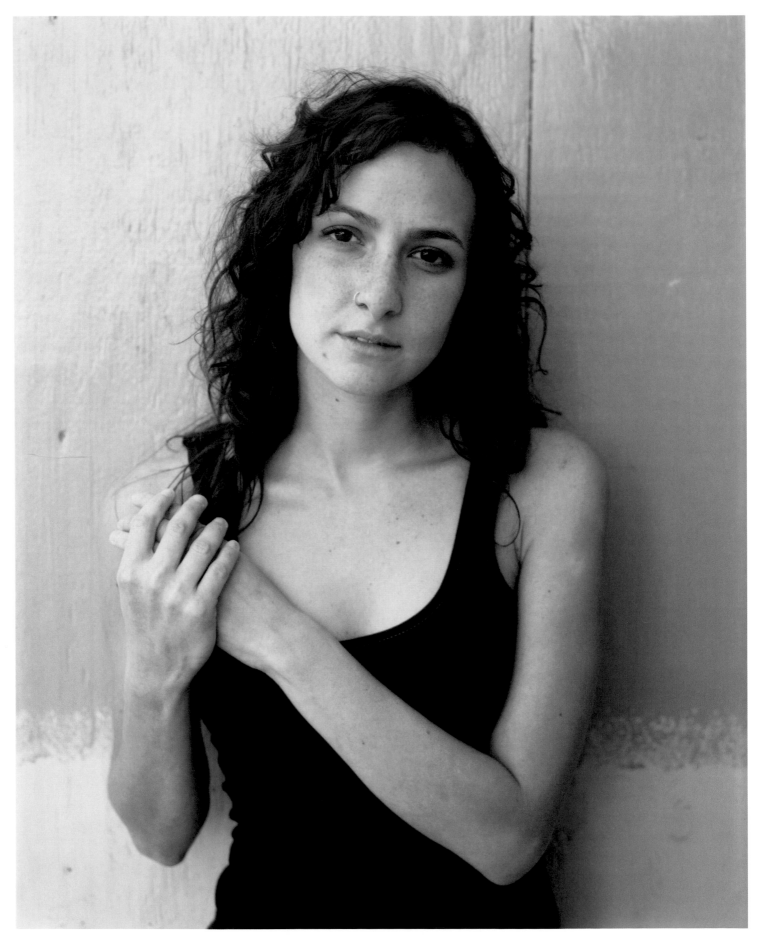

Eva, Chicago

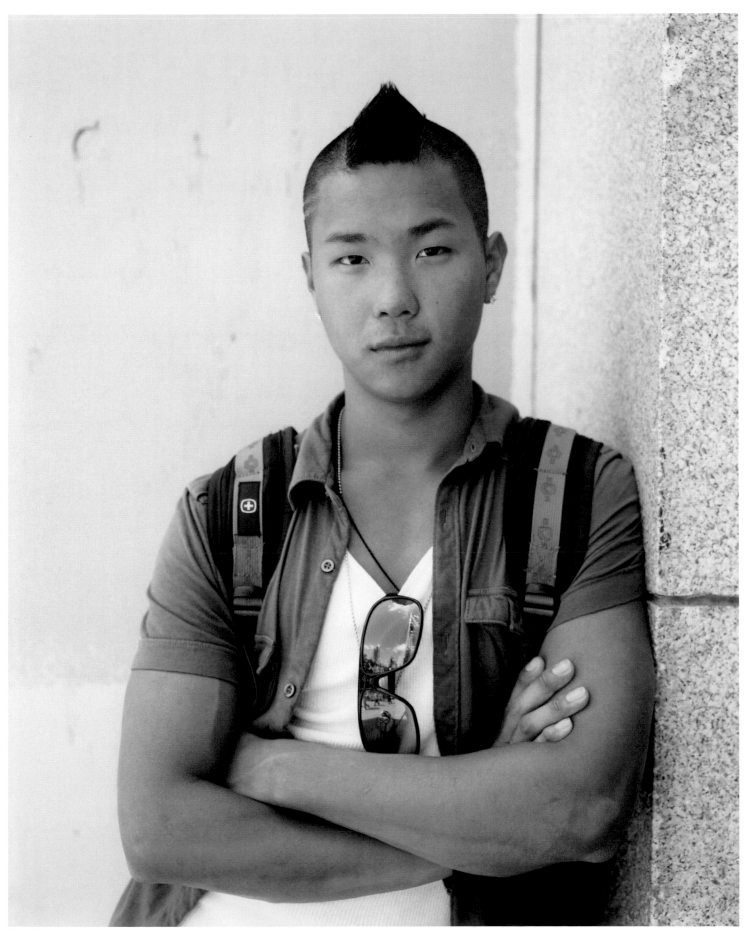

Ed, Chicago

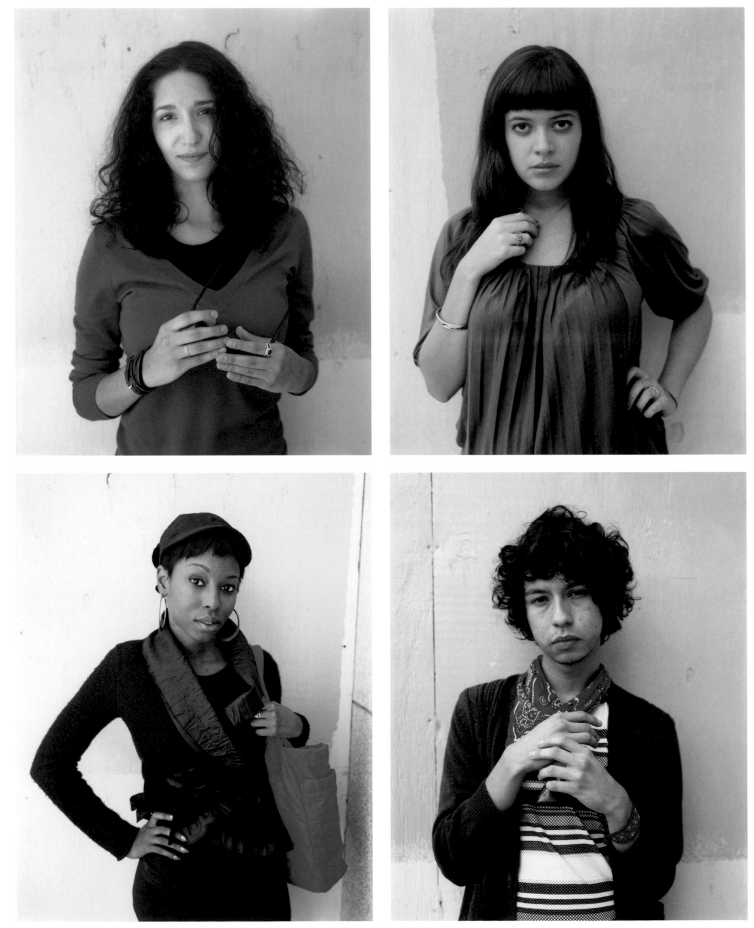

Clockwise from top left: **Jessica, Elisiana, Jovanni,** and **Robbie,** Chicago

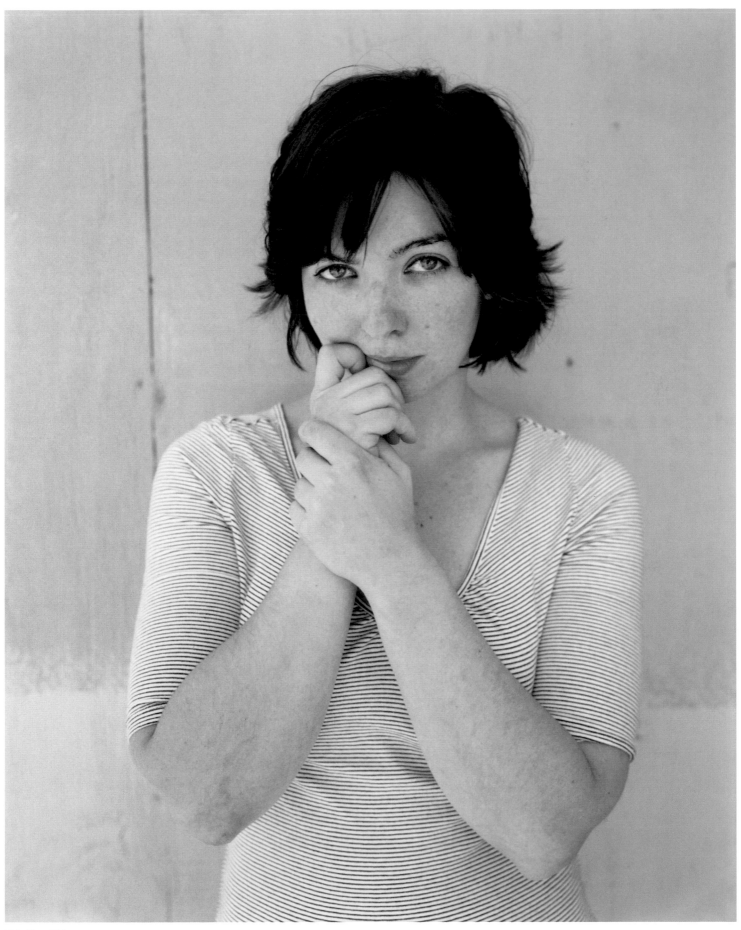

Cristin, Chicago

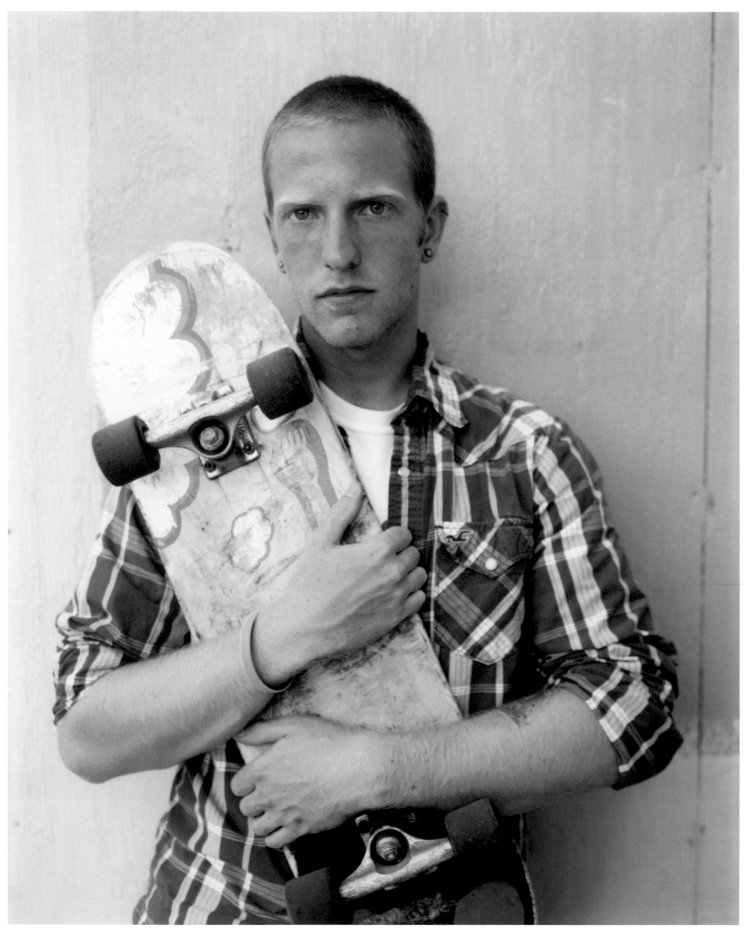

Mike, Chicago

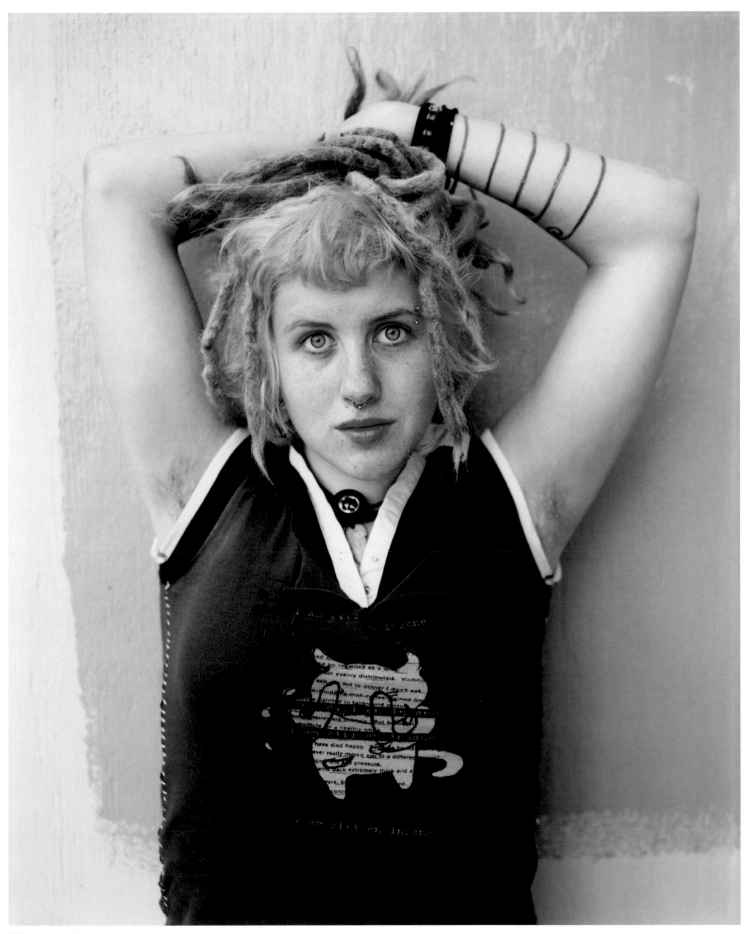

Elizabeth, Chicago

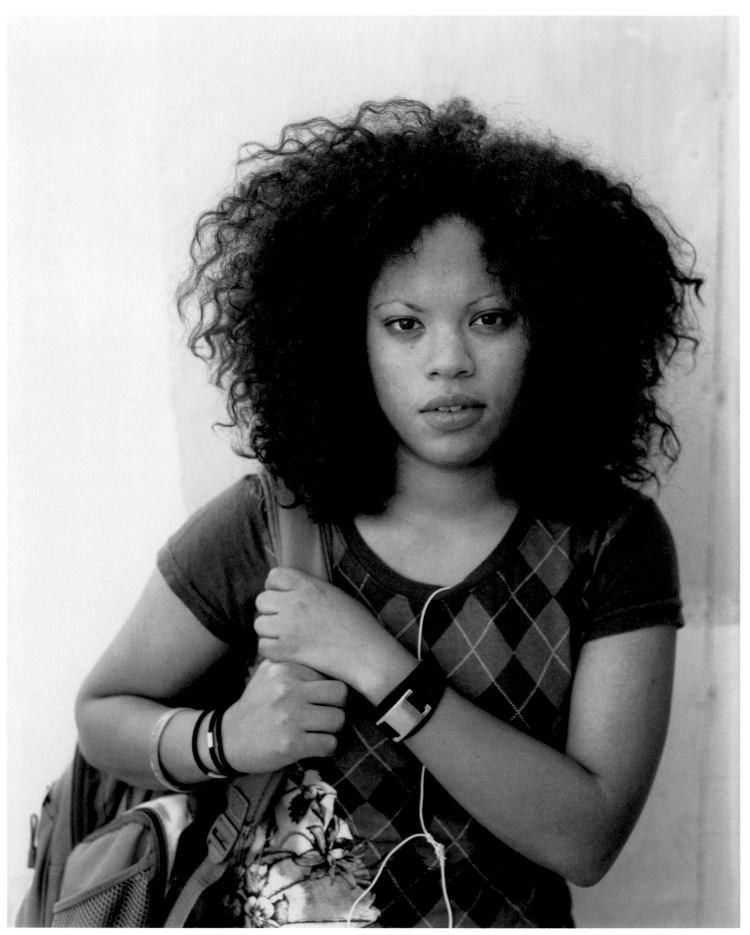

Mesun, Chicago

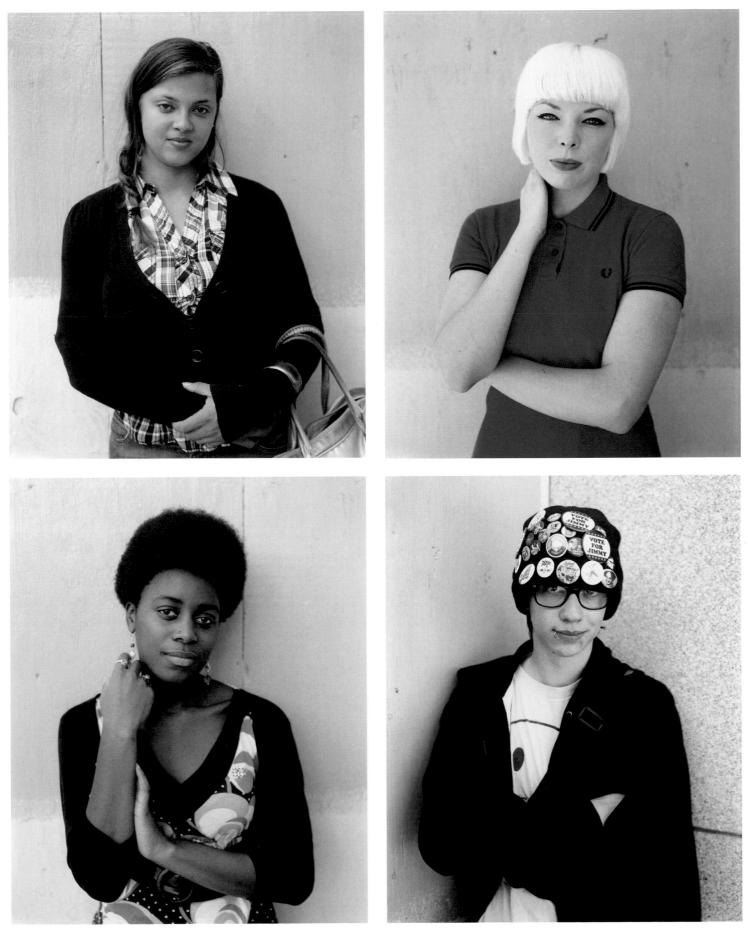

Clockwise from top left: **Anita, Aoife, Nikolas,** and **Lauren,** Chicago

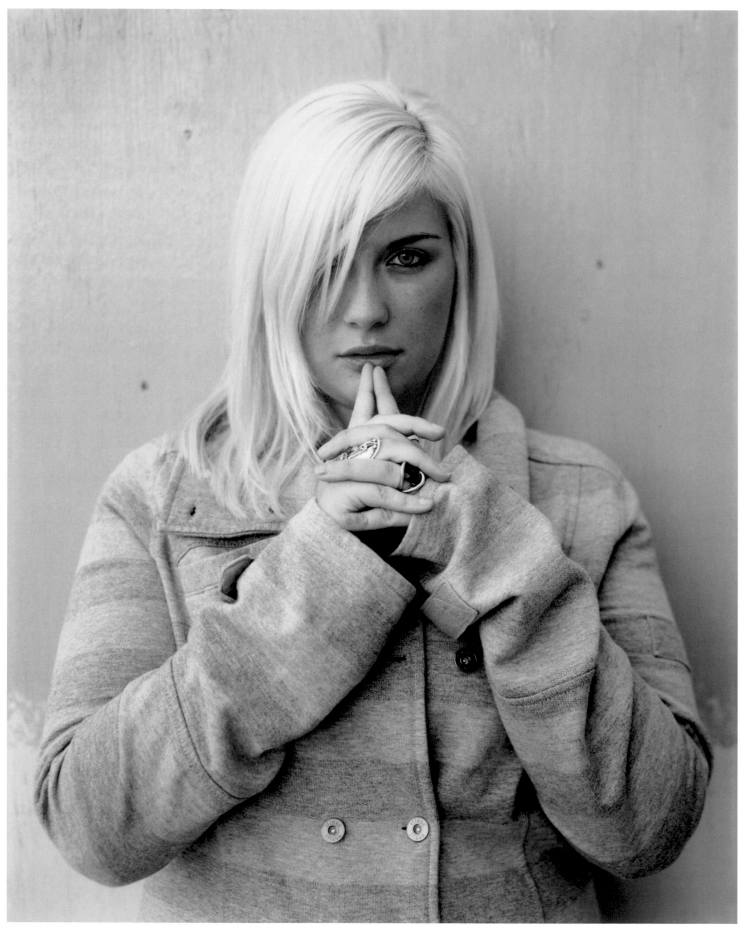

Tiffany, Chicago

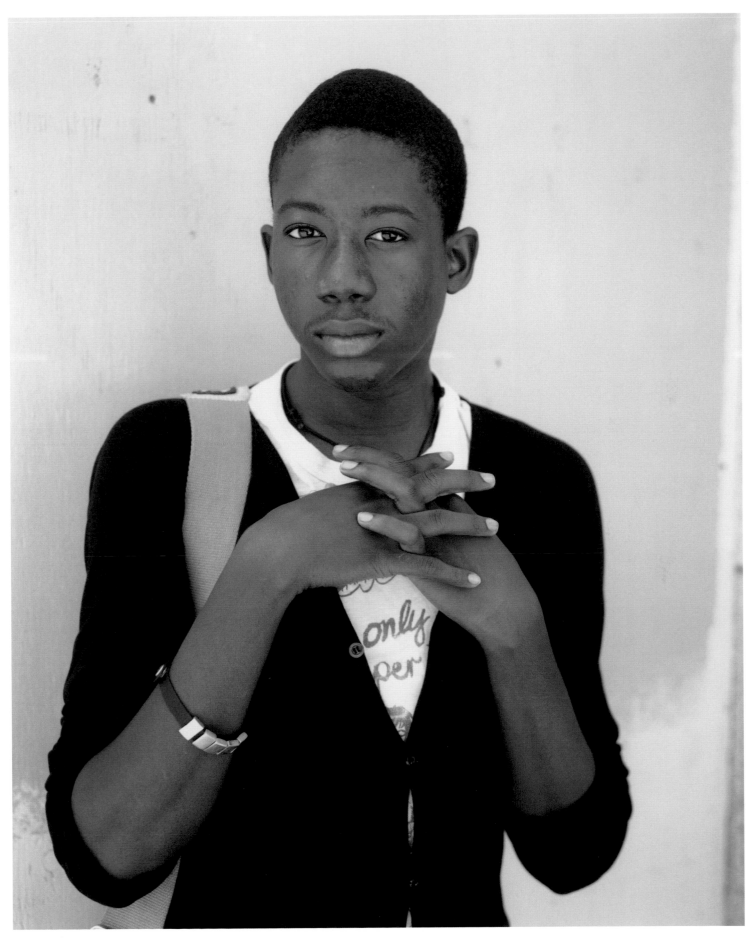

Aaron, Chicago

ERIC McNATT

MY FAMILY TREE goes back five generations (on both sides of the family) in central Texas. Brownwood is where I learned to milk a cow, gather eggs from the coop, and saddle a horse. It is also where I remember, as a child, watching my great-grandfather cut the heads off chickens while my great-grandmother boiled drinking water from the well. And I remember my grandfather taking me to the Gordon Wood Stadium to watch hometown football, the epitome of Texas spirit.

These memories are a far cry from the New York surroundings I am accustomed to today, but they inform my ethical choices as a person and my artistic choices as a photographer. In the same way that the iconic image of my great-grandmother, proud and strong, making soap in the kitchen is burned into my memory, I try to photograph the true nature of my subjects so that they, too, make indelible impressions.

My intention for this project was to look for the wild and woolly, quiet and intense, quirky and idiosyncratic spirit of the small Texas town I remembered. Using family and personal connections to gain access to the homes and businesses that make this part of America tick, I wanted to capture the strength and character of a town built on faith and determination, while highlighting the individuals who comprise it. From the Brownwood Lions high school football team to Country-Western singers, from rodeo clowns to the women's basketball team at Howard Payne University, I wanted to photograph as large a cross section of people and places as I could.

When I went back, I found that Brownwood wasn't as sentimental or as tough as I remembered it. The people I met, who in their way of talking and acting may be unmistakably "Texan," are a lot more nuanced and complicated than my memory had allowed. They're characters, yes, but they're not caricatures. They're just like the aunts, uncles, cousins, and family friends I am connected to through generations.

One memory in particular of my time in Brownwood stands out: the Traveler's senior citizen's dance, also known as the "Old Folks Honky Tonk." I set up my camera in the very same seat my grandfather used for five years. With every new face I photographed, I couldn't help but see a mental image of my grandfather smiling and dancing the two-step. I wanted to hold the experience forever in my pocket.

With Character Project, I started out trying to capture a slice of contemporary America. But what I walked away with was something much broader and more introspective than I had anticipated: I expanded the perception of my history. Before I went back, I kept wondering how things would have turned out, how different I would look today if I had stayed in Texas. When I look at these pictures now, I see that they are a way of creating not just new memories but also, inevitably, new fictions. Any photograph is an incomplete truth. My hope is that these pictures of Brownwood trigger your own individual images and ideas about "home," however similar to or different from these pictures your images may be.

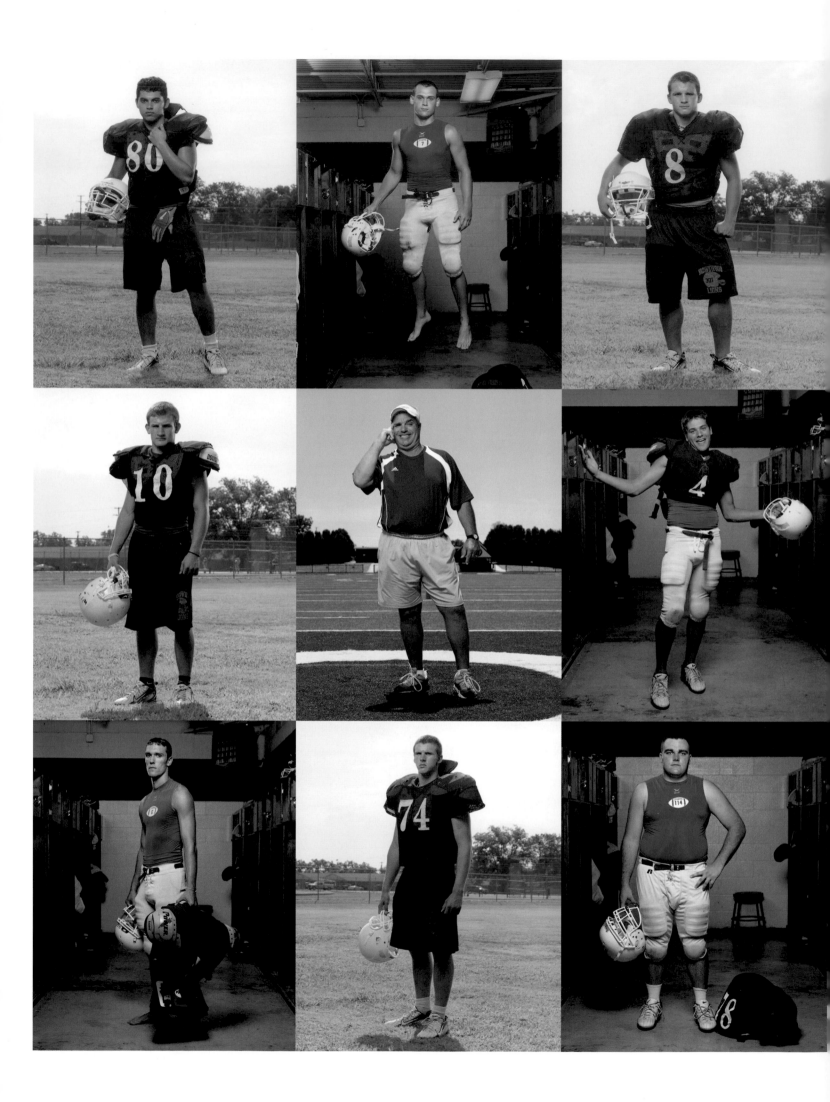

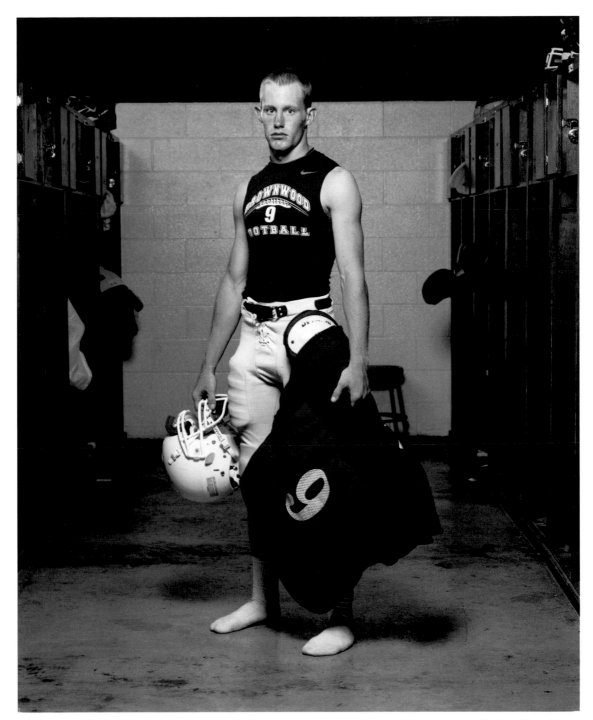

Tanner Vaughn,
Brownwood Lions,
Brownwood, Texas

Left to right, from top: **Joseph Bates, Bubby Harrell, Payton
Ragsdale, Travis Holleman, Coach Steve Freeman, Parker
Taylor, Casey Pachall, Tracer Skelton,** and **Jake Senkirik,**
Brownwood Lions, Brownwood, Texas

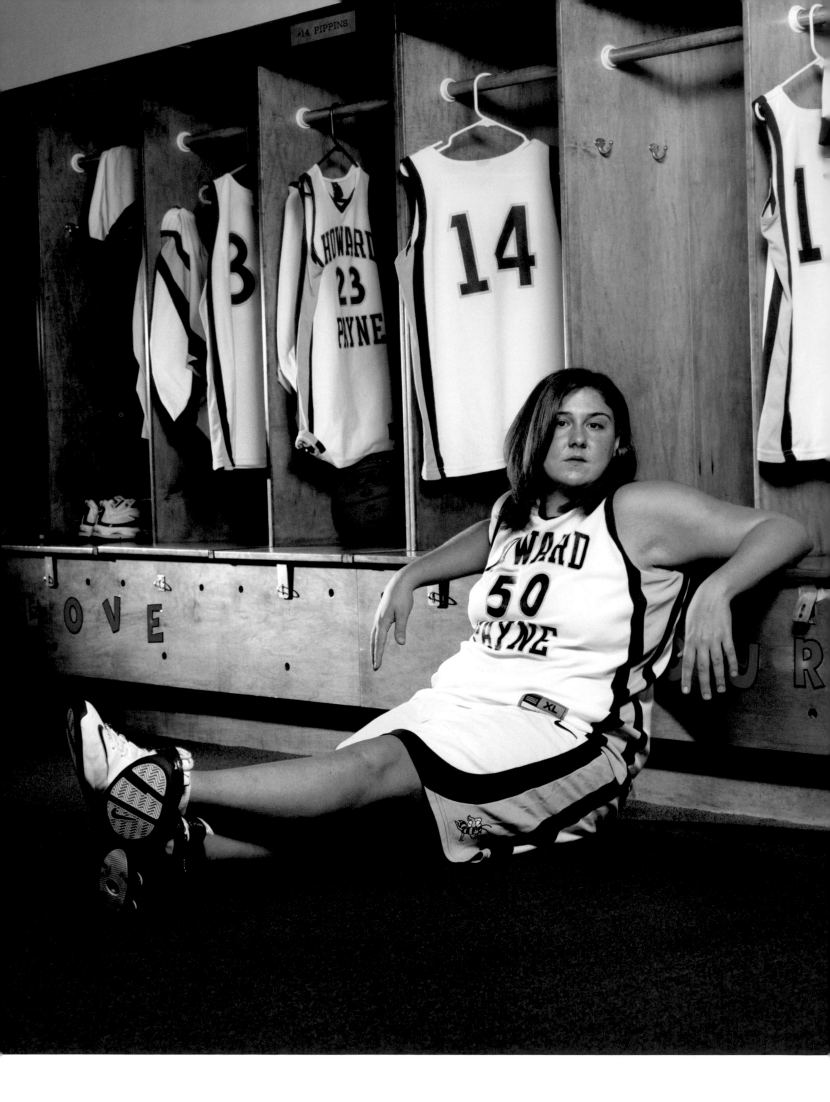

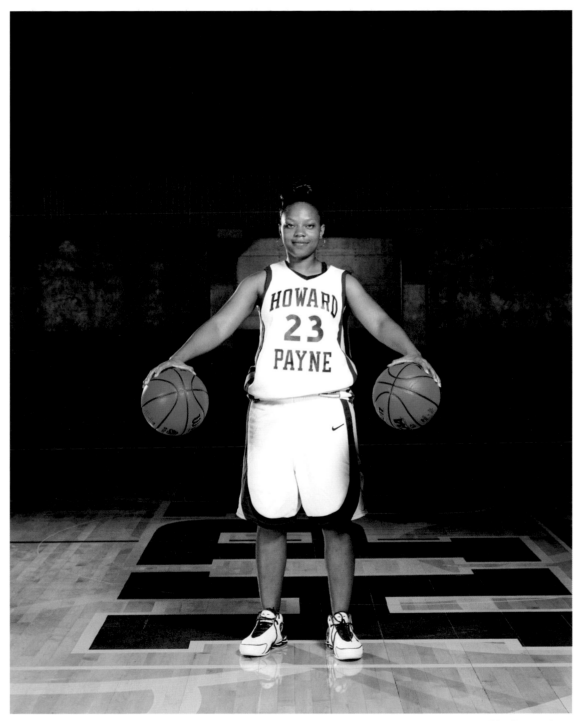

Makiesha Davis,
Howard Payne Lady Jackets,
Brownwood, Texas

Sarah Jockers,
Howard Payne Lady Jackets,
Brownwood, Texas

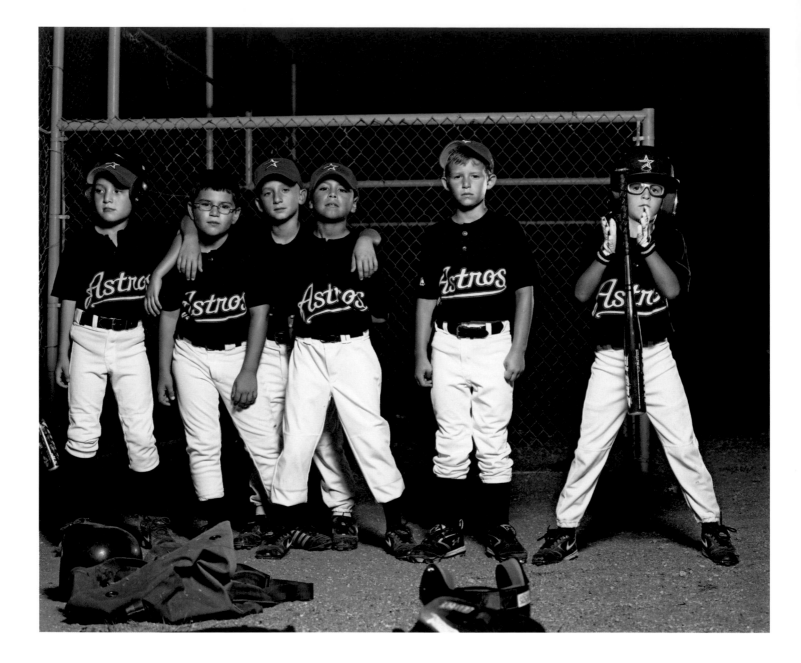

Left to right: **J. J. Mares, Tyler Garza, Chris Farrow, Fernando Alvizo, Xavier Porter,** and **C. J. Hanley,** Astros, Jr. Midget State Championships, Brownwood, Texas

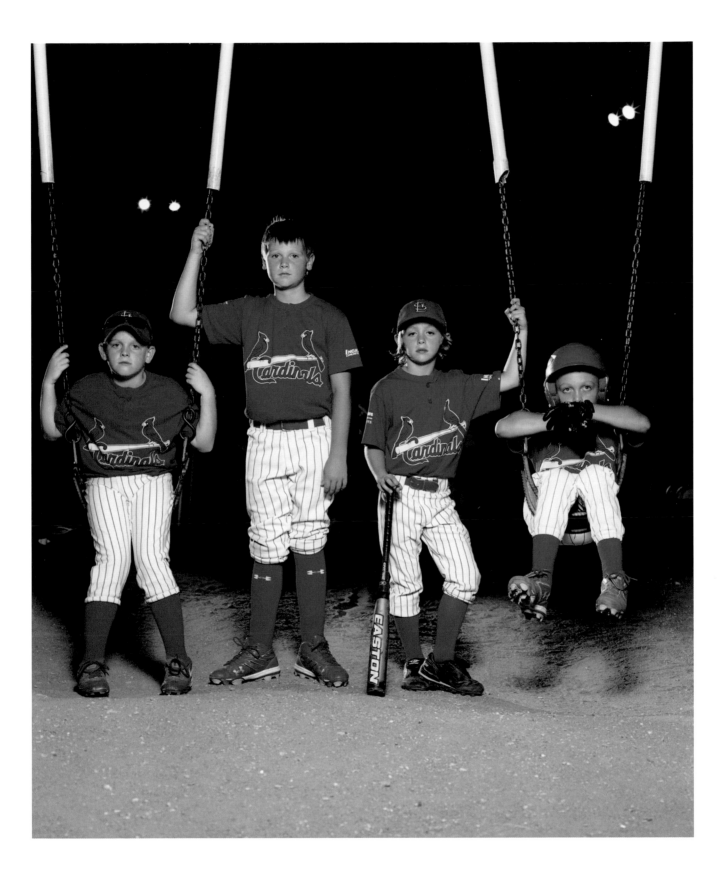

Left to right: **Hayden Donahoo, Ryan Reagan,**
Ben Pennington, and **Hunter Mares,** Cardinals,
Jr. Midget State Championships, Brownwood, Texas

Chelsea Tuley, Miss Heart of Texas,
Brown County Rodeo Parade,
Brownwood, Texas

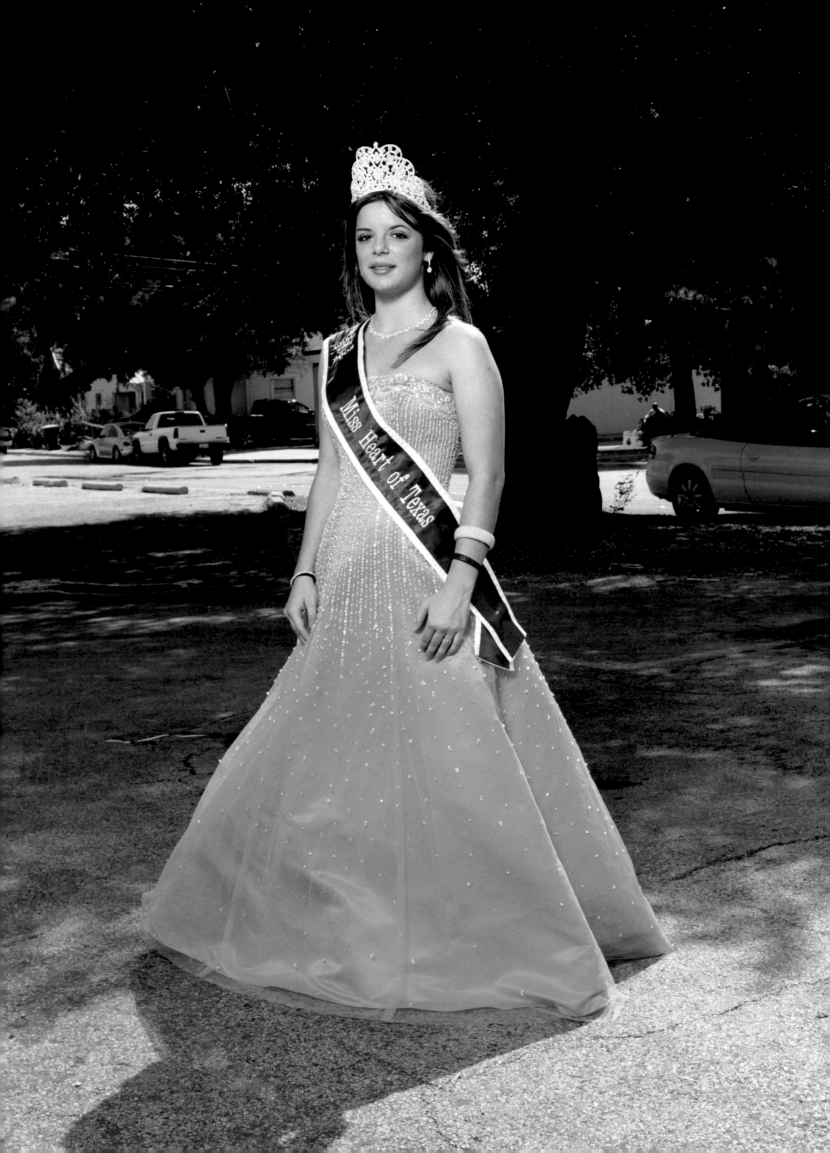

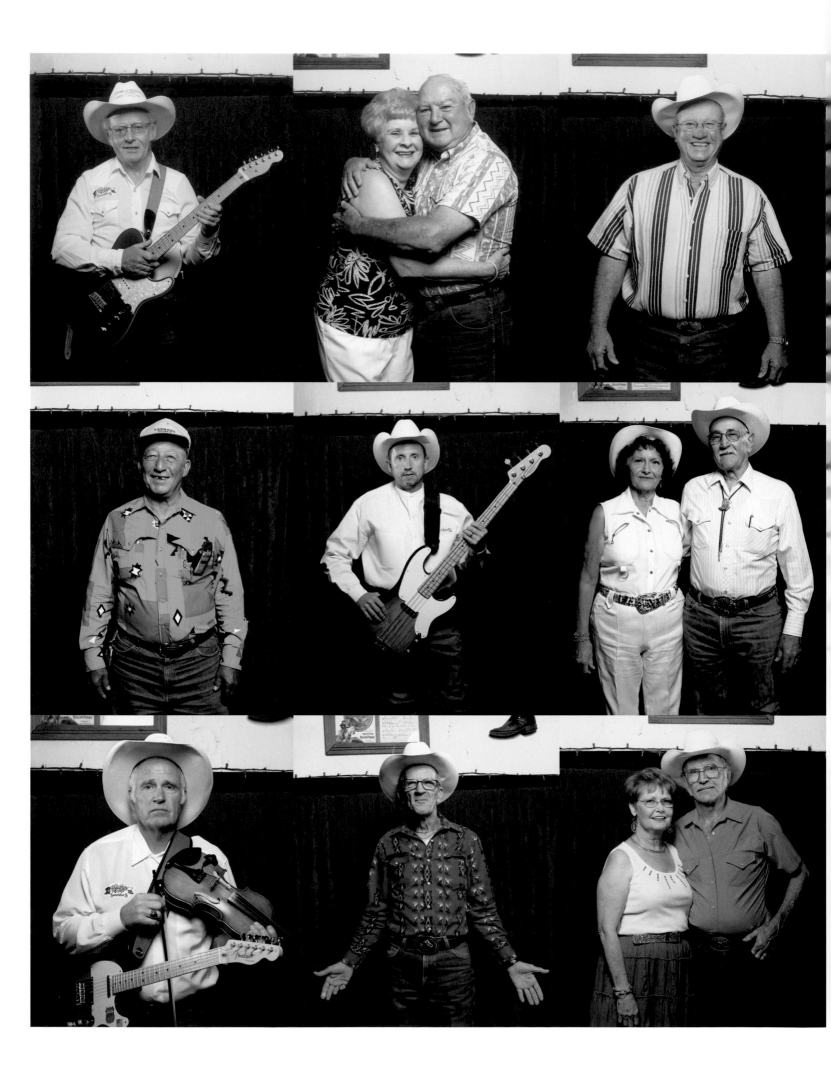

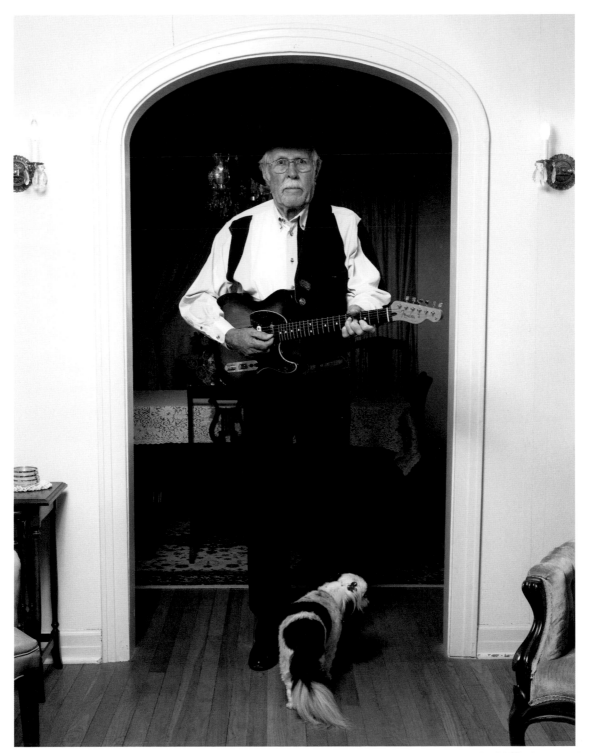

Earl Hill, Western Swing Hall of Fame pioneer, at his home in Brownwood, Texas

Left to right, from top: **Dick Powell, Lois P. Watkins** and **Lee Umberson, James Hiroms, Helioedoro "Jo" Garza, Ricky Lynn Pannell, Nina Martin** and **George Watts, R. C. Willey, Carl Hobbs,** and **Frances** and **Donald "Bo" Inglet,** Traveler's senior citizen's dance (a.k.a. "Old Folks Honky Tonk"), Brownwood, Texas

Lecile Harris, PRCA rodeo clown of
the year and actor in Westerns, Brown
County Rodeo, Brownwood, Texas

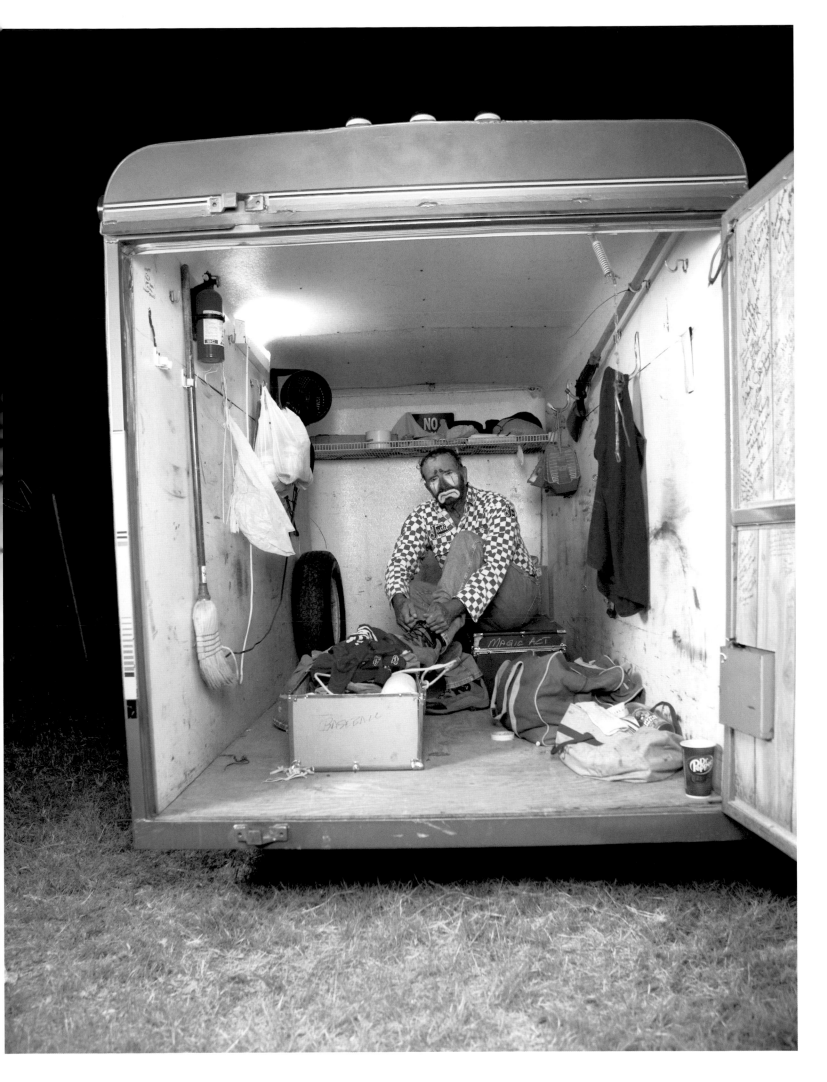

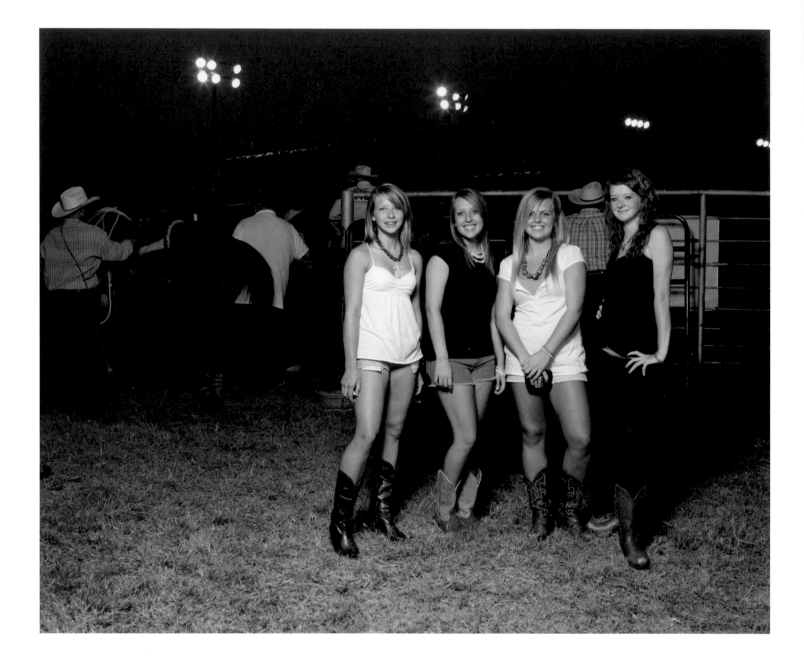

Left to right: **Katie Mullins, Randa Newman, Ashley Combs,** and **Sheldyn Miller,** Brownwood Lions cheerleaders, Brown County Rodeo, Brownwood, Texas

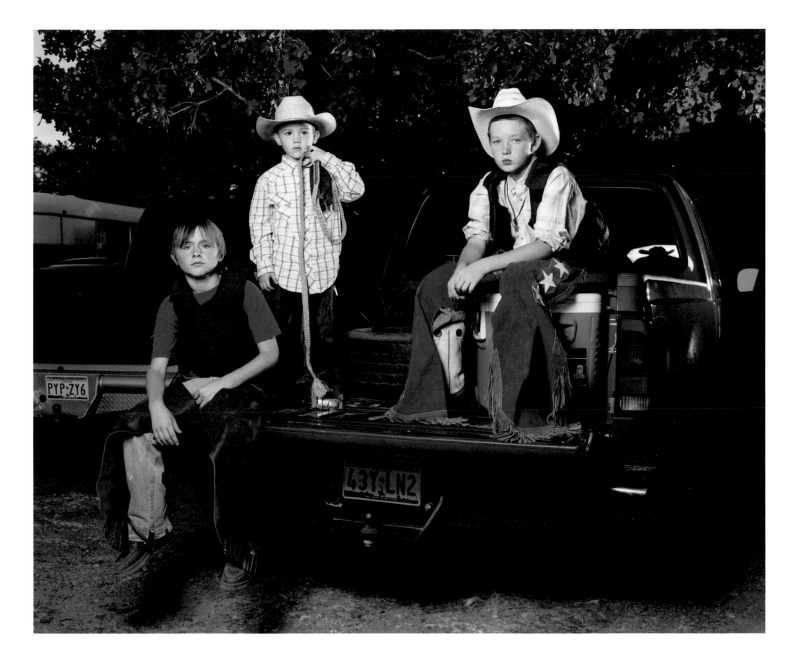

Left to right: **Austin Walker, Brayden Baker,**
and **Bryant Cahill,** Elm Grove Jr. Rodeo,
Elm Grove, Texas

The Spirit of the South

SYLVIA
PLACHY

MISSISSIPPI . . . My first time in the Delta was with my friend Jane Robbins Kerr, who had offered to be my guide. Miss Jane, as some call her, is an artist, a writer, and a photographer, and grew up in Jackson, Mississippi. She was visiting her past, and I was looking for something new. We headed north, and took the less-traveled roads. We stopped at old churches and took pictures of the many faded signs and leaning gravestones.

In late July I returned alone to the Delta, where the landscape stretches as far as the eye can see. I went back for Character Project, to see my new friends in Greenwood and vicinity.

I started in Memphis, surrounded by a swirl of large black butterflies, which in late summer put their trust in the breeze and migrate. They flitted dreamily across the highways, and while most were lucky, fate wasn't always kind. Large orange eyes on their wings, beautiful like velvet paintings, were of little use in warding off the speeding cars crossing their paths.

Driving south along the Mississippi River, I passed small dusty towns and fields on fire. Bill and Edwina took me to a wedding, and I was entertained by Dianne and Thad and their dogs, goats, and peacocks in McCarley. I went to Spoony's, the Glamour Salon, and met Ricky Ferguson, the painter of many charming murals in the town of Greenwood. I even met Elizabeth Spencer at her book signing in Turnrow Books.

I discovered a little of the Northeastern Hills, saw Elvis's birthplace in Tupelo, tasted Beth's tomato sandwich in Columbus, and learned about bees from Birney.

On my way to the Neshuba County Fair I stopped off at Bea's Antiques & Vintage furniture store in Aberdeen to look around. Bea asked, "Where you from?" "New York City," I said, a little hesitant. Within minutes, she was on the phone, calling the *Aberdeen Gazette* to see if they could send a photographer around. "I'm not that interesting," I protested. "Honey," she said, "in this town—you are news!"

A stubborn past waits to be absorbed by the present. A stubborn past will not be forgotten. Spirits whisper in the bayous and there are ghosts in the attics. History will not be ignored. Strange how the dust and textured look and old ways of the South comfort me. I like that everyone takes pleasure in talking and enjoys laughter. "There is time here," said Ron Shapiro, who lives in Oxford but is not a native. The houses are crumbling, but the South still has much of its character. It hasn't succumbed to the neutralizing power of generic malls yet. Just as the trees continue in the clutches of the kudzu, life goes on at a human pace, and the music, the stories, and the paintings on the walls attest to the resilience of the people who live there.

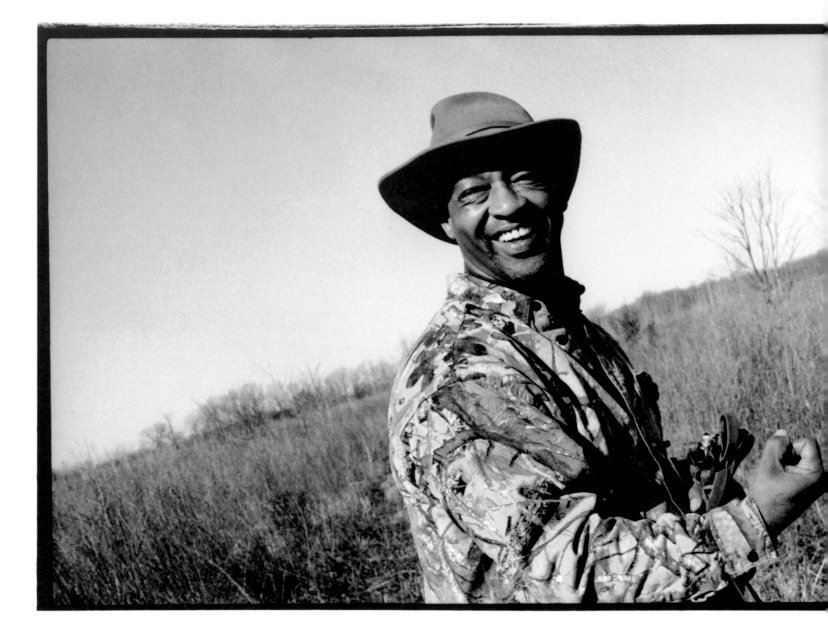

Terry Stancil at the end of rabbit
hunting season, Delzonia, Mississippi

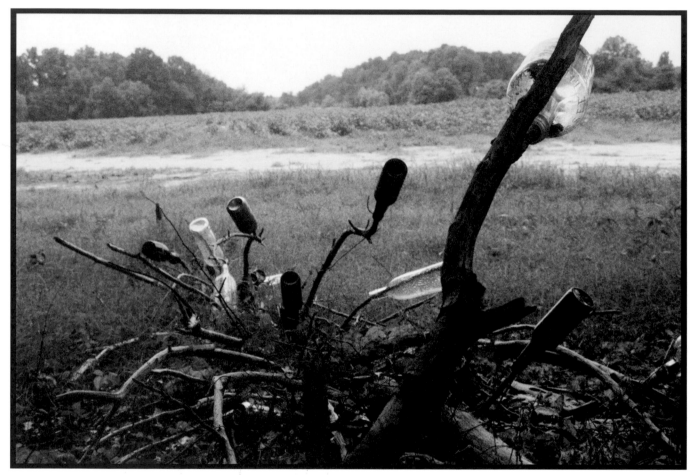

A bottle tree, intended to capture evil spirits
and to keep the house safe, Taylor, Mississippi

A memorial in **Friendship Cemetery** to the
Confederate soldiers killed in the Civil War,
Columbus, Mississippi

This statue stands, surrounded by tombstones
(many of them of unknown soldiers), with a
one-word inscription: REST.

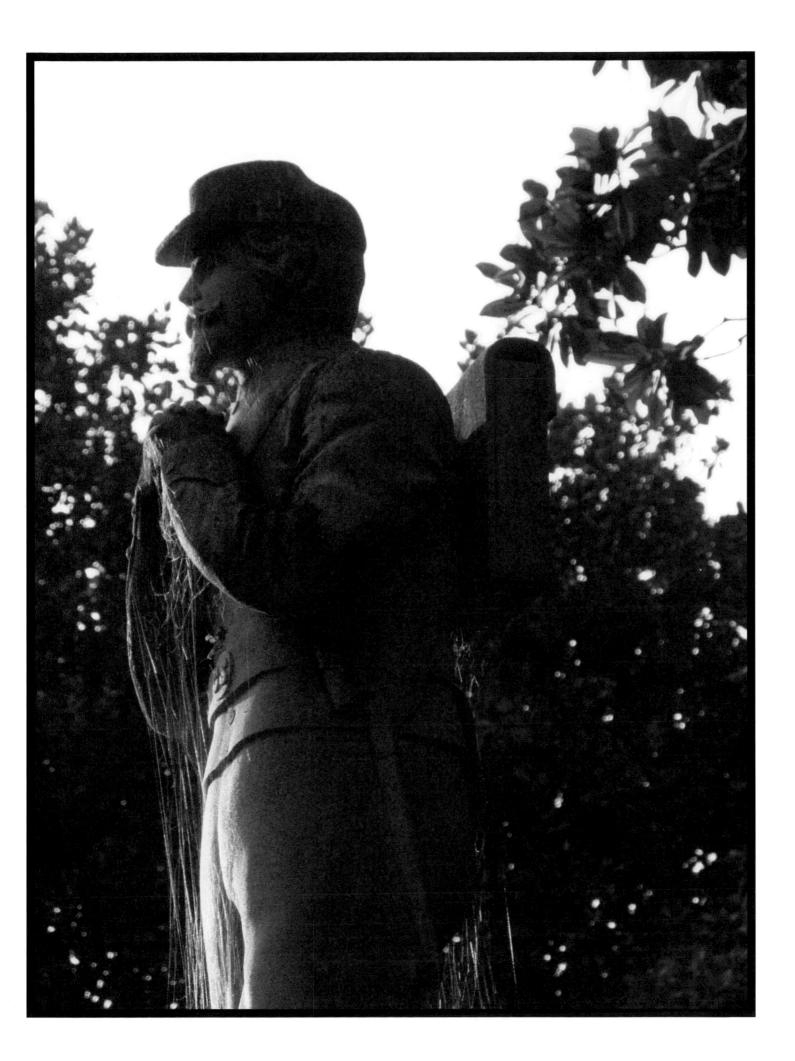

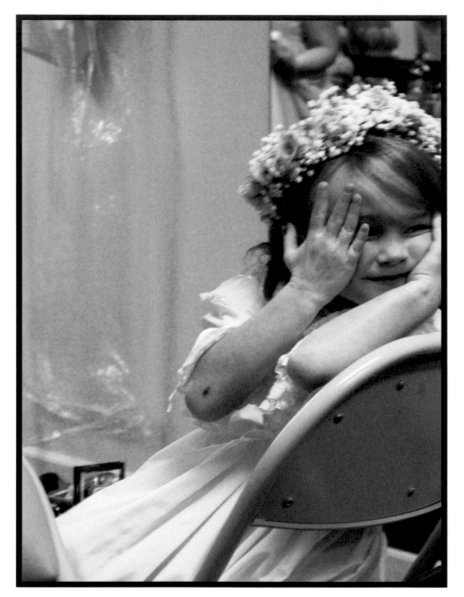

Lauryen Makayla Vest,
a flower girl, waiting for the
wedding ceremony to begin,
Greenwood, Mississippi

Dianne Wilkes telling stories
in her living room,
McCarley, Mississippi

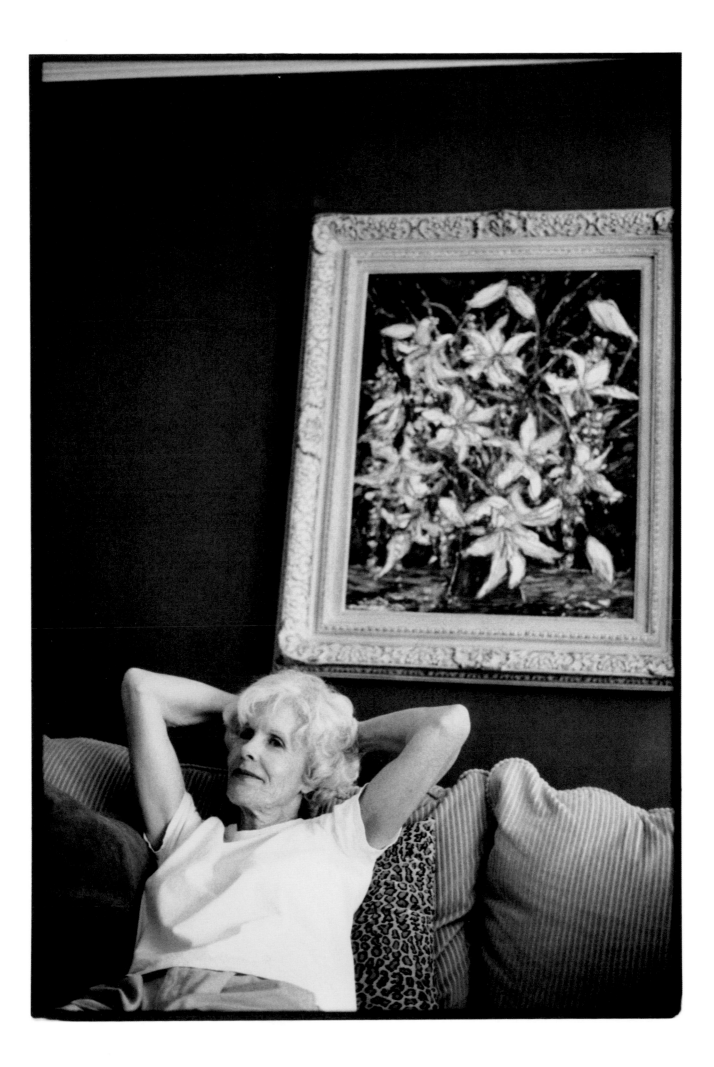

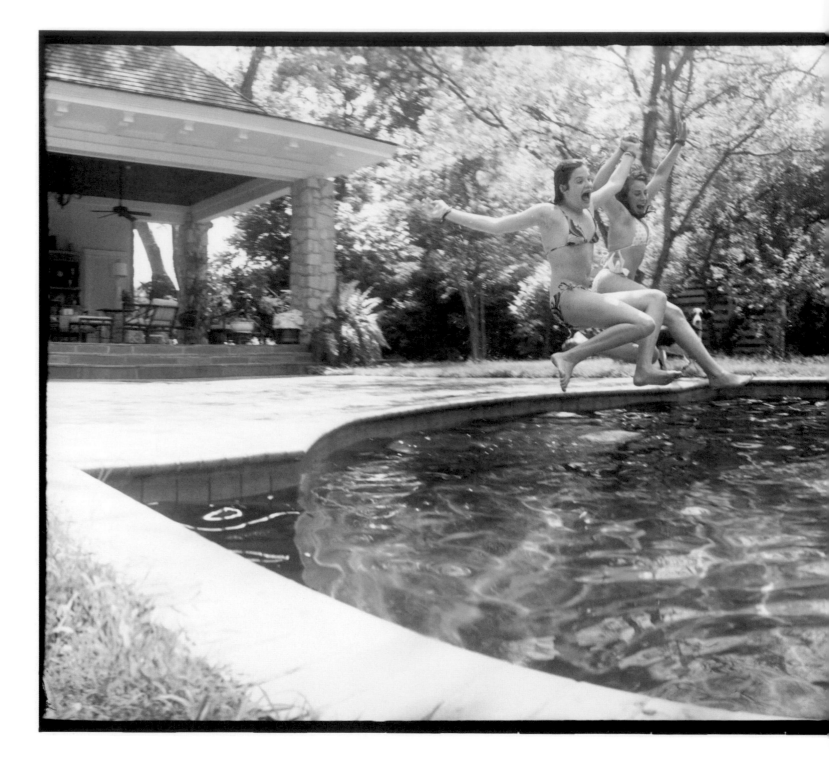

Sophie Clay and **Abigail Wagner** on a hot day,
Sumner, Mississippi

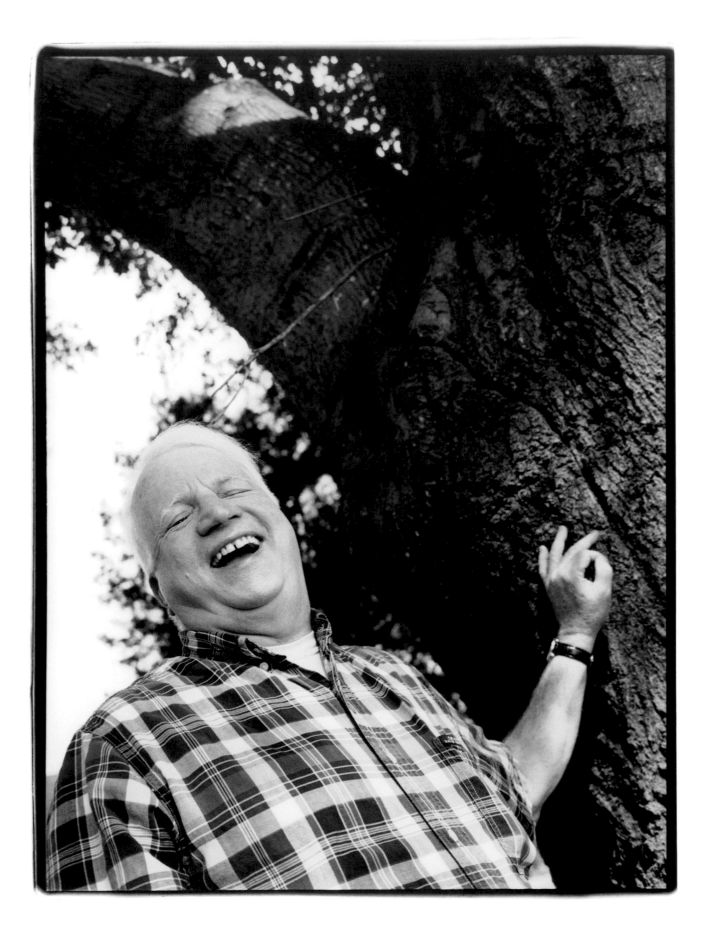

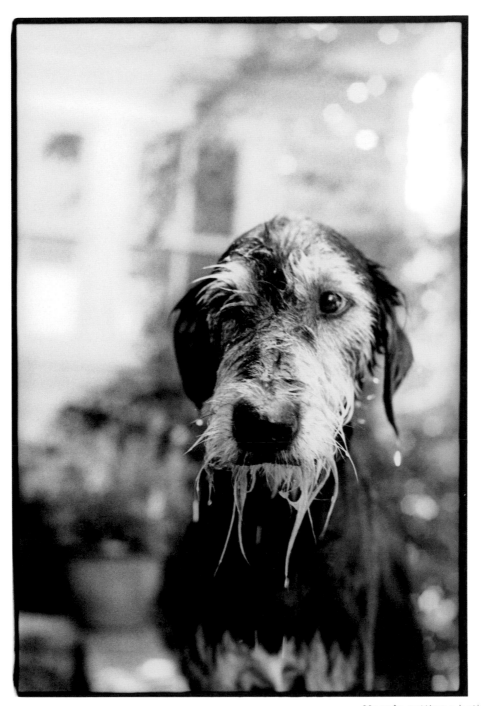

Maggie getting a bath,
Columbus, Mississippi

Joe McCain, brother of Senator
John McCain, on a visit to Teoc for a
family reunion, Greenwood, Mississippi

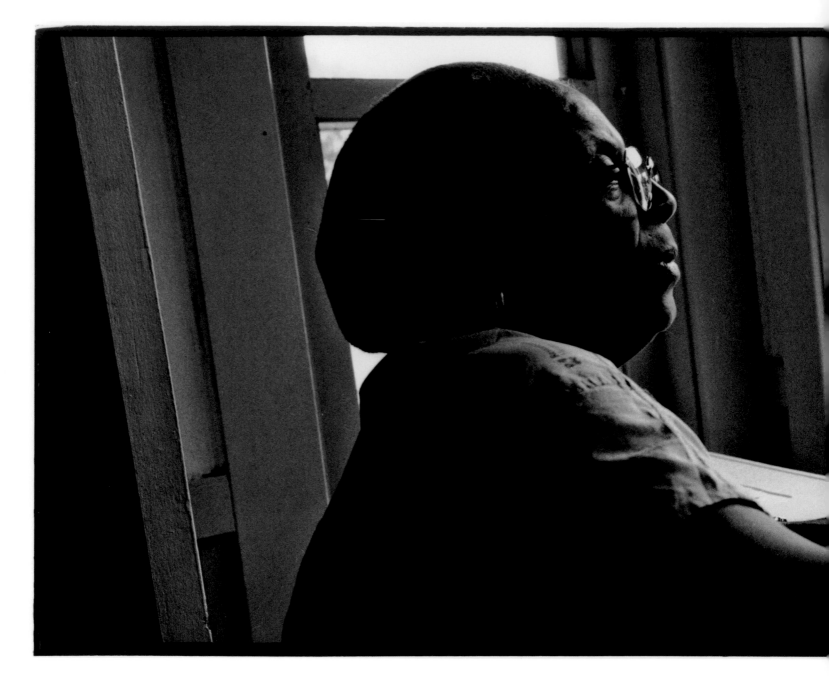

Sarah Henderson in a moment of introspection before serving lunch at the Greenwood Senior Center, Greenwood, Mississippi

RICHARD
RENALDI

UNTIL RECENTLY, few of us regularly contemplated Alaska, the largest and least-known member of the Union. But at the northernmost watery edge of the American nation, an altogether different understanding of character exists.

In 2009 the United States will celebrate the fiftieth anniversary of Alaskan statehood. In order to explore the nature of character in America, I chose to look to the edges. I wanted to explore how life is lived along the distant margins of the American continent—in Kodiak and Homer, Alaska.

Kodiak Island is one of the largest islands in the United States. It is home to a year-round population of fishers and cannery workers whose character is defined by hard and dangerous work in an extreme climate. They are a mix of races and nationalities: descendents of the native Koniaga tribe and the great-grandchildren of the eighteenth-century Russian settlers who were drawn to the fertile waters of North America.

In the village of Homer, I encountered members of indigenous tribes who suddenly became Americans only fifty years ago, as well as those Americans who have gravitated there from the mainland. There is an unmistakable dichotomy between these populations, but there are also signs of an increasingly shared experience.

Life is cold in Alaska and it is often hard, which makes the experience of living there uniquely intertwined with the land. This experience is enlarged by the spirit of the native populations and by those adventurers who have left the mainland to make a new life for themselves far away from the centers of American culture. This photographic essay is a tribute to their character.

Thor, Kachemak, Alaska

Oyster farming at Northern
Lights Oyster Company

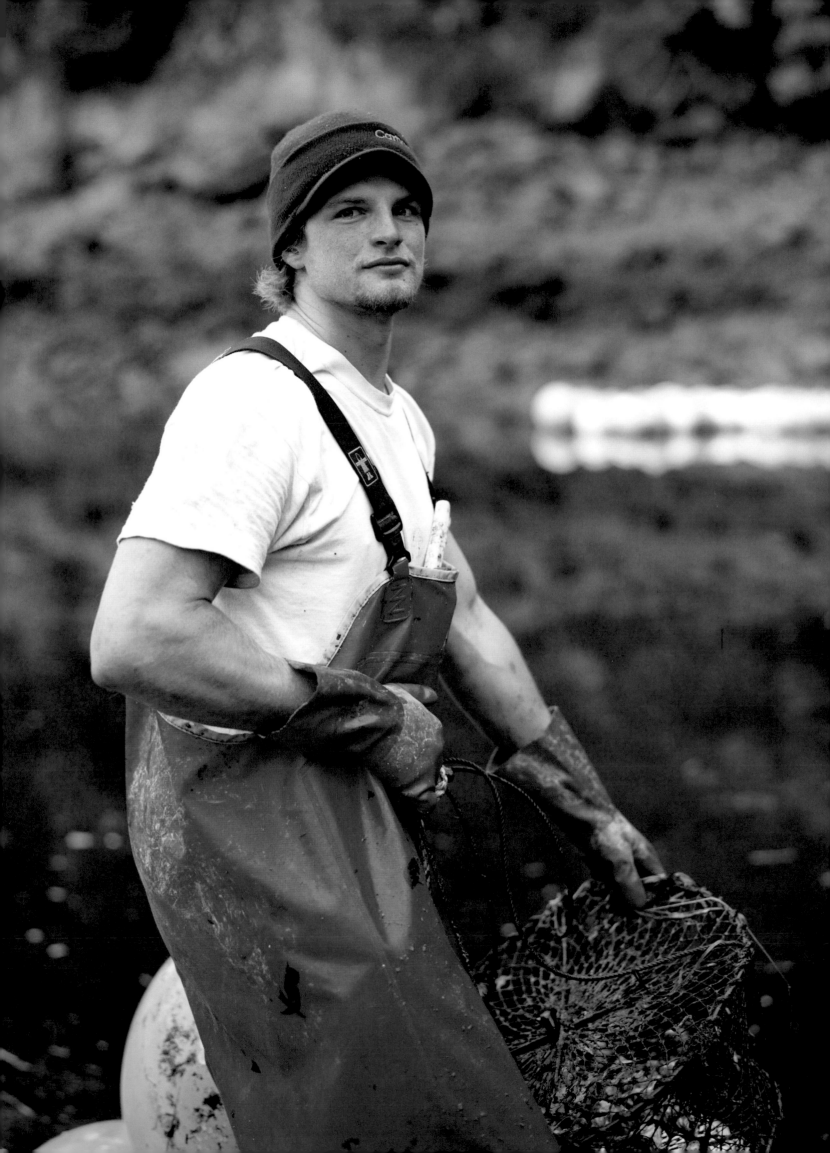

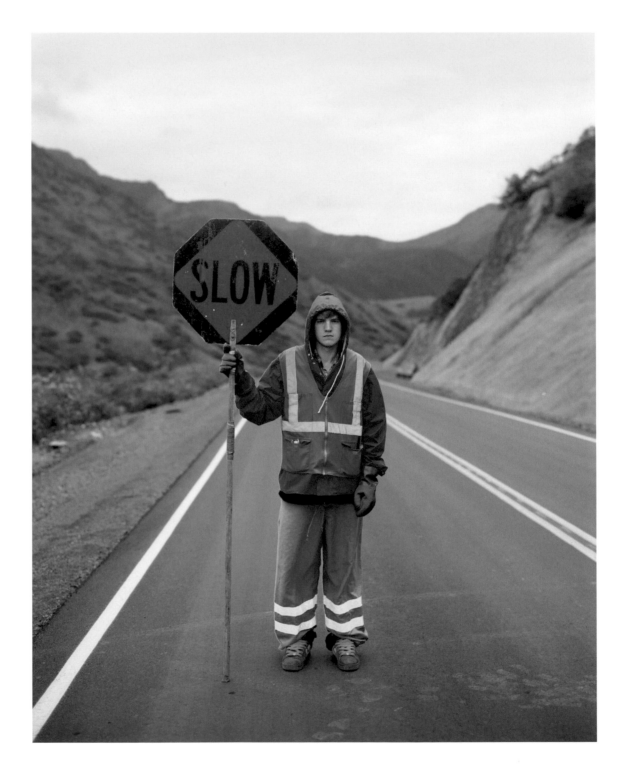

Ryan, Kodiak Island, Alaska

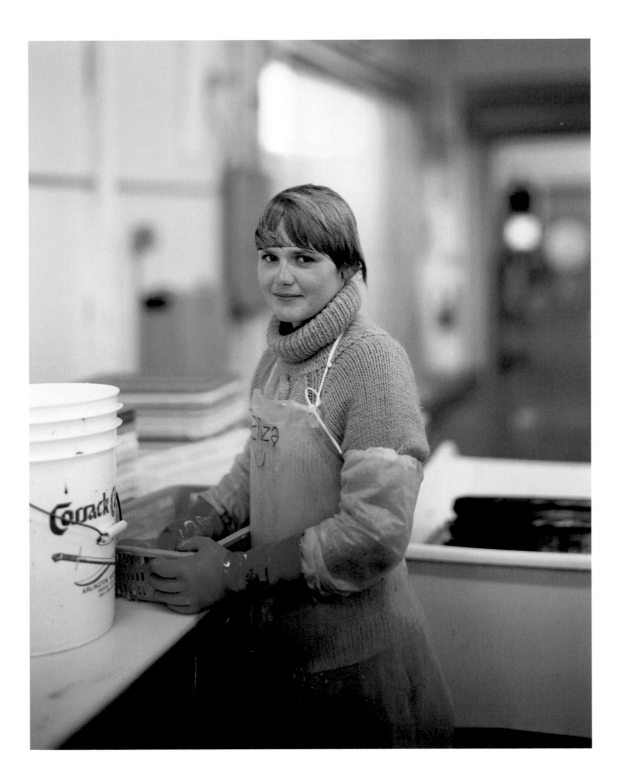

Eliza, Kodiak, Alaska

Working at Pacific Seafood,
a fish-processing plant

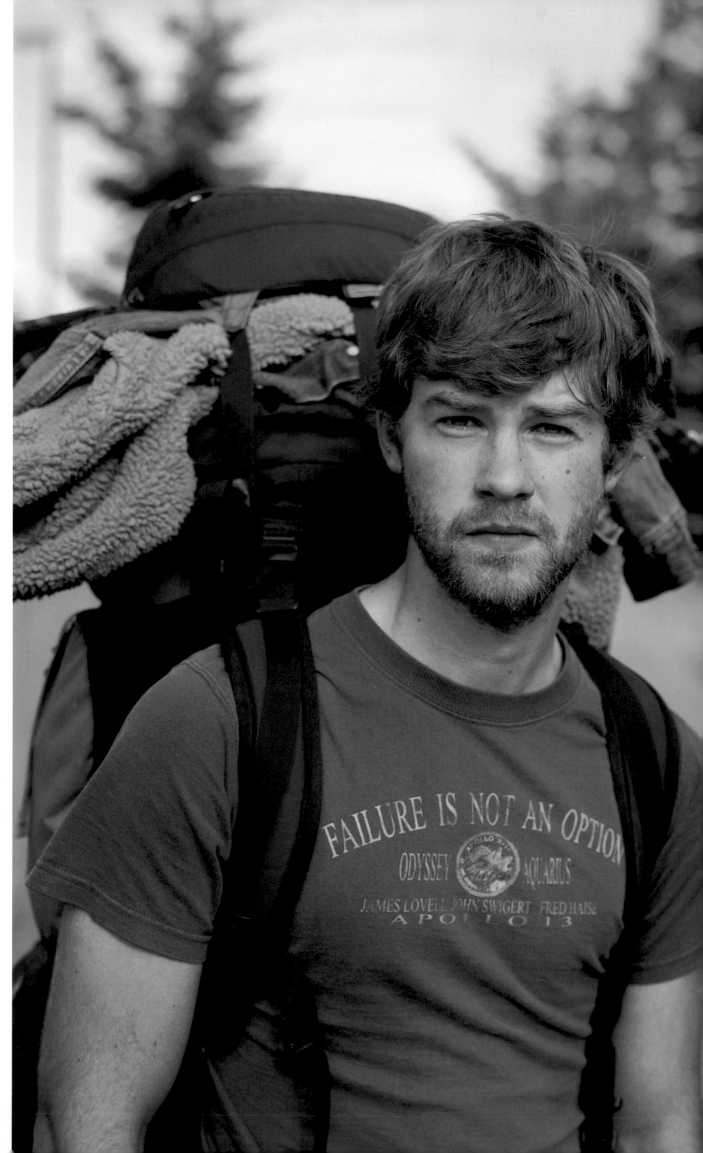

Michael and
Franklin, Homer,
Alaska

Summer workers
from Seattle

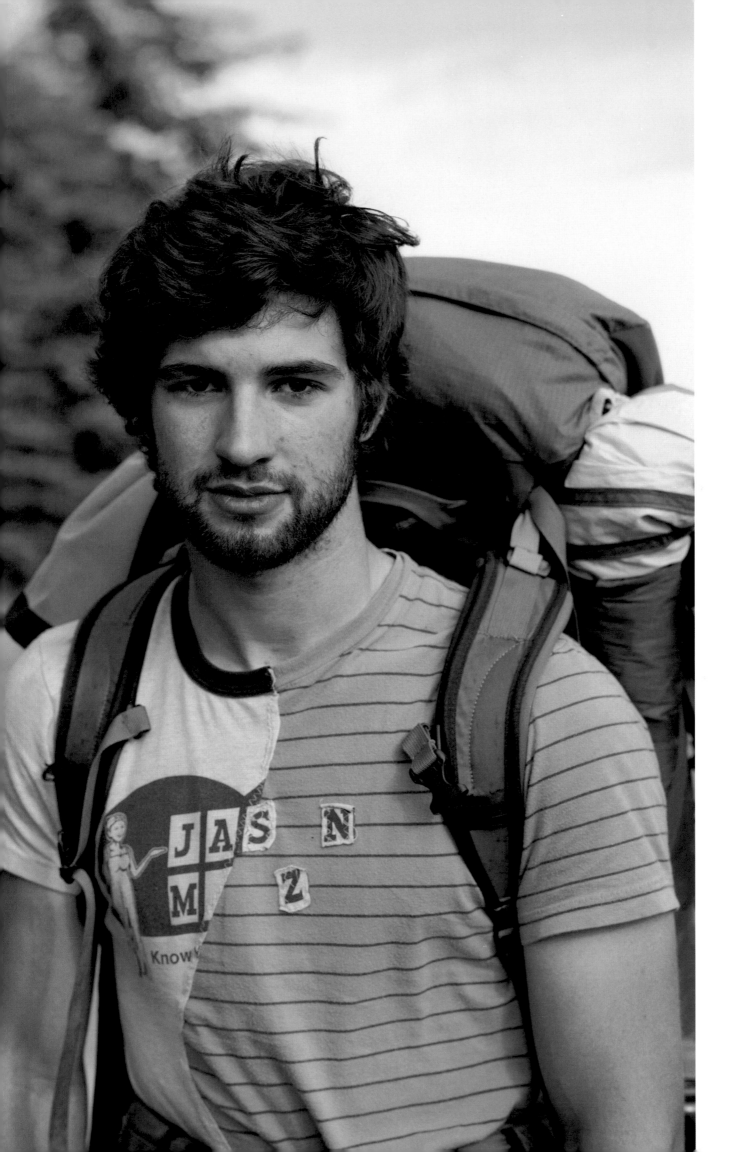

Mike, Kachemak, Alaska

Owner and founder of Northern
Lights Oyster Company

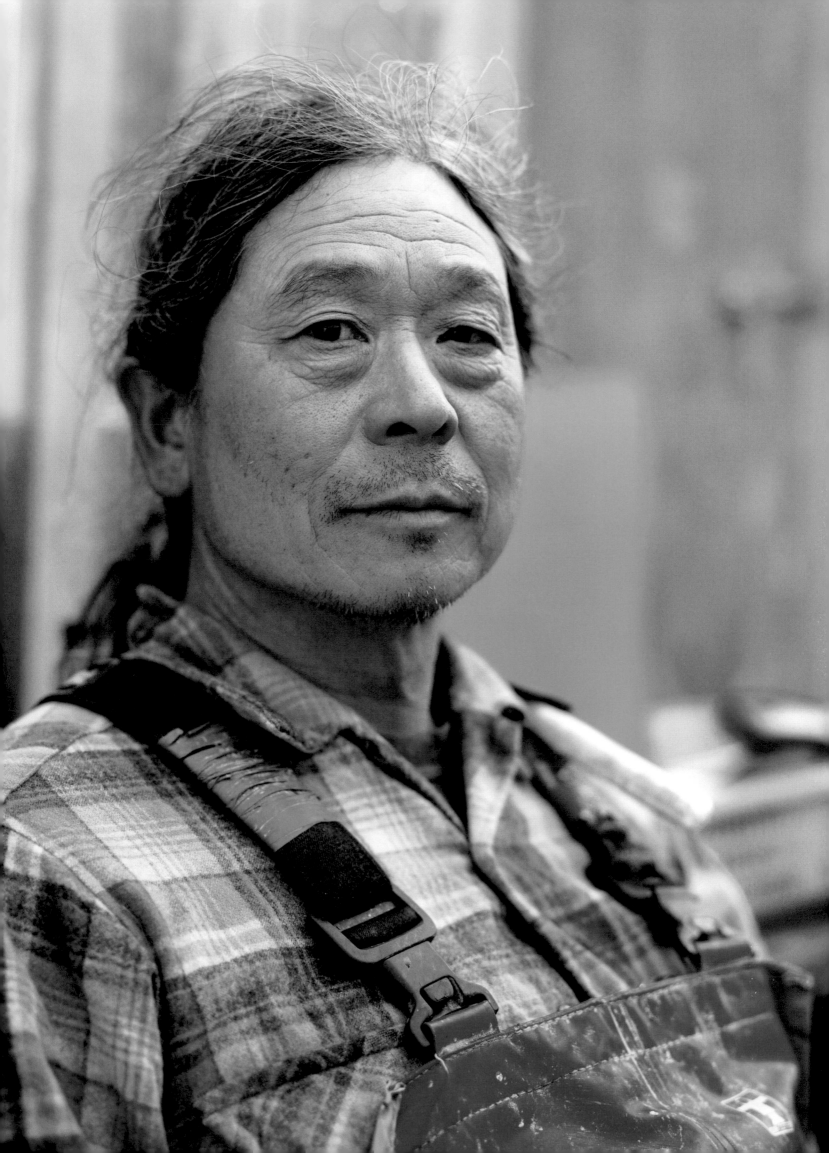

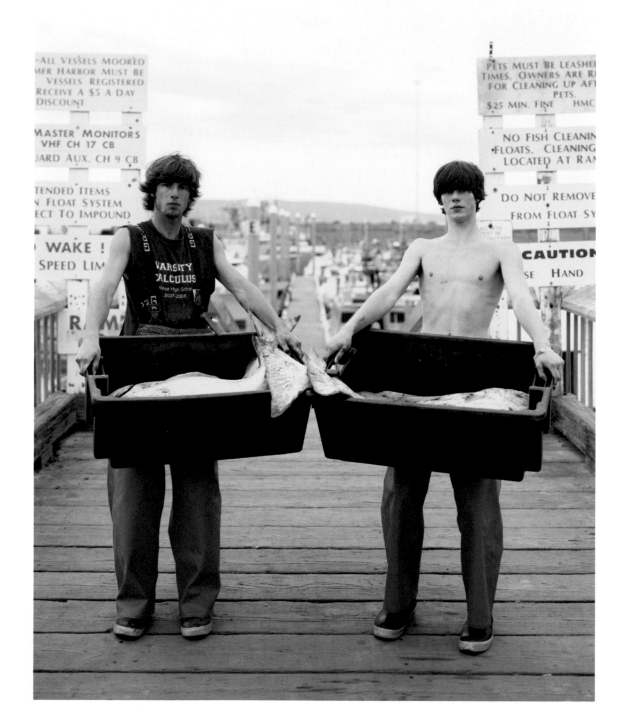

Ethan and **John,**
Homer, Alaska

Fishermen with halibut

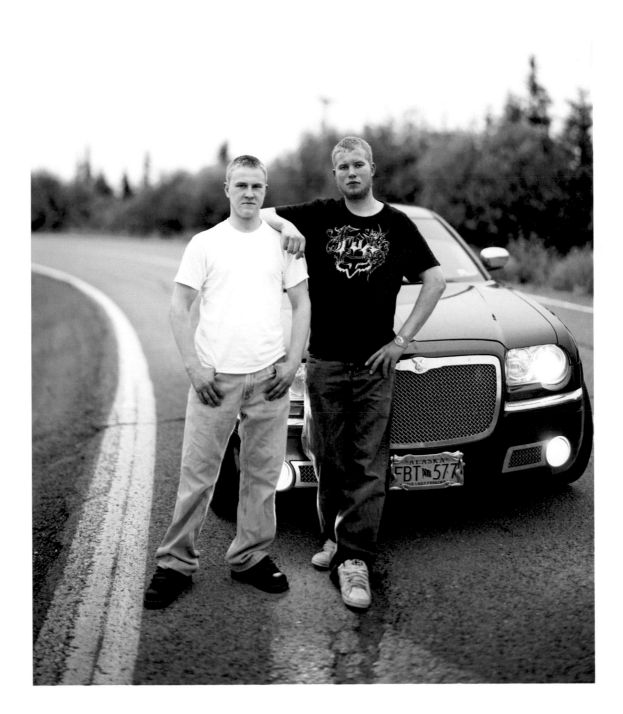

Kallistrat and **Joe,**
Kachemak, Alaska

Old Believer youth
with their wheels

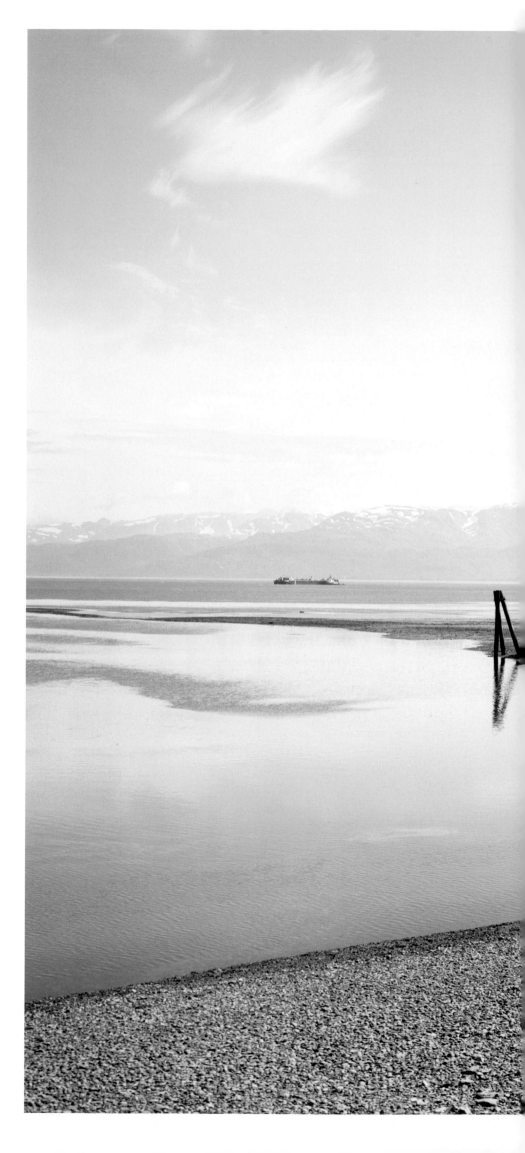

A crane on the **Homer Spit,**
Homer, Alaska

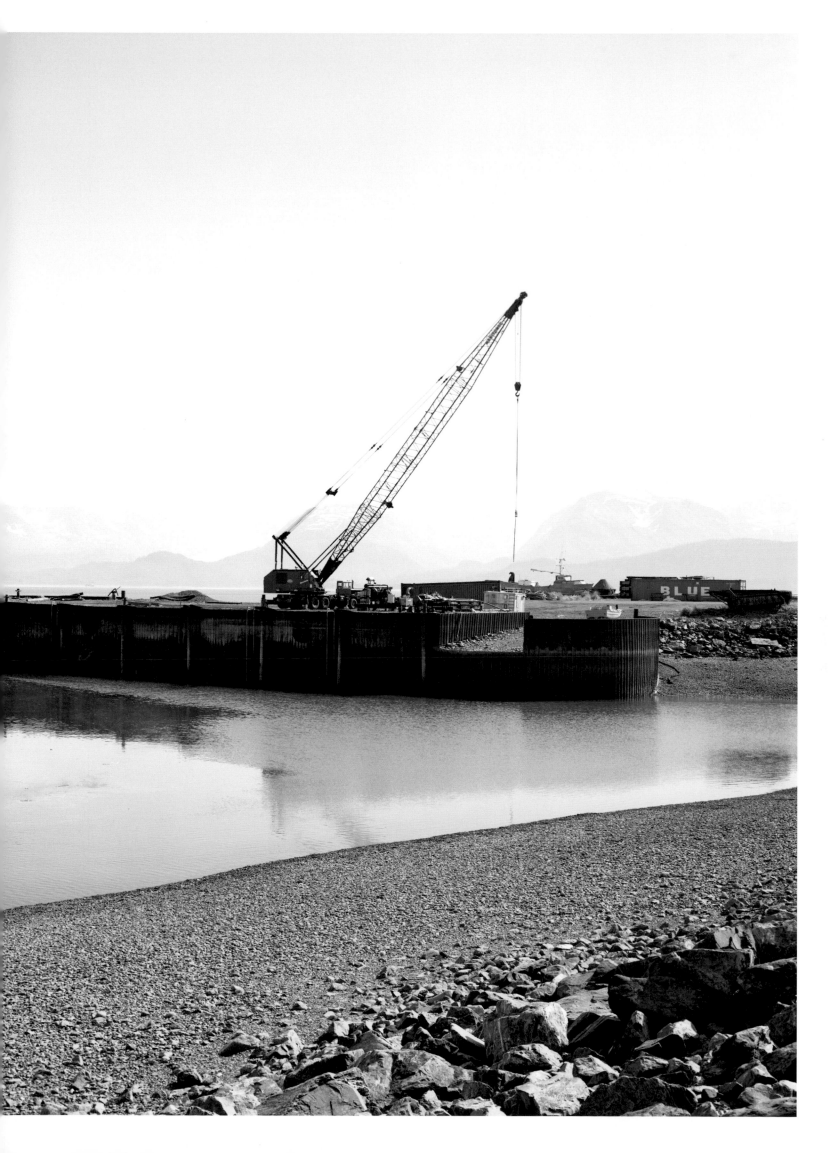

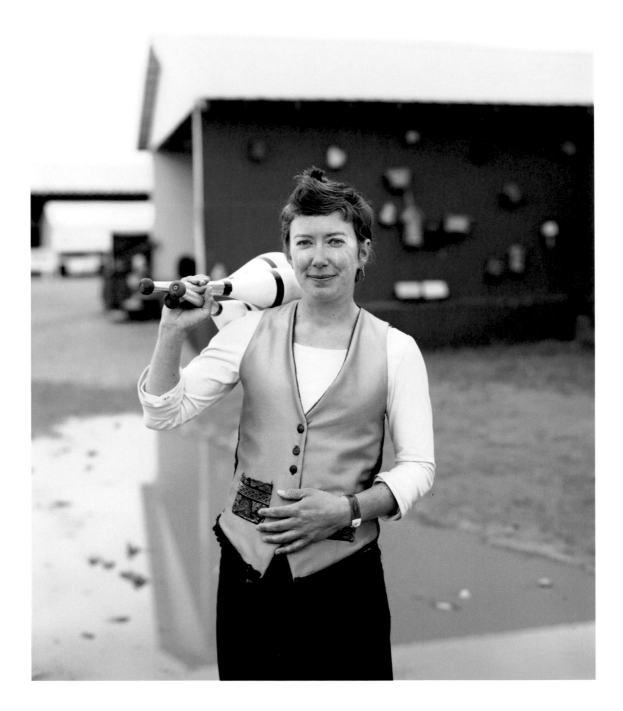

Meghan, Ninilchik, Alaska

Juggler from the Kenai
Peninsula State Fair

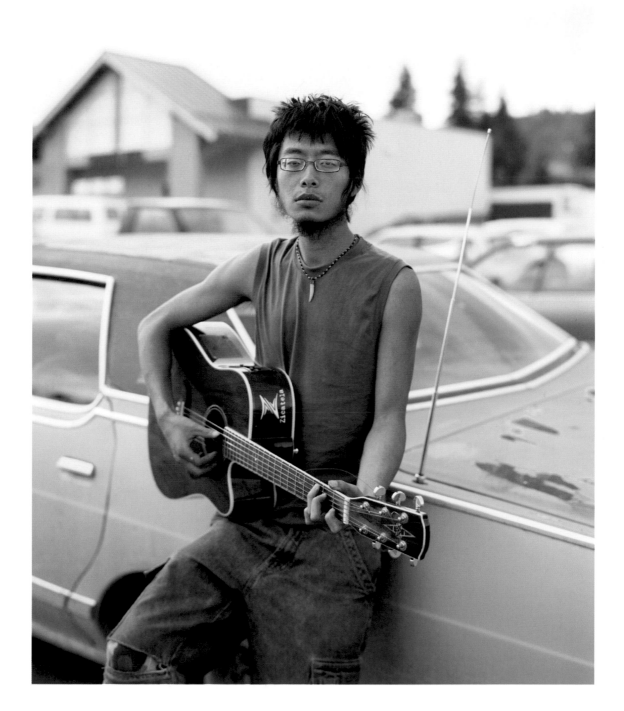

David, Homer, Alaska

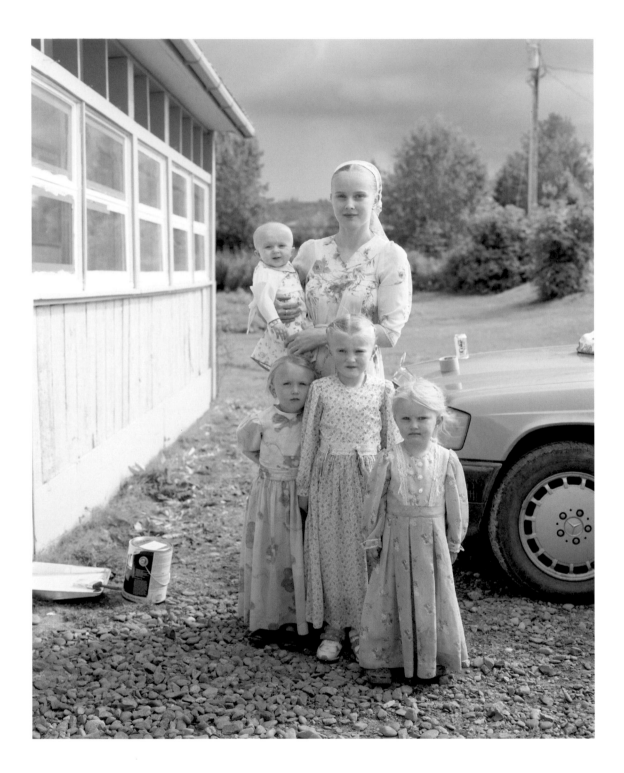

**Irina, Uliania, Lukia,
Feonilla,** and **Anastasia,**
Nikolaevsk, Alaska

Old Believer family

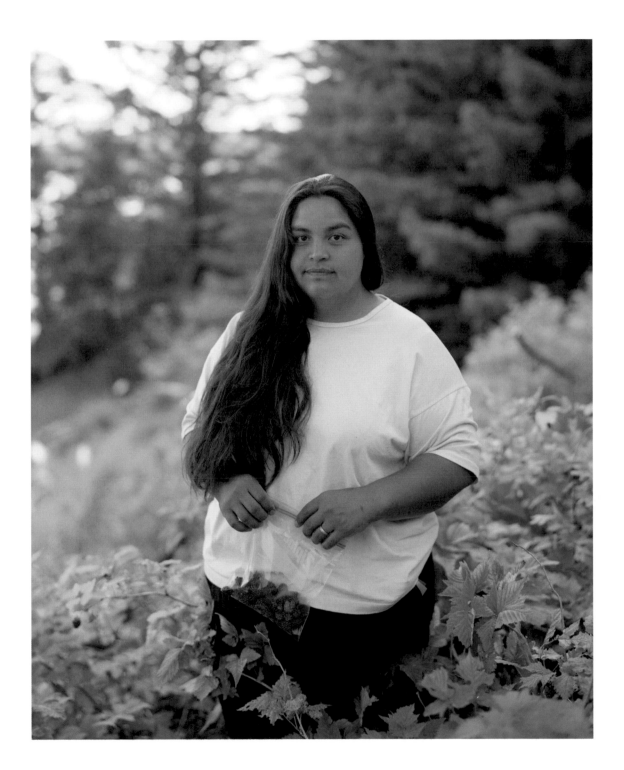

Tonya, Kodiak, Alaska

Collecting salmonberries at
the Sun'aq Tribal Picnic

MARY ELLEN
MARK

I LOVE NEW YORK. Since the late 1960s, I have photographed life on the streets here—often behind the scenes at parades and celebrations or in parks and at beaches, especially Coney Island. So when I was invited to be a part of Character Project, I immediately decided to photograph people in the city that I love.

I began at the Pride March, an event full of crazy characters. Two of my favorites were Chayanne Yate and Alex Londono, whose incredible makeup blended perfectly with the massive buildings in the city landscape. When I saw them, I knew they were just the characters I was looking for.

Next, I photographed the Giglio Feast in Williamsburg, Brooklyn. The day was unbelievably hot; my team and I would work and then immediately find relief somewhere in the shade and drink gallons of water. Luckily, there was another Giglio Feast in East Harlem (with less heat!) two weeks later, where I was able to get more photographs. At both events, the power and camaraderie of the Italian-American community was evident.

I made two trips to the South Bronx to photograph a wonderful dance group called Second Generation South Bronx Kids. I've known these dancers for years and have watched them grow. It was rewarding to capture their youthful beauty and magnificent energy.

I also shot two Dominican parades: one in Manhattan and one in Brooklyn. I've always been intrigued by princesses, and the Dominican and Puerto Rican community events are full of them.

At Coney Island, one of New York's unique landmarks, I've taken thousands of pictures. For years it didn't change much, but now it's slowly closing down to be developed into high-end hotels and attractions (Astroland just recently closed). The nostalgic, edgy quality that defines Coney Island will soon be gone forever. This was perhaps my last chance to experience a part of New York I've always loved and to photograph it as the funky, beautiful, and strange place that I have always known it to be.

Labor Day weekend was my final shoot for this project; I photographed the Junior Carnival and the West Indian-American Day Parade, both of which are visually incredible. I found many characters there, dressed in elaborate costumes, full of energy, and having a great time.

It can be difficult to photograph on the streets today; everyone is a photographer, and often when I started to frame a situation, people using their cell phone cameras would immediately surround me. Even so, it was really exciting to be commissioned to photograph subjects that are very much a part of my personal work. It was an excellent opportunity—photographing characters was an ideal assignment for me.

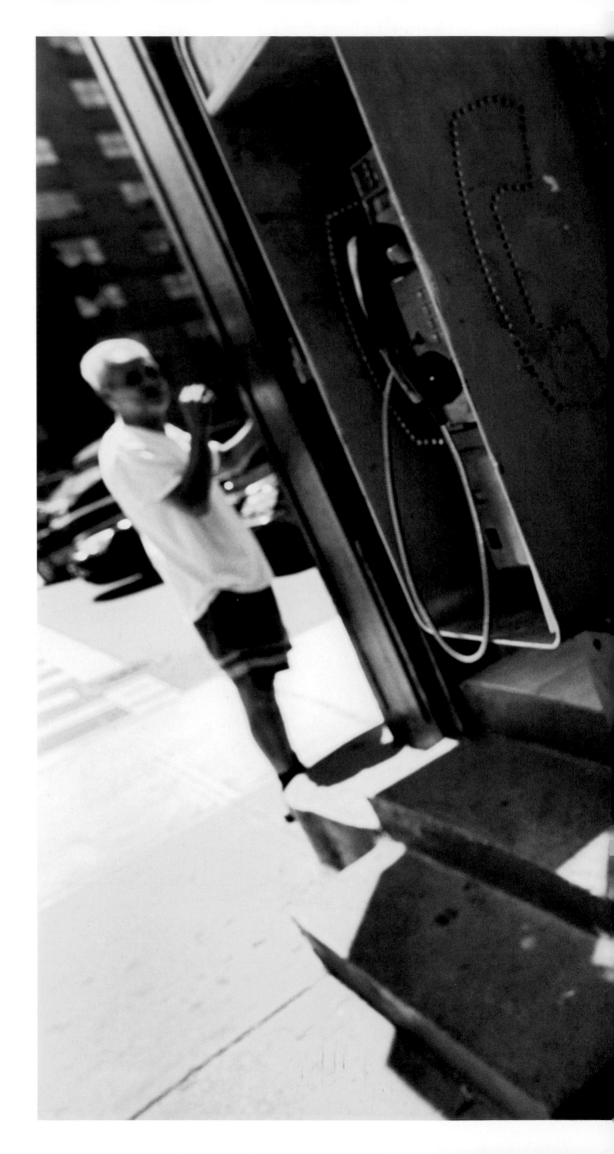

Louis Lilio, Giglio Feast,
Manhattan

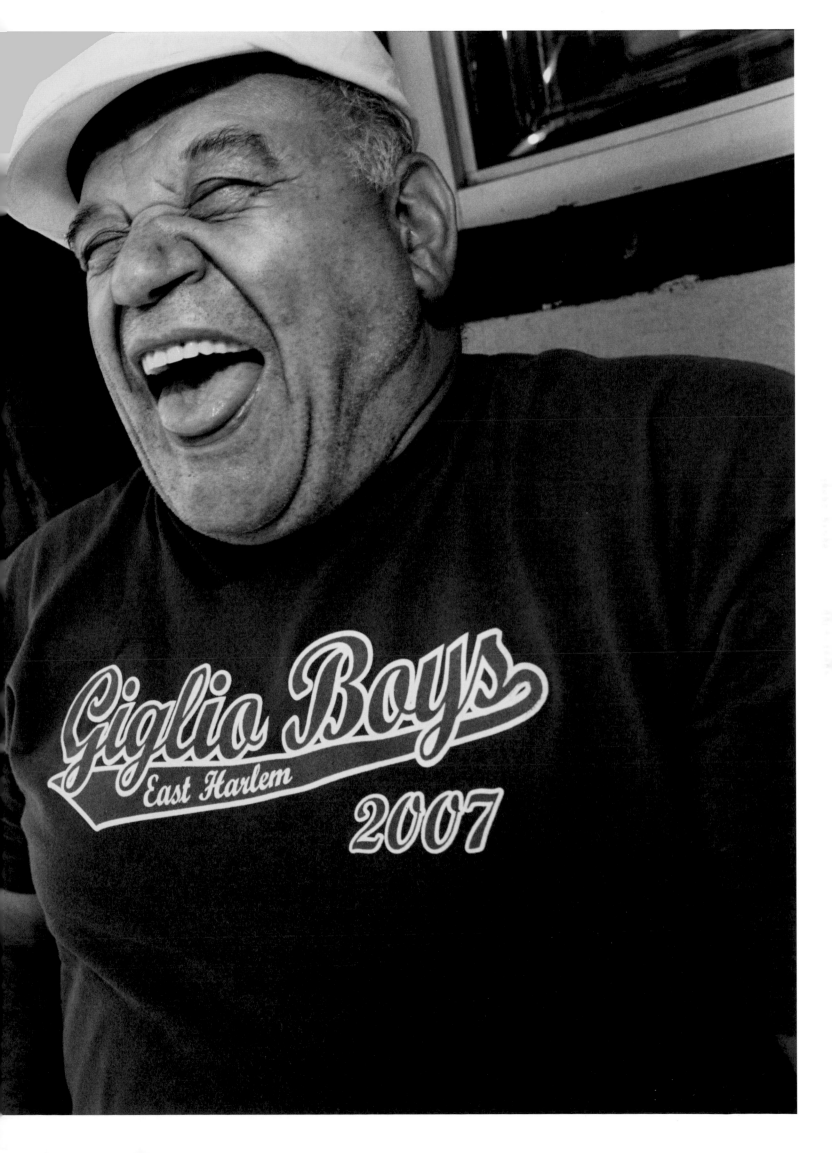

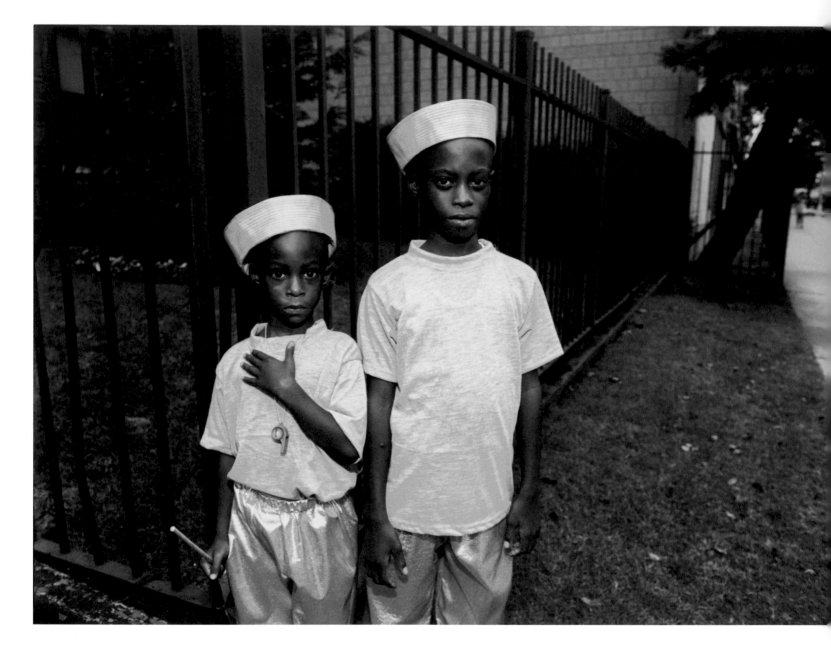

Spurdle Cupid and **Brian Providence,** Children's West Indian Parade, Brooklyn

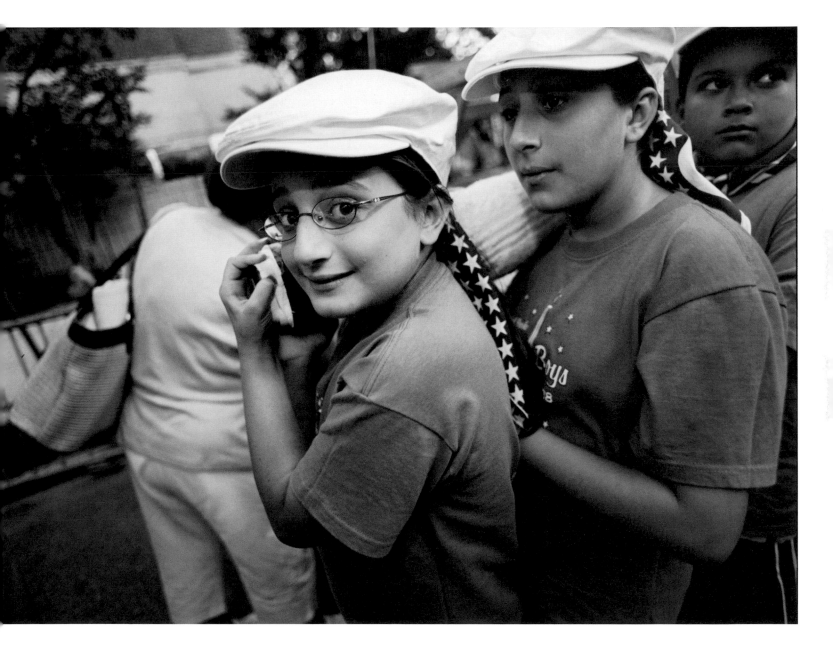

Anna Mancuso, Melissa Mancuso,
and **Stephen Javakian,** Giglio Feast,
Manhattan

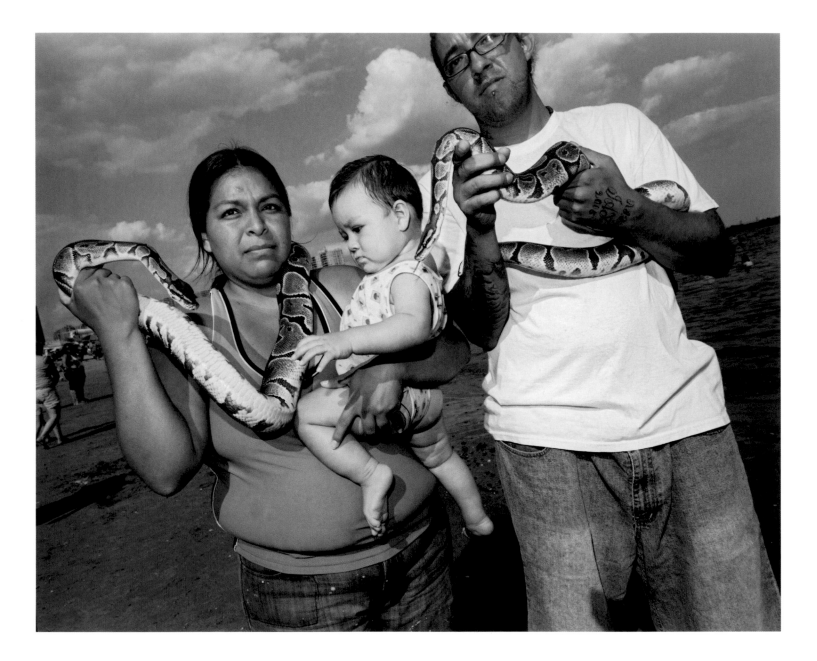

Ivette Cruz, Michael Cruz,
and **Carlos Maganai,**
Coney Island, Brooklyn

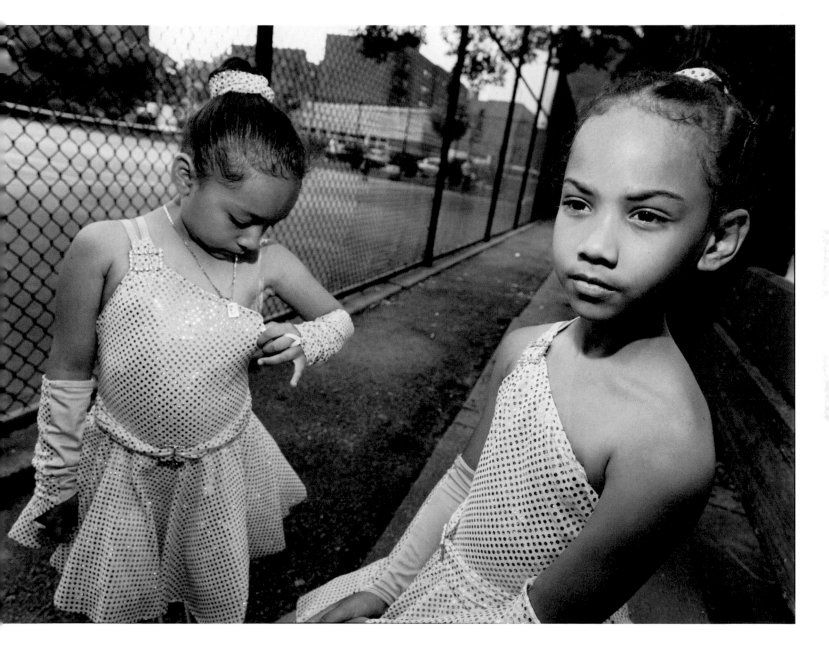

Jacqueline Sanchez Rojas and
Krystal Santiago, Second Generation
South Bronx Kids, the Bronx

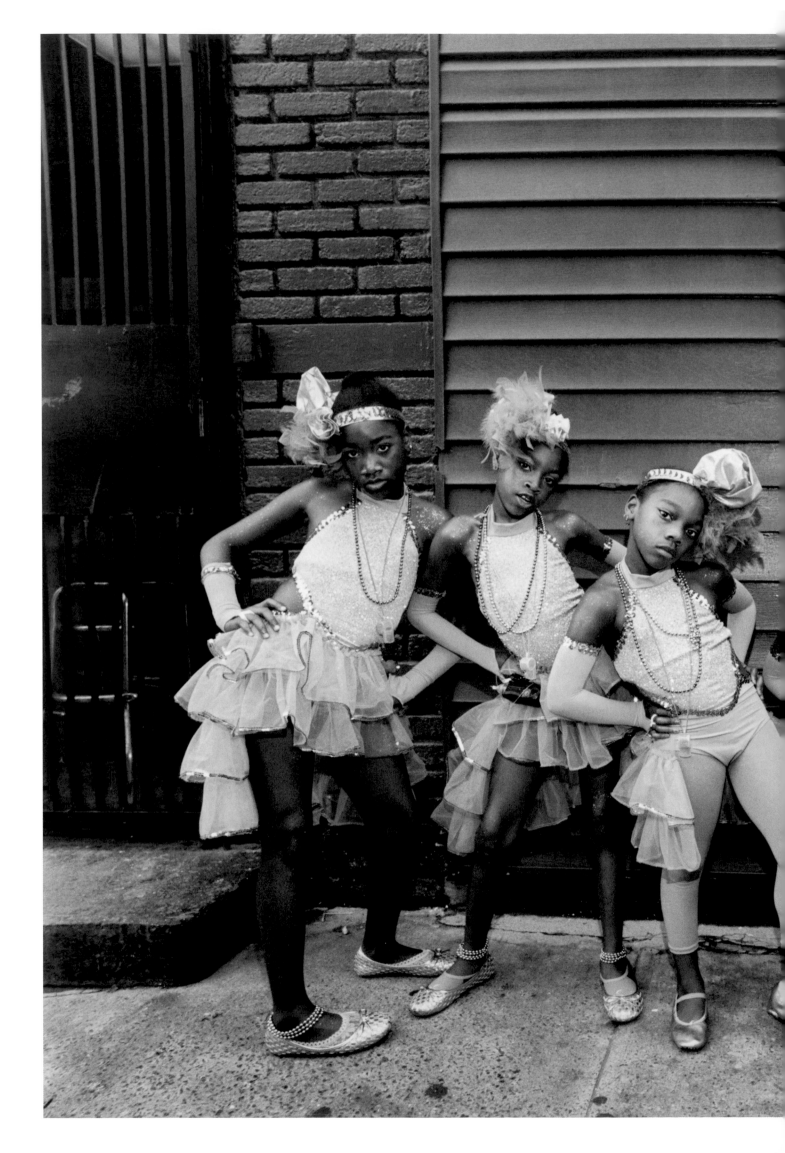

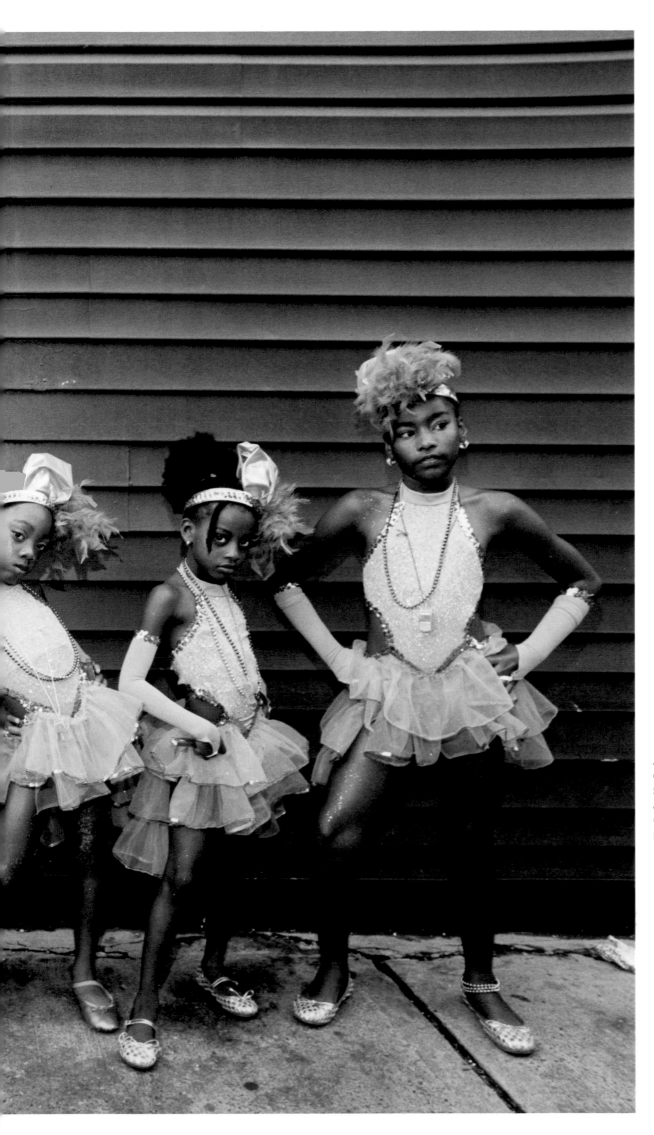

Jahliya Cliftone, Jahneisha
Cliftone, Lakai Arneaud,
Sydnie Cliflon, Imani Atwell,
and **Khadijah Atwell,**
Children's West Indian
Parade, Brooklyn

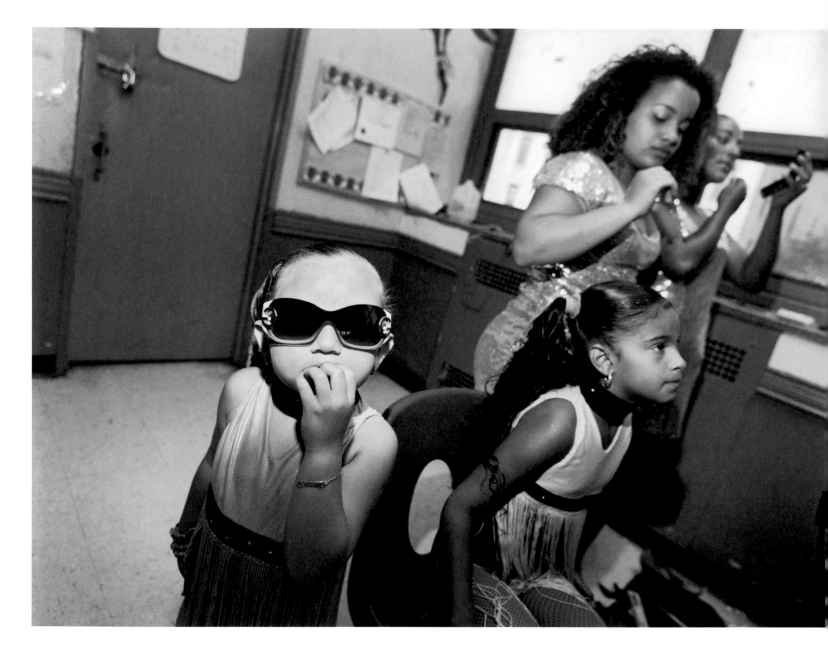

Destiny Rodriguez, Alexis Hernandez, Candice Lozada, and **Jalisa Waddler,** Second Generation South Bronx Kids, the Bronx

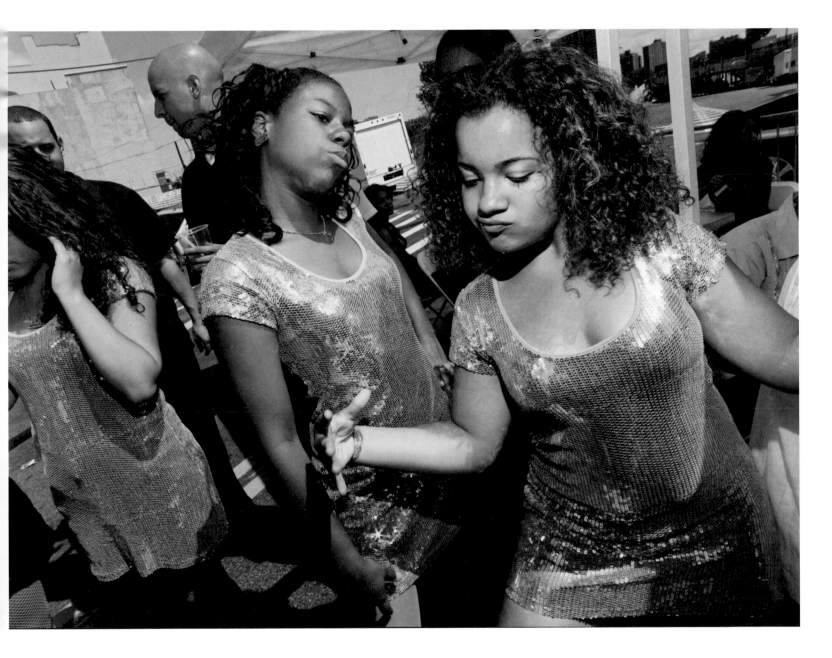

Jalisa Waddler and **Candice Lozada,** Second Generation South Bronx Kids, the Bronx

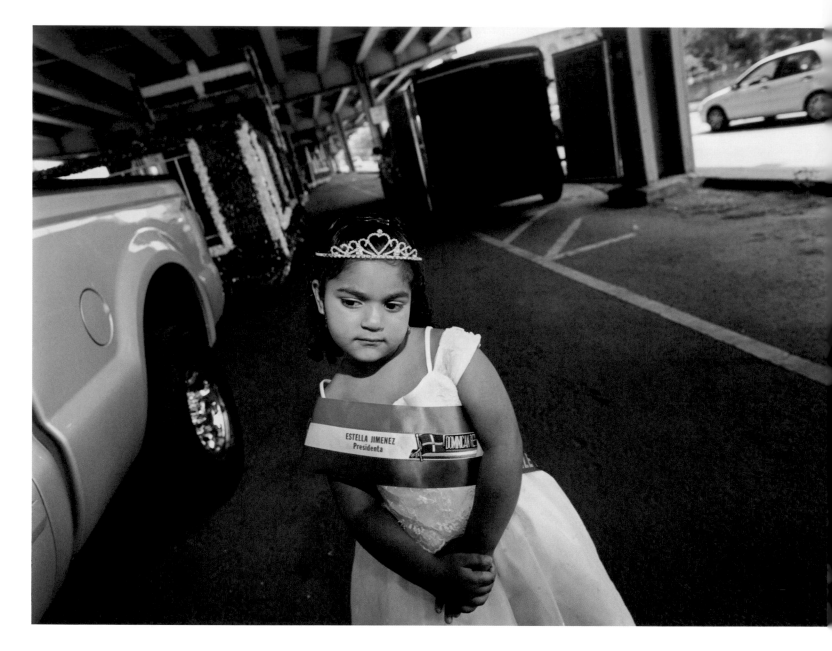

Kiarra Reyes, Dominican Parade, Brooklyn

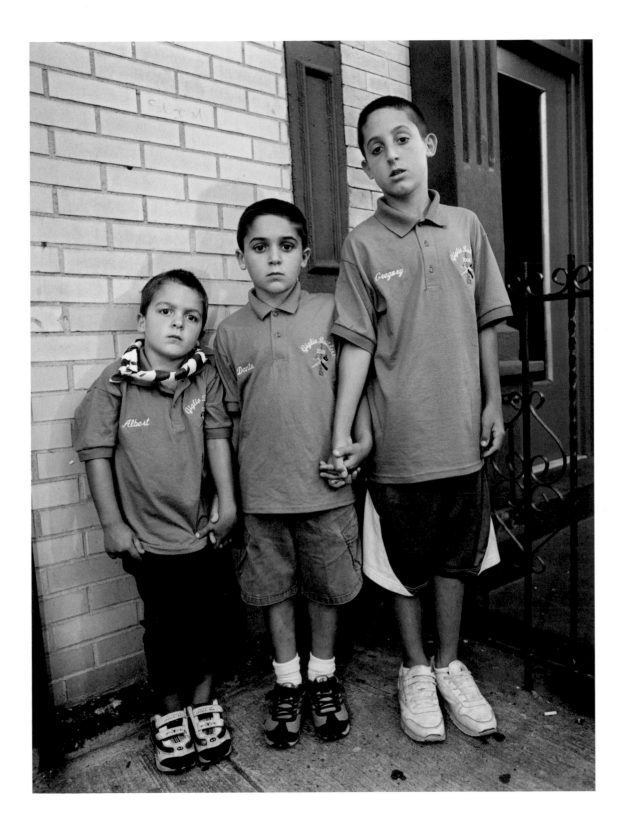

Albert, Dante, and **Gregory Esposito,** Giglio Feast, Manhattan

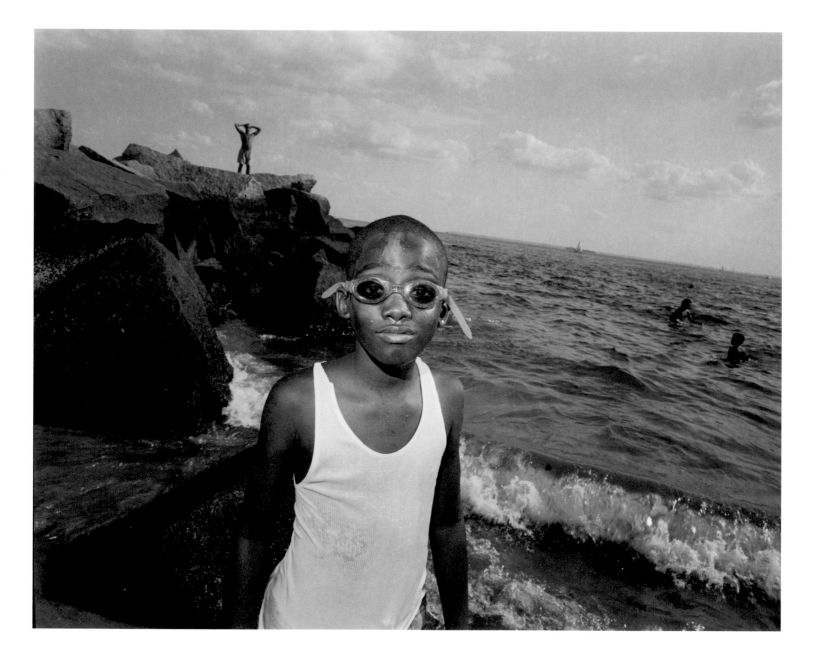

Jamani Robinson,
Coney Island, Brooklyn

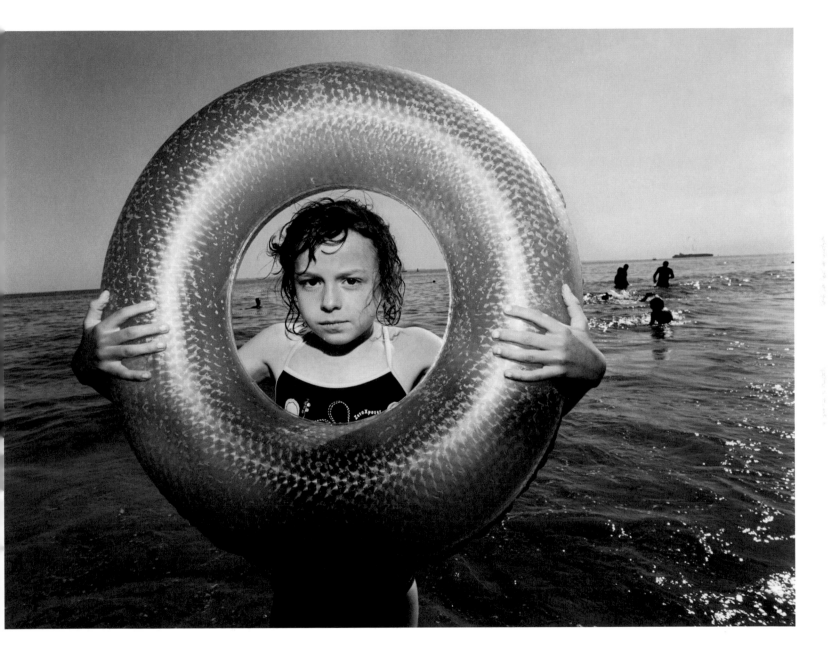

Julia Bialobrzewski,
Coney Island, Brooklyn

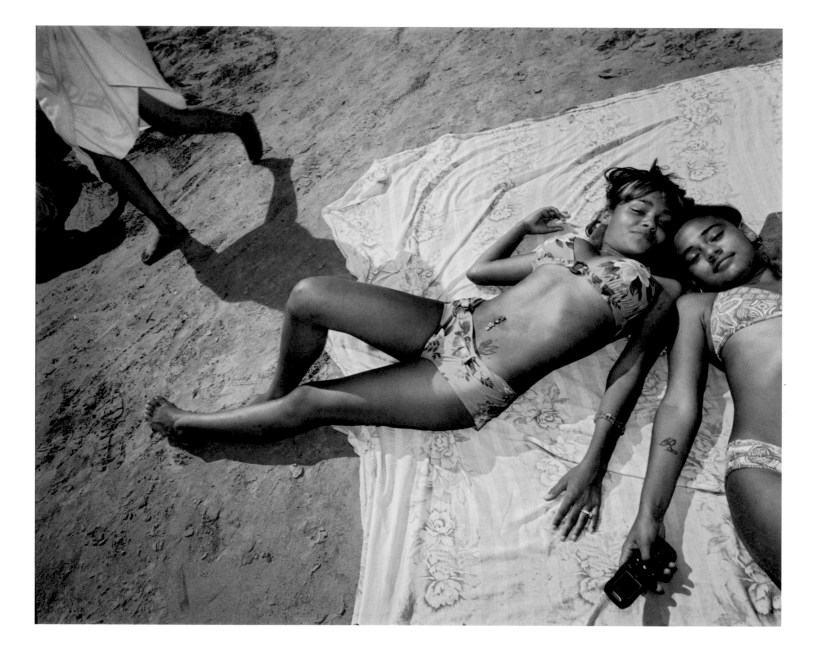

Kimberly Torres and **Elizabeth Collazo,** Coney Island, Brooklyn

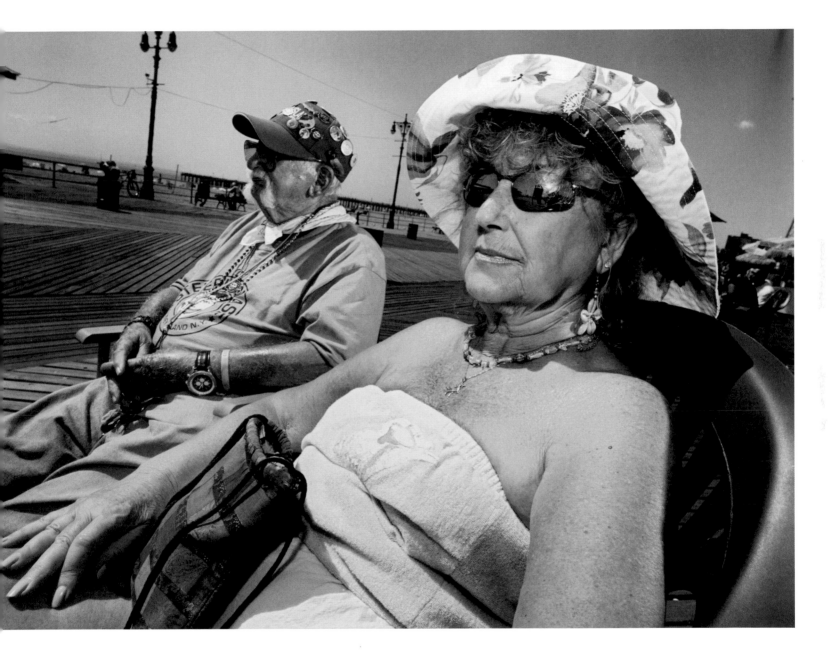

Philip Sanalitro and **Stella Jouvanis,** Coney Island, Brooklyn

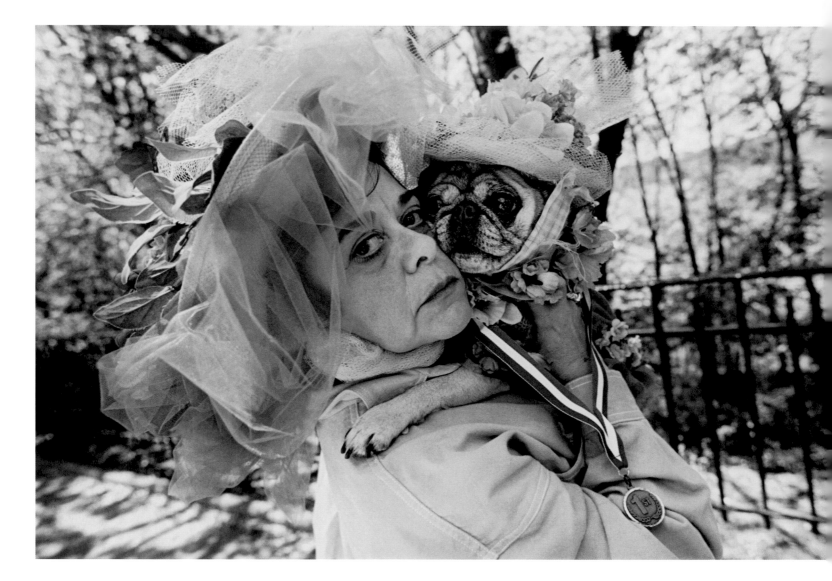

Margot Dossantos and
Miloluche, Riverside Park
dog walk, Manhattan

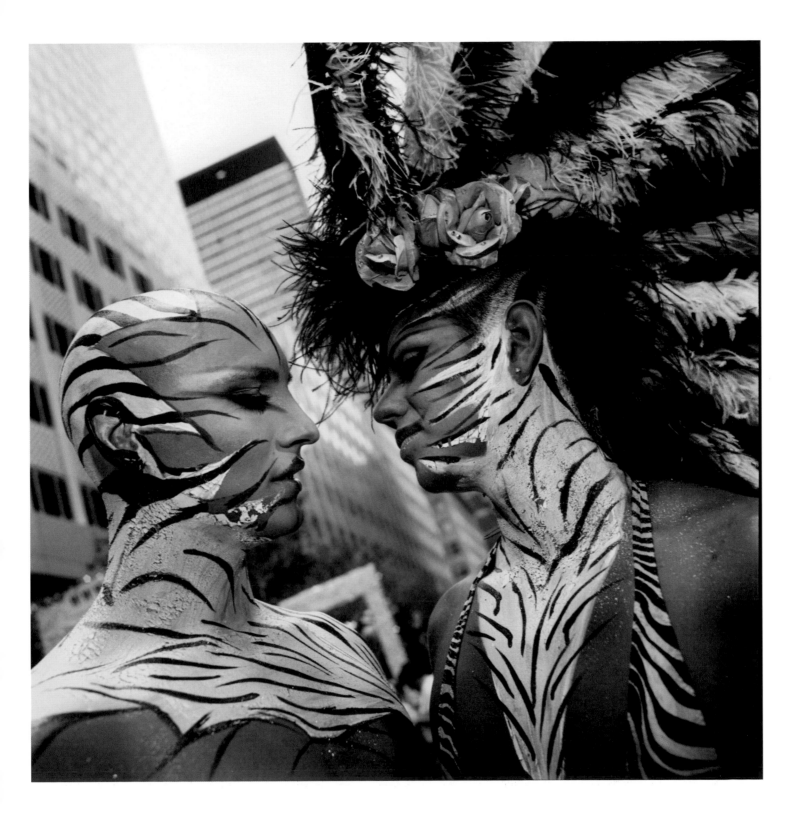

Alex Londono and **Chayanne Yate,**
Pride March, Manhattan

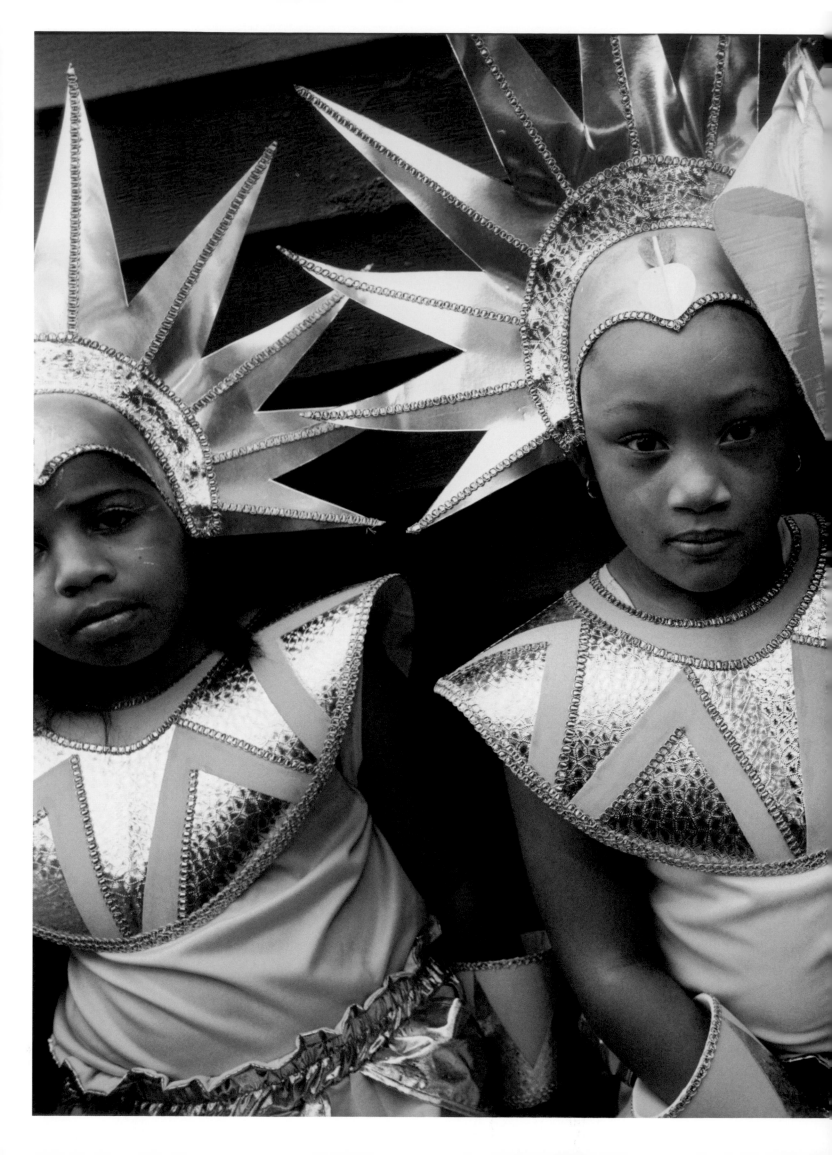

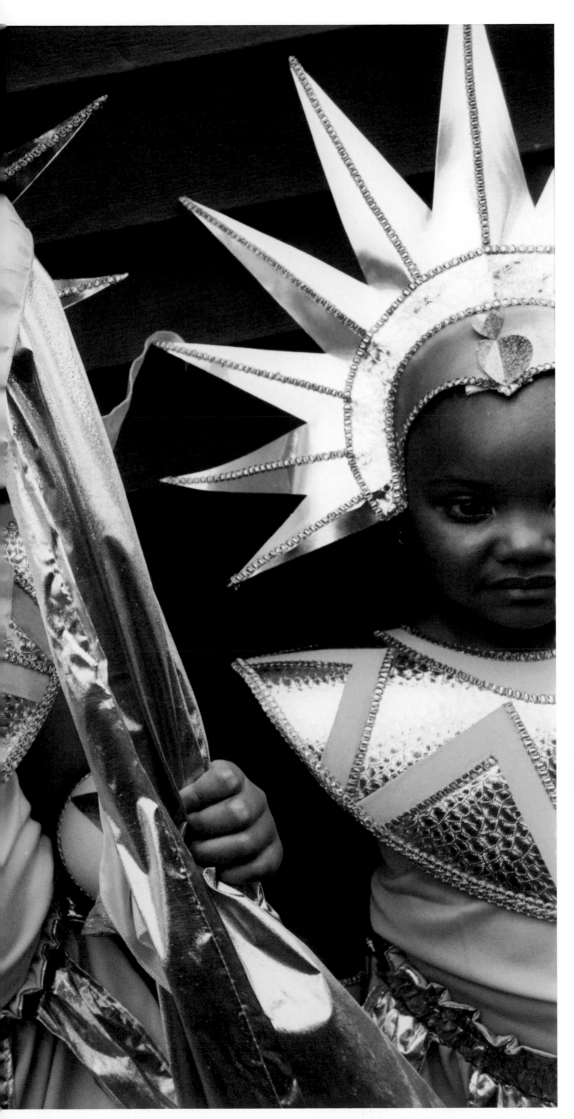

Sierra Ash, Nyla Wongwon,
and **Kaila Joyner,** Children's
West Indian Parade, Brooklyn

115

Moment of Fame

MARLA
RUTHERFORD

YOU CAN'T walk up to strangers on the street, ask them to lunch, and expect them to tell you their life story in detail. But you can ask people to model for you and then, during the photo session, get them to reveal their history. Photography gives you a golden ticket into other people's lives, a chance to venture beneath a stranger's facade. That's what I love about it.

It's that passion for getting to know people, the anonymous people we pass on the street every day, that inspired my concept for Character Project. My goal was to find individuals who had never before been photographed in a professional setting and give them a unique opportunity to express themselves in front of my lens.

I asked anyone and everyone to participate—from my cleaning lady and my makeup artist, to people I'd encountered on MySpace or through L.A. casting agencies, to random people I met at bars, dance clubs, and parties. To my surprise, of the fifty-four people I approached, forty-six showed up at my studio.

Though excited to be included, most of the subjects felt quite uncomfortable at first, so I tried to create a relaxed atmosphere with music, conversation, food, and drink. This helped me to capture genuine smiles and candid moments between more "posed" takes. By shooting in a studio with uniform lighting, I was able to take them out of their usual environment and put them in a setting that gave them the utmost freedom to expose themselves. What I caught on film was true to the essence of each subject's character.

Though I generally based my casting choices on a range of appearance-based characteristics—from looks and style to general pantomime—I was most captivated by the unique personality and fascinating story of each subject. And I would never have known anything about them had I not approached them to model for me.

The truth is, people are open to expressing themselves through photography because, regardless of ethnicity, age, or economic background, we all want to be part of something creative. The character of America is trusting and adventurous. That forty-six people, most of whom didn't know me and had never before been professionally photographed, drove across the city to come to my studio was an incredible surprise. But as it turned out, just the simple act of asking them to participate made them feel special, singular, and unique. To me, that was one of the greatest rewards of all.

Jerry, Los Angeles

"I've been in four motorcycle accidents. In one I suffered from
two broken vertebrae, three broken ribs, four facial fractures,
eight torn ligaments, and six fractures on both my arm and hands.
Was conscious the whole time."

Clockwise from top left: **Jen** and **Laura, Dee, Elva** and **Moruato,** and **Danna,** Los Angeles

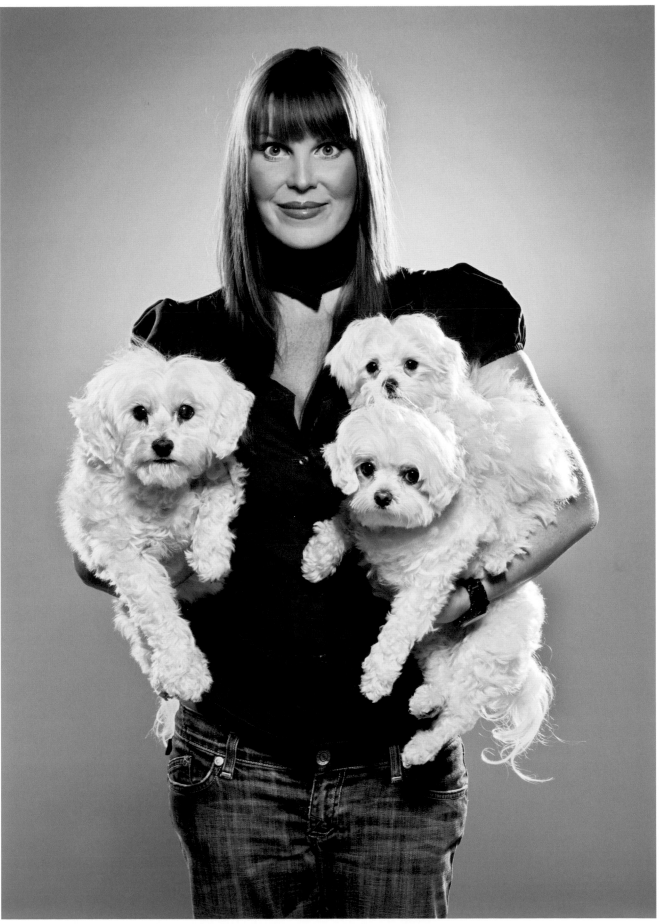

Kimberlee, Los Angeles

"I love these three madly, despite their repeated efforts to probe my ears and eyes with the same tongues they use for other atrocities."

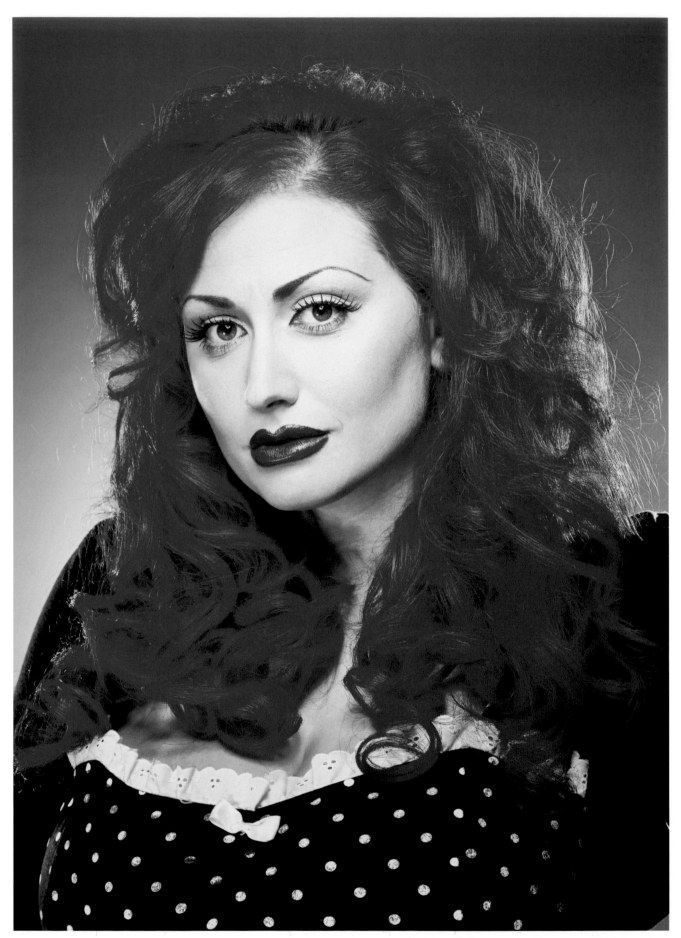

Lenora Claire, Los Angeles

"When I was young, I ran away with the circus and learned how to eat lightbulbs for both fun and profit. I even had my own sideshow night called Apocalipstick."

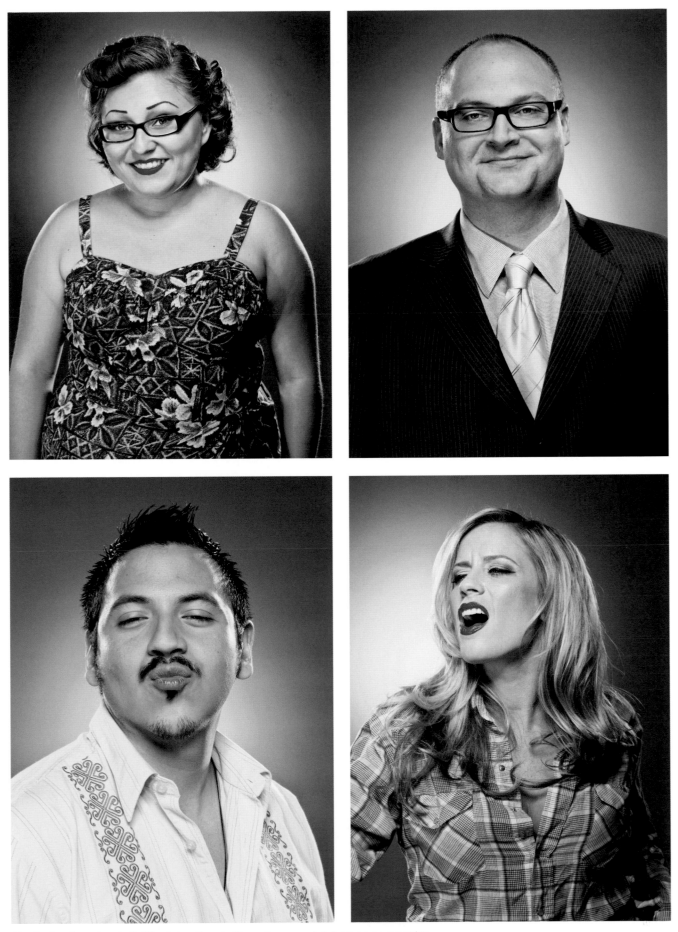

Clockwise from top left: **Virginia, Grant, Mary Jane,** and **Johnny,** Los Angeles

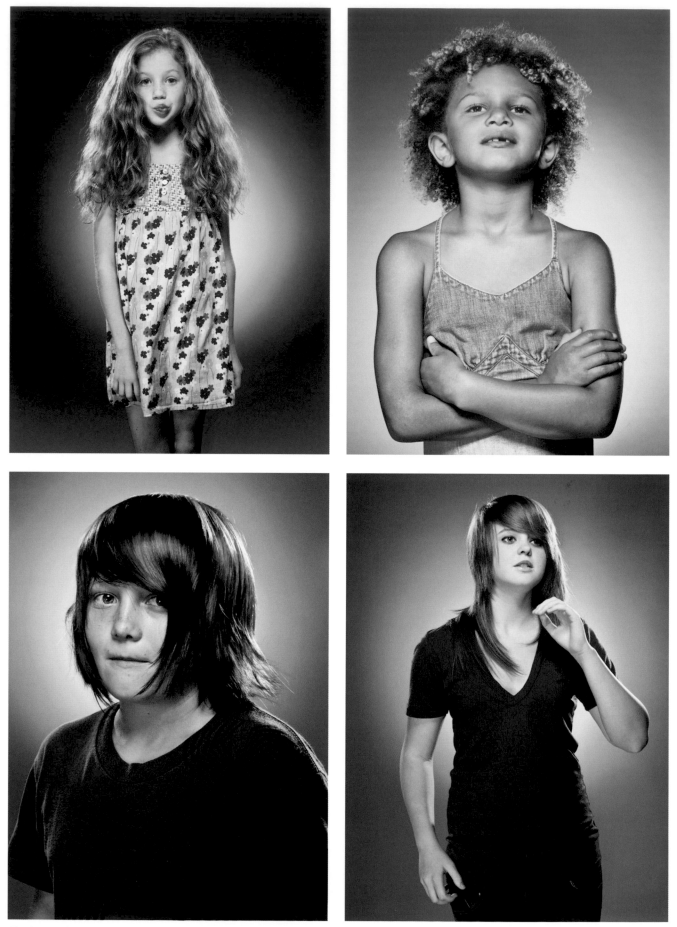

Clockwise from top left: **Greta, Lela, Brynn,** and **Shea,** Los Angeles

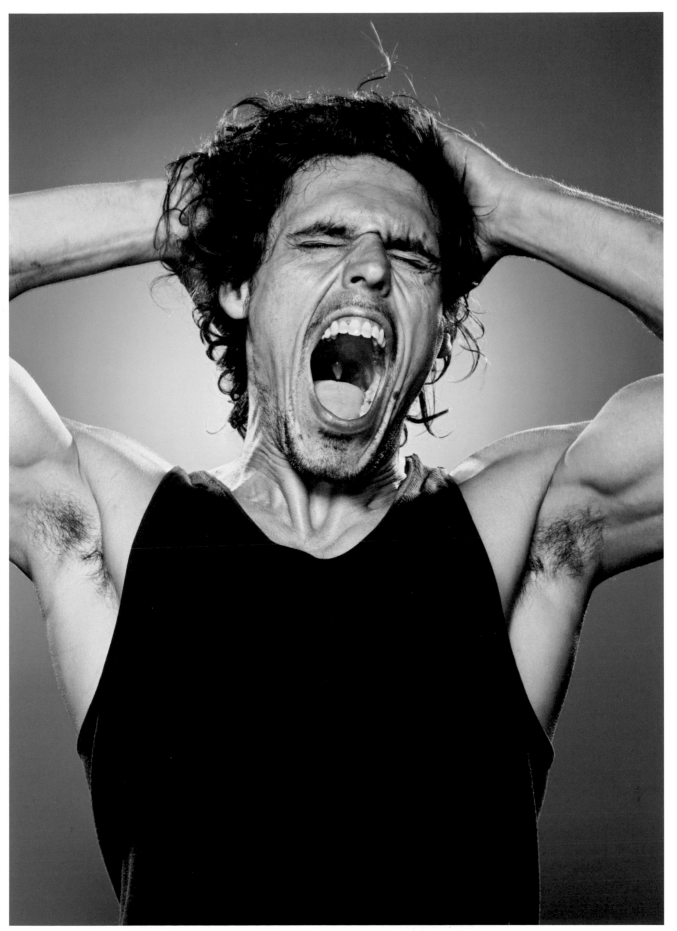

Rajiv, Los Angeles

"One of my favorite moments is when an actor forgets his lines on stage or the choreography, and somehow must recover without anyone knowing."

Krystle, Los Angeles

"I was born a paradox. A contradiction. Someone once said, 'They're going to tell you that you're beautiful . . . don't believe them.'"

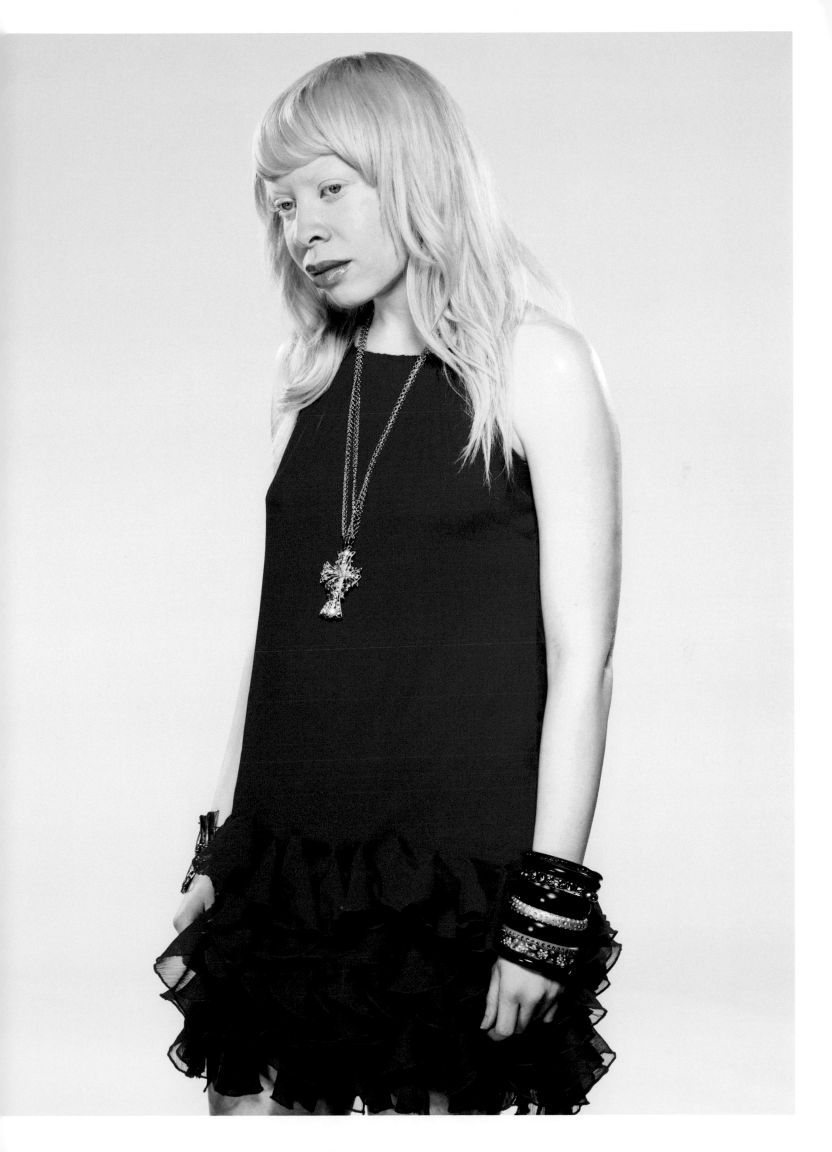

JOE
FORNABAIO

LET'S FACE IT: We all care about how we look. Some people care more than others, but our appearances are what make us unique. And while clothing can be changed and makeup can be washed off, the thing that makes the most personal statement of all is our hair.

So whether you're paying a few hundred dollars or just a couple of bucks, whether you are the president of the United States or a child in need of a trim, we all share in the same regular ritual: We get a haircut.

I've always been fascinated by the things that make us uniquely American, the things that transcend wealth, race, politics, and geography. The way we each achieve our "look" is one of those things. That's why I chose haircuts as my subject for Character Project.

We each select our barbers and stylists for different reasons, but once we're in their chair, we are all equal and vulnerable. We trust them. And we return loyally to the artist who gives us the confidence to walk out our door every day, happy with who we are.

The common denominator I sought for this project was the visceral experience we share with our stylist or barber. Getting a haircut is intensely personal. We watch intently as the stylist cuts, blow-dries, and sculpts. Sometimes we're nervous, like when we take a risk and try something new. We watch with an eagle eye to make sure the barber isn't making any mistakes—trimming our bangs too short or leaving an edge not quite sharp enough. Sometimes, when we really trust our stylist, we relax and let them do their thing. And sometimes, we just sit back and have fun.

And so it was for me—fun. I did not direct any of the stylists. I simply put myself in a position to observe how they work. Some stylists were quick, some took their time, some loved to talk, and some just focused on their craft. But they all had one thing in common: They're all worth every penny.

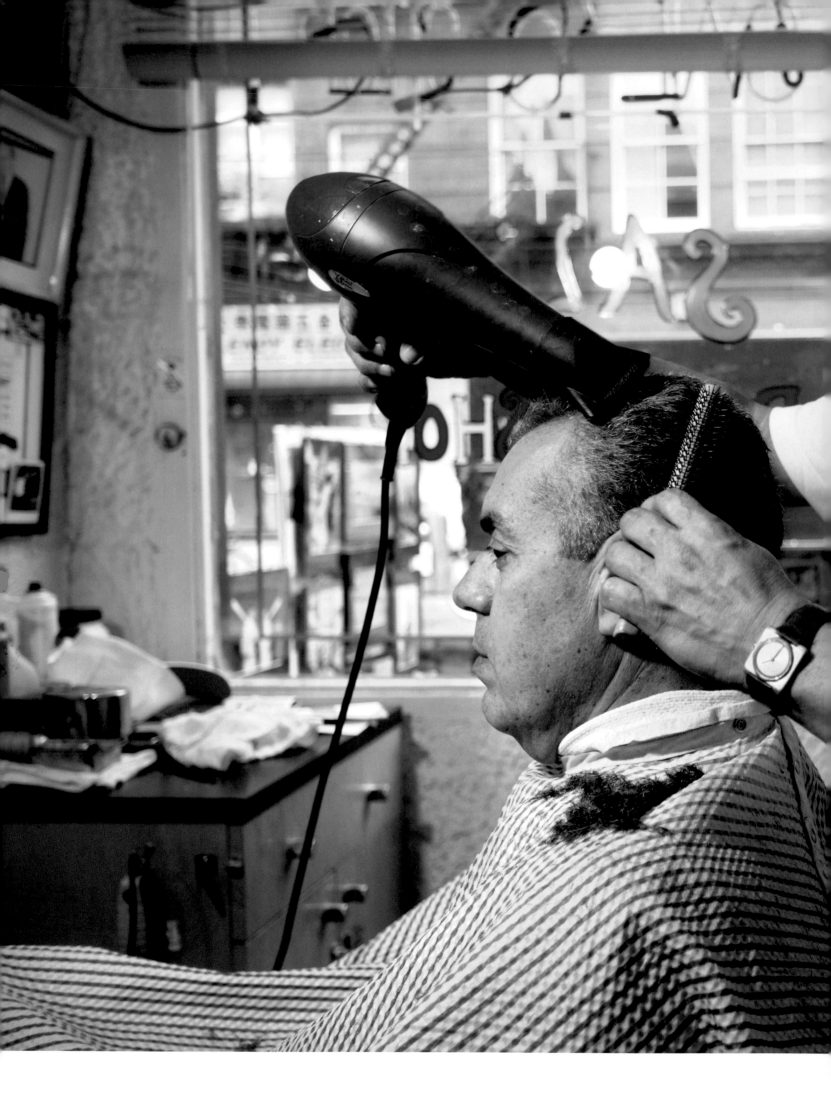

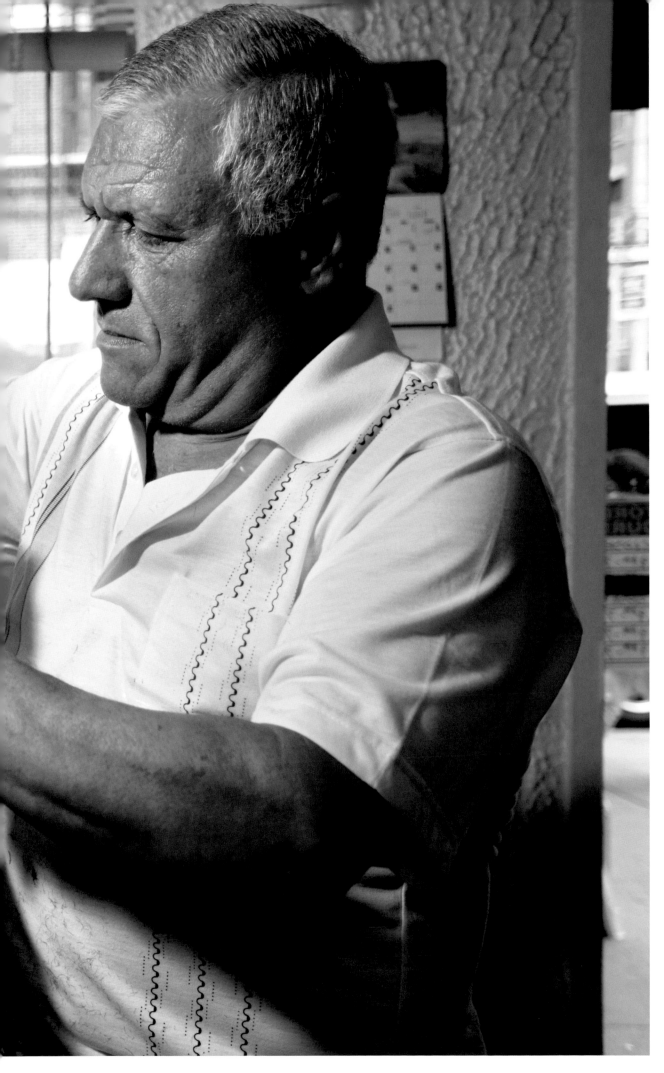

Salvatore Cangelosi
cutting **Lou Di Palo**'s
hair at Sal's Barbershop
in Little Italy, Manhattan

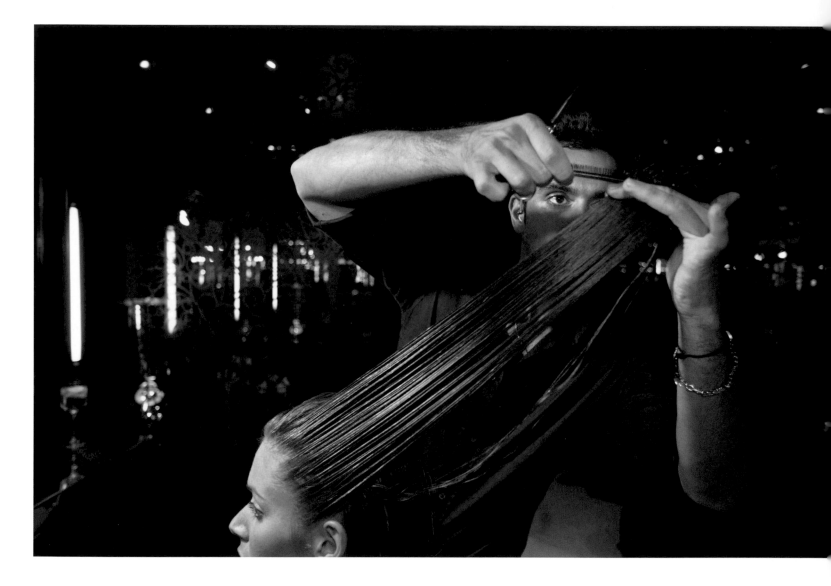

Andreas Anastasis cutting
Bari Goldberg's hair at Chris
Chase Salon in Chelsea,
Manhattan

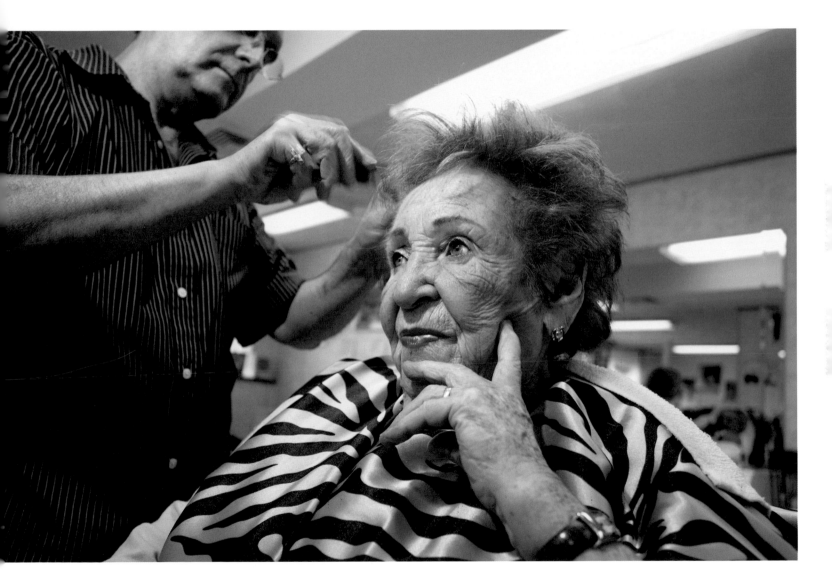

Rose Cohen getting a haircut from **Vincent Aiello** at Prince Unisex, Brooklyn

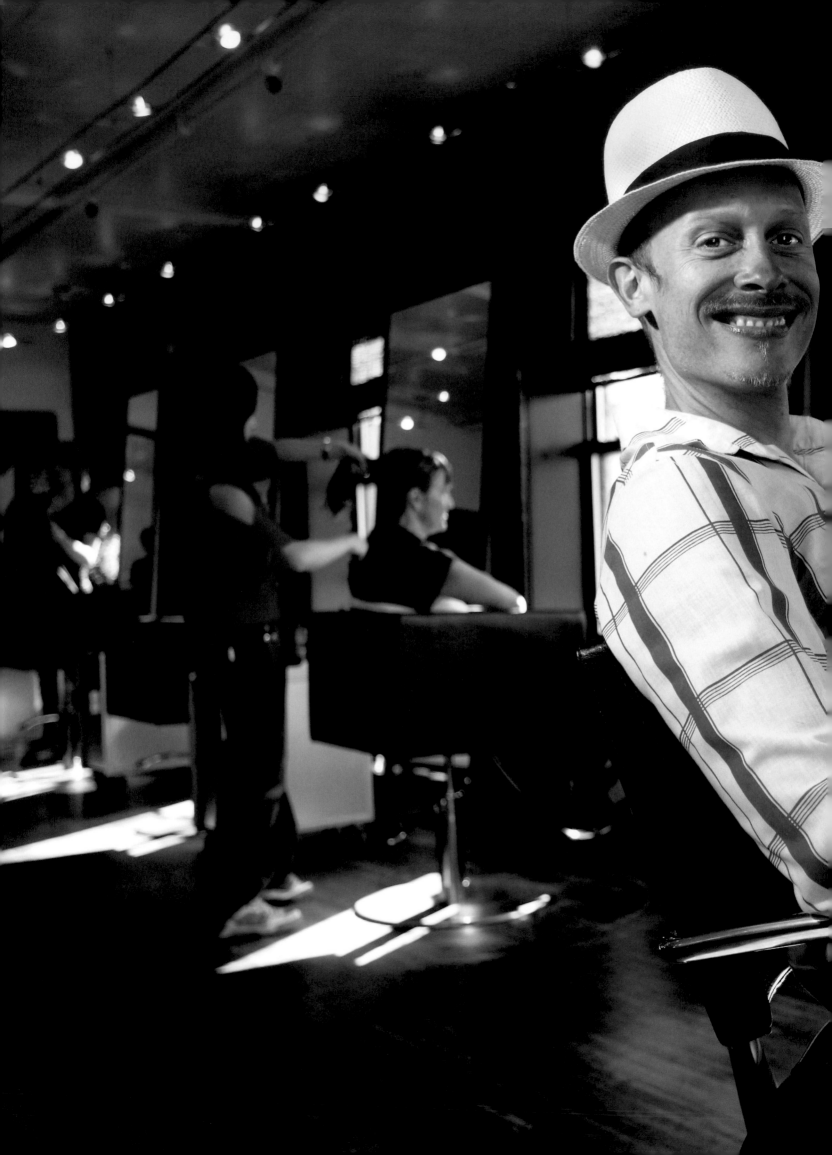

Hairstylist **Todd Byington** at Edris Salon, Manhattan

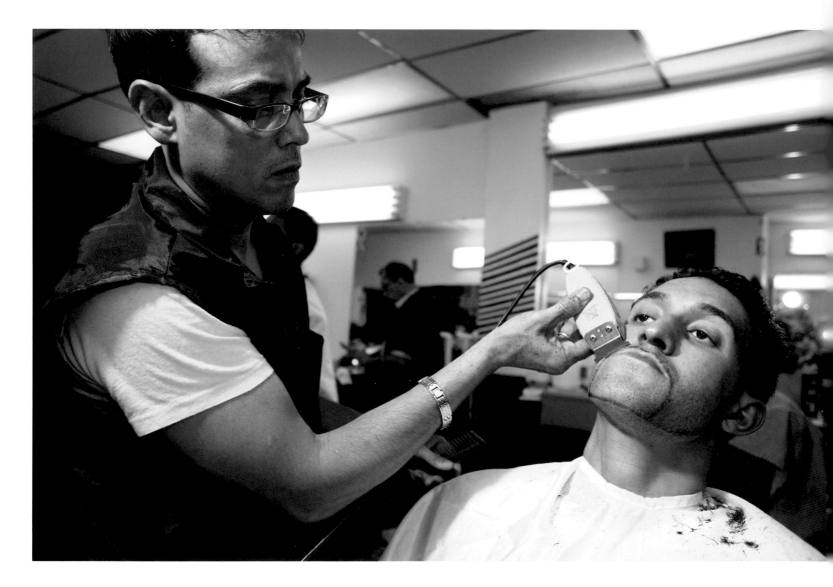

Raul Velez giving **Jose Sanchez**
a haircut at Raul & Joe's Barbershop
in the Lower East Side, Manhattan

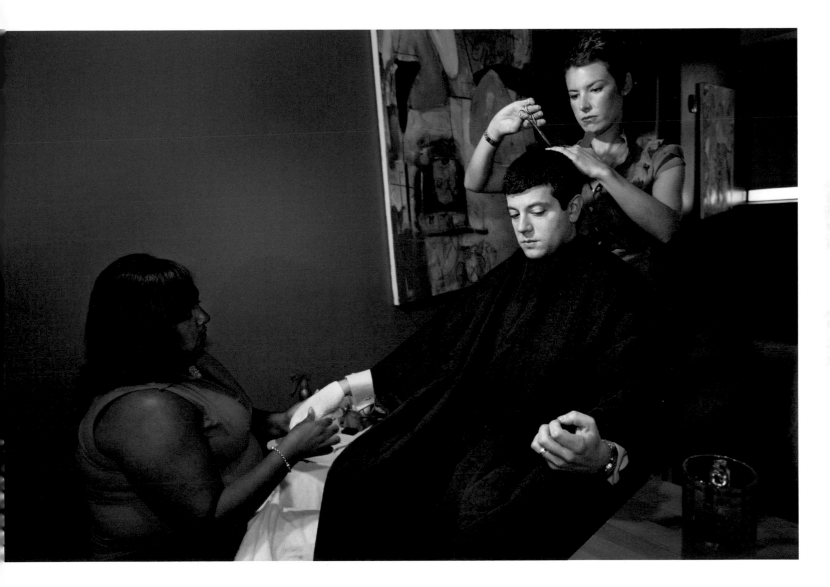

Kostas D. Katsiris getting a haircut from stylist **Lorraine Leninger** and a manicure from **Xenia Fret** at Truman's, Manhattan

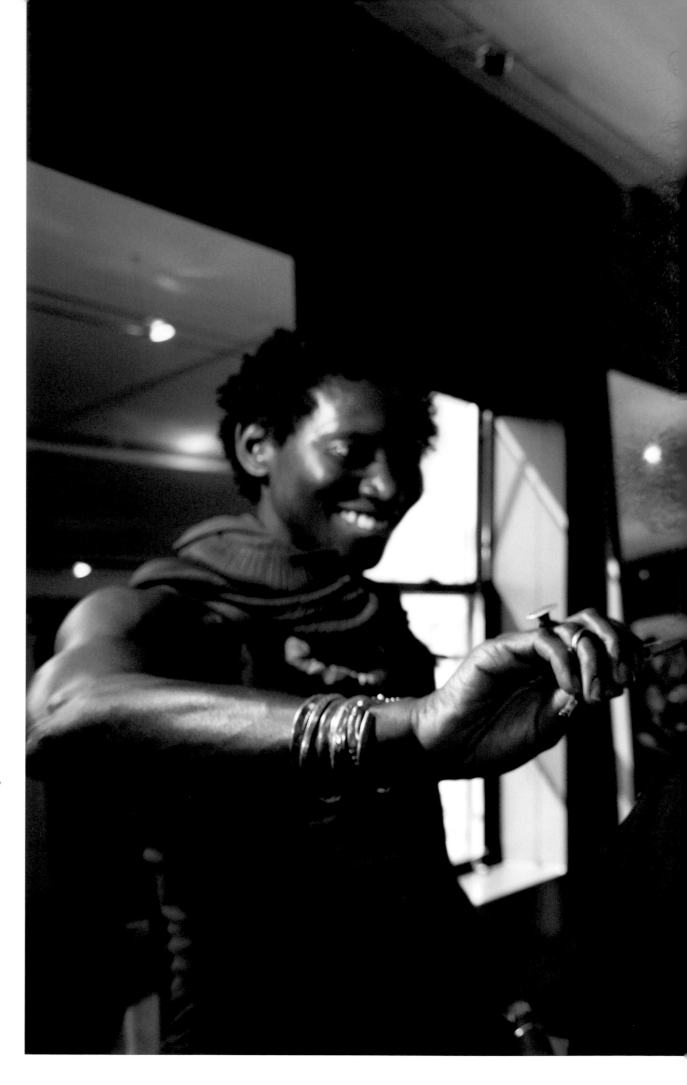

Edris styling **Erica Lawry** at Edris Salon, Manhattan

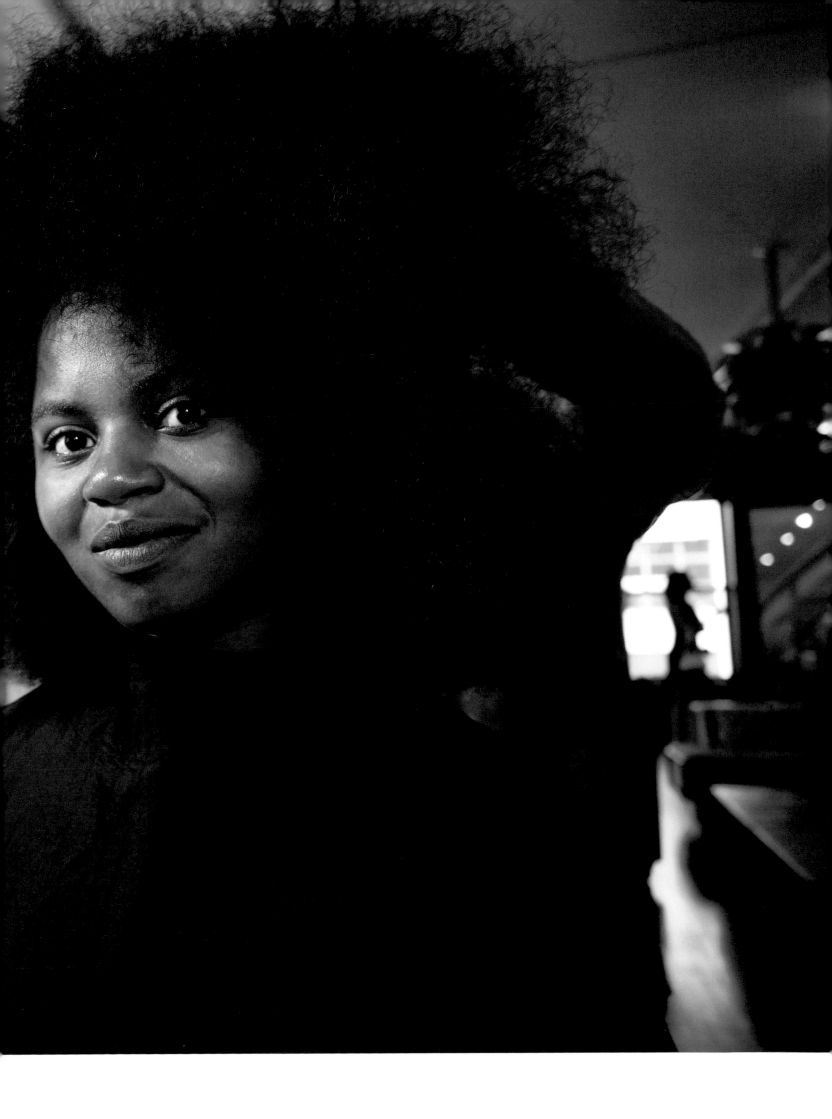

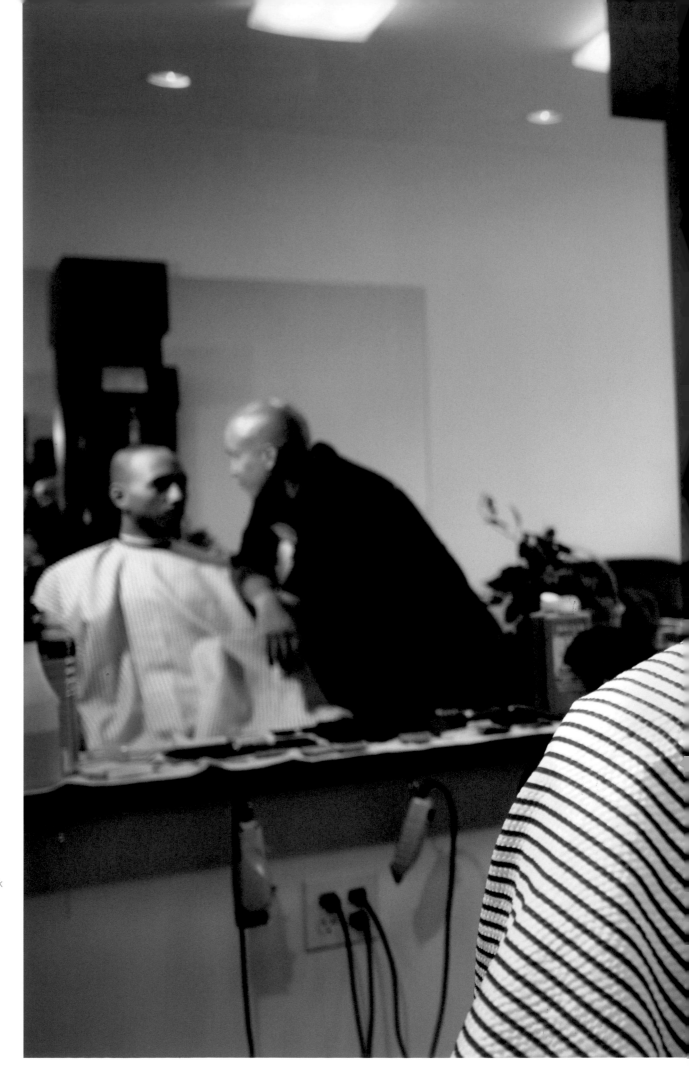

Jose Bermudez with a barber's pole designed and blended into the back of his head by **Erik Figueroa** (right) at Major League Barbers, Bay Shore, New York

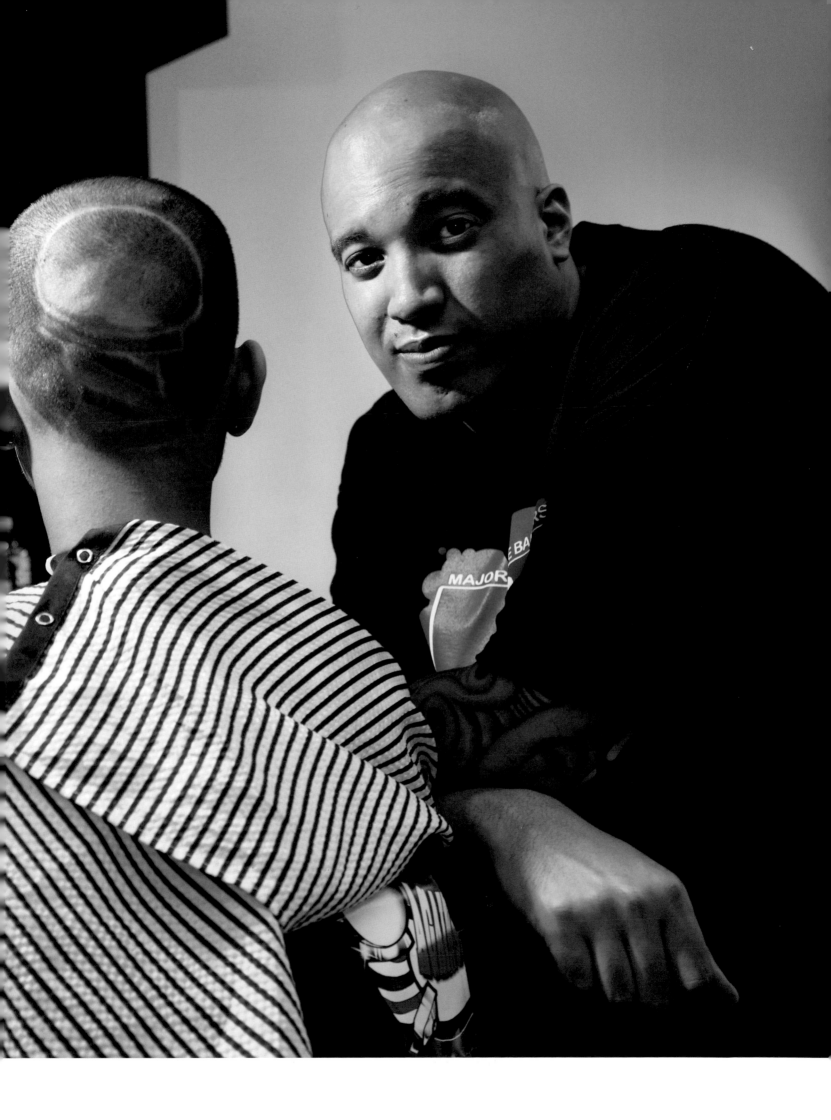

In the Shadow of Los Angeles

JEFF
DUNAS

FROM 1993 until 1999, I traveled throughout the United States photographing glimpses of my childhood in black and white. Since 1999 I've repeated that exercise in color and the work I've created has been informed by color. Not the hues and tones in which we see the world, but color that's more vibrant, more intense. Color you can only find in America.

I've always tried to reveal the honest, direct way Americans live and work, concentrating on the "real" people with whom I can identify. When asked what kind of photography I do, I always reply, "Everything but still-life and landscape." I'm a people person, an admitted extrovert—unafraid to approach and photograph anyone and everyone I meet.

And so my proposition for Character Project was simple: I wanted to spend two weeks photographing every barbecue, dance, birthday party, public swimming pool, community sports facility, beach, boat marina, hopscotch contest, skate marathon, bowling alley, dog show, public park, historic home, and funeral that I could find. I'd follow my nose, as always, checking in with local diners and local newspapers and using word of mouth to determine my next move.

As it turned out, I found my inspiration all within the shadow of the city of Los Angeles. My team and I photographed a full spectrum of the colorful American summer experience. A sandcastle building contest and an event for inner-city kids in Long Beach. A watermelon festival in Sunland. A rodeo and county fair in Ventura and line dancing at a cowboy bar in Chatsworth. A block party and the Festival of Sail in San Pedro, lawn bowling in Santa Monica, an RV park in Van Nuys, and a senior talent show and '80s sing-along evening in downtown L.A.

No matter where I went or whom I met, I was captivated by the colorful characters and the untethered optimism that only summer can bring.

Jane Wallace and **Elizabeth Osborne,**
75th Annual Great Sand Castle
Contest, Long Beach, California

Drew Williams, 75th Annual
Great Sand Castle Contest,
Long Beach, California

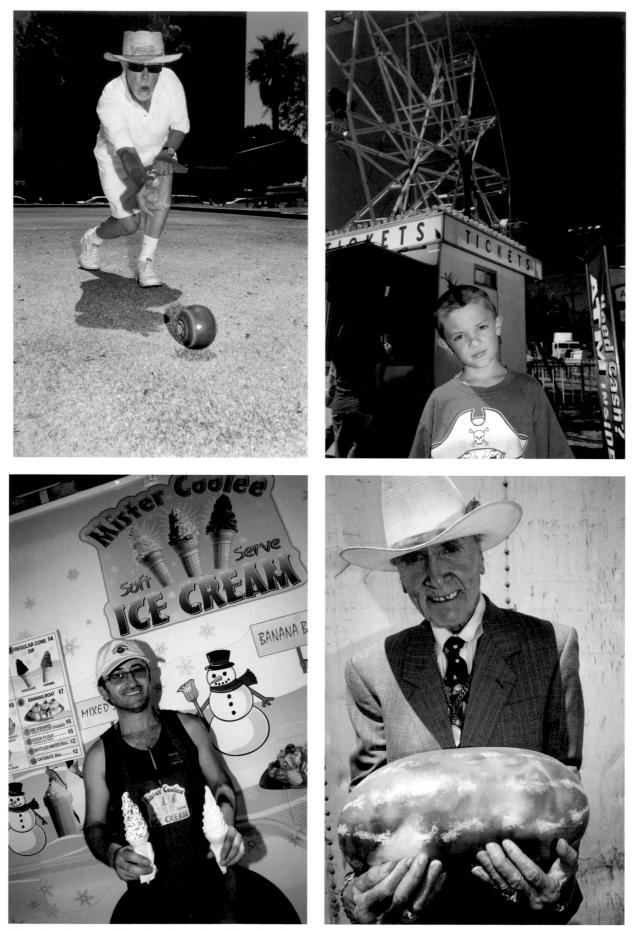

Clockwise from top left: **Alan Power** lawn bowling, Santa Monica, California; **Zebulan R. Winfield, Frank Galante,** and **Vazgen** and Mister Coolee, 47th Annual Watermelon Festival, Sunland, California

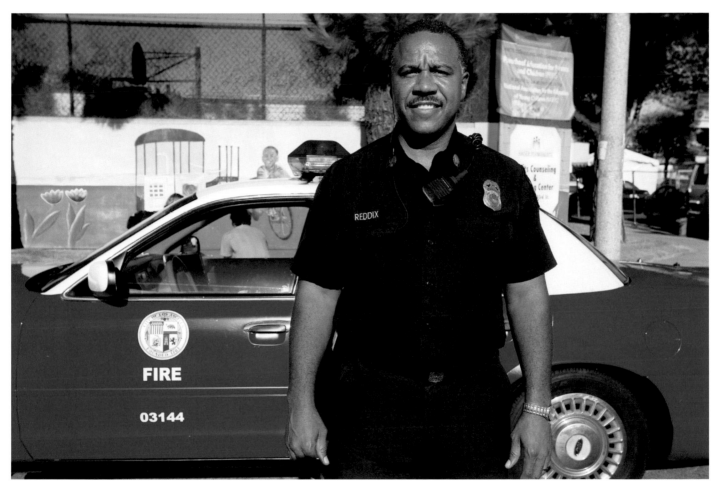

David Reddix, fireman, 42nd Annual Watts Summer Festival, Watts, California

Following pages, left to right: **Mike Gomez, Rachel Matheny,** and **Jennifer Fauskin,** Festival of Sail, San Pedro, California

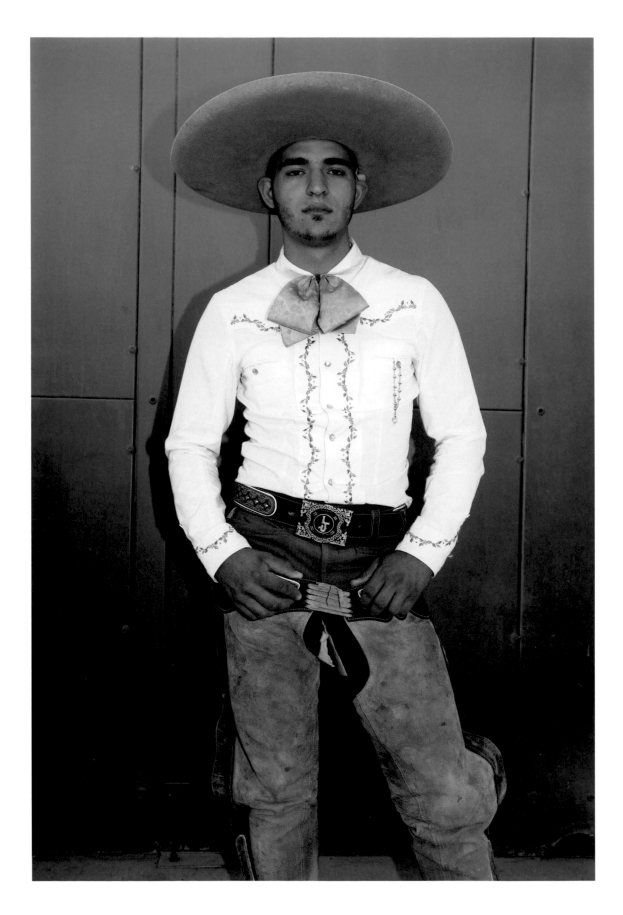

Javier Loza, Ventura County Fair
and Rodeo, Ventura, California

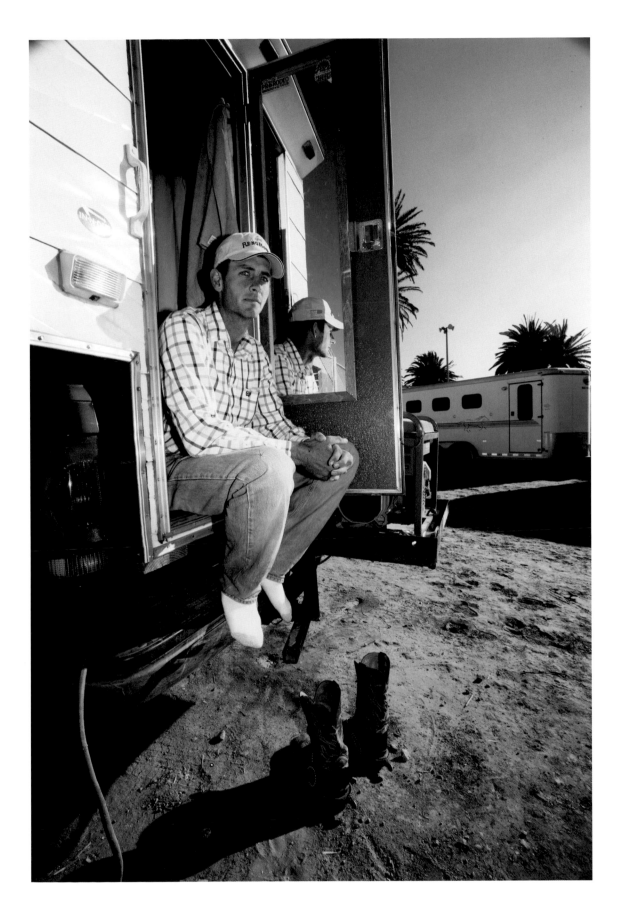

Stephen Howard, American cowboy,
Ventura County Fair and Rodeo,
Ventura, California

Ann Mack, senior talent contest, downtown Los Angeles

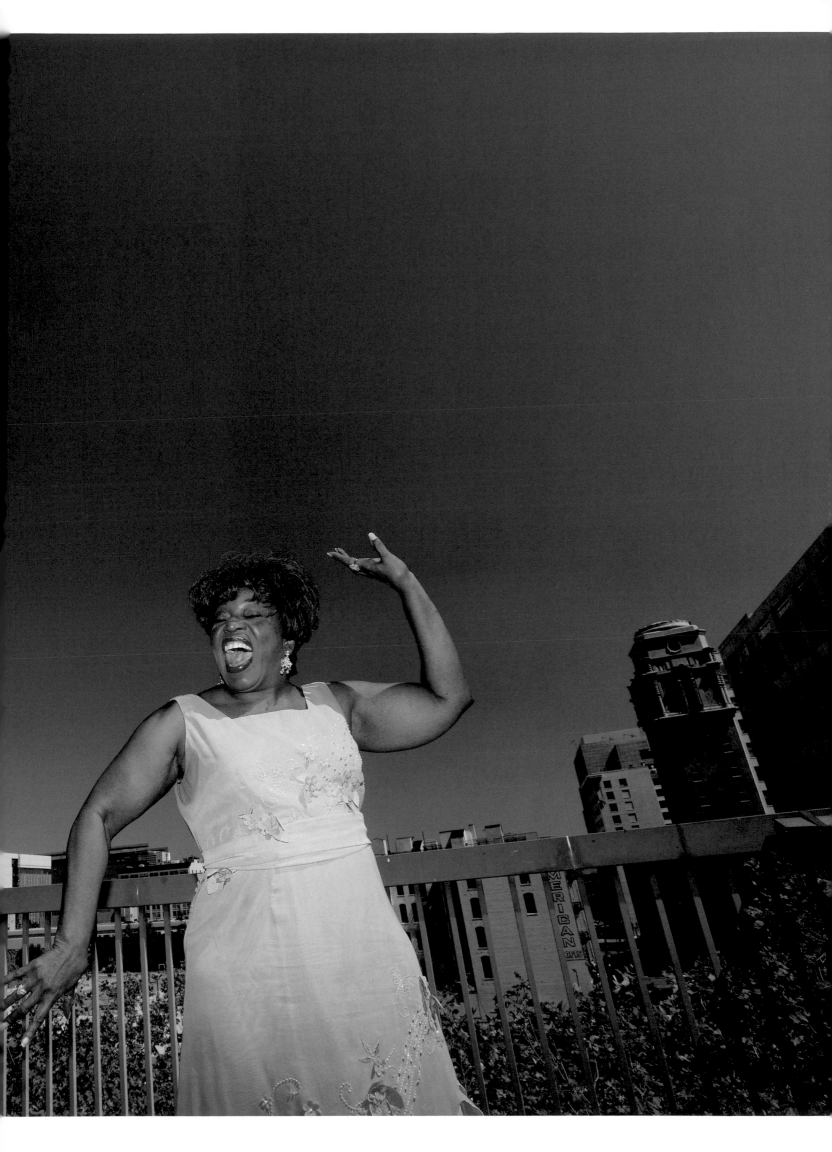

Organic Farmers of the Northwest

ANNA MIA
DAVIDSON

THE SUBJECT I chose for Character Project was the resurgence of sustainable farming in the Pacific Northwest. The individuals who have embraced the movement to farm responsibly, despite the many obstacles they face, are bright, passionate, and inspiring characters.

For me, each photo shoot for this project was a personal journey into the lives of these farmers, and each journey was inspiring. The amount of work and dedication required to be a true steward of the land is humbling to witness. I was struck by the idealism of Julie, the young visionary workhorse who is just getting started, and the dedication of Kao Lee Cha, a Hmong farmer who was born and raised in Laos and became the first organic Hmong grower in Washington State.

No one embodies depth of character more than these organic farmers who have chosen to create a positive way to feed our nation and give back to the land that sustains us. They exemplify a way of life that is often overlooked, yet they represent a universal experience that is integral to the fabric of our country.

Agriculture is a link we share with practically every other nation on earth and a bond that makes us more similar than different. Despite their cultural, educational, and familial differences, the farmers I photographed in the Pacific Northwest had a common thread that linked them to each other and united them with a movement larger than themselves.

I believe that photography has the unique ability to capture the essence of a person's being in an instant. A photograph bears witness to events and can tell an important story within a single frame or within a series of frames. Pictures have the ability to inspire and motivate people into action, and can be a powerful tool for social change by allowing the masses to digest important truths in simple, quiet moments.

My interaction with the farmers I met has renewed my faith in our country and the positive change we are capable of creating. Our future depends on a new appreciation for local production and consumption, and by embracing this vision, we may inspire our nation to take a drastically different approach to our food system. Though powerful social and political influences can lead us astray, the individuals in these photos are living proof that if we persevere and summon the best in ourselves, we can show the true essence of what it means to be an American.

John with tractor at dusk,
Nature's Last Stand Farm,
Carnation, Washington

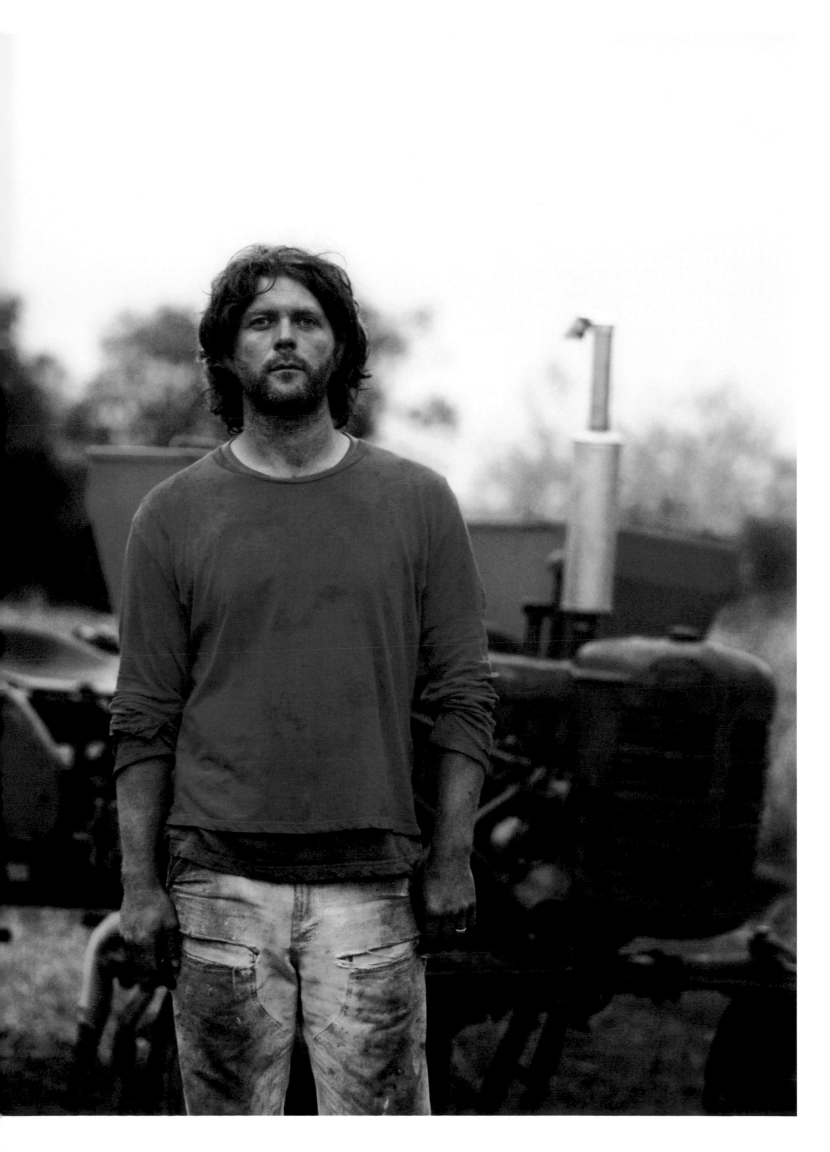

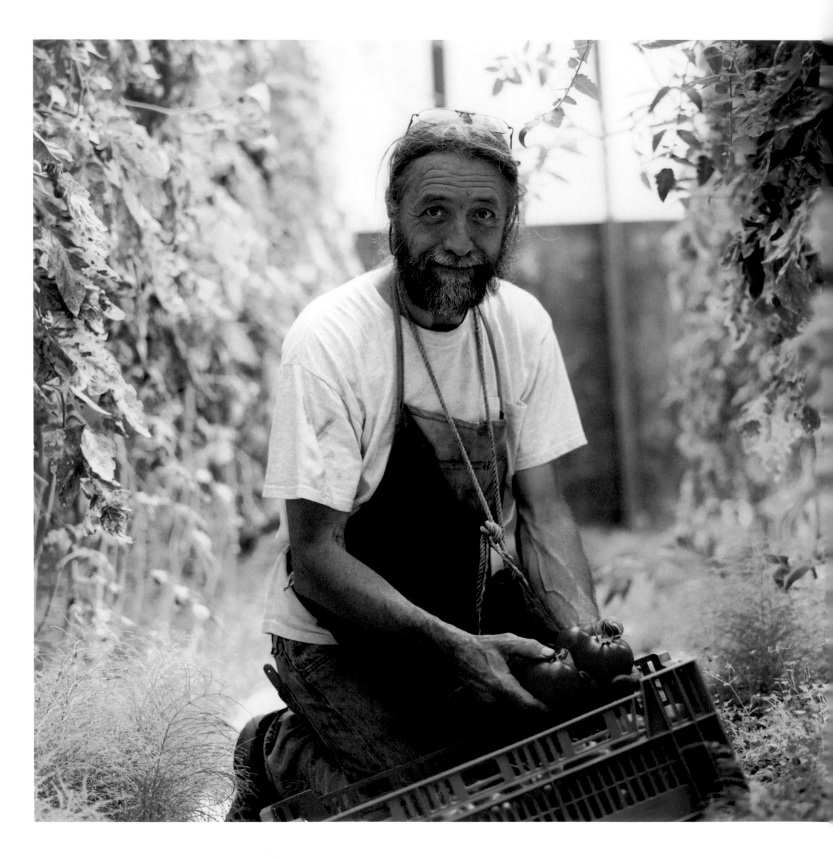

Mike with tomatoes,
Pilchuk Farm, Pilchuk,
Washington

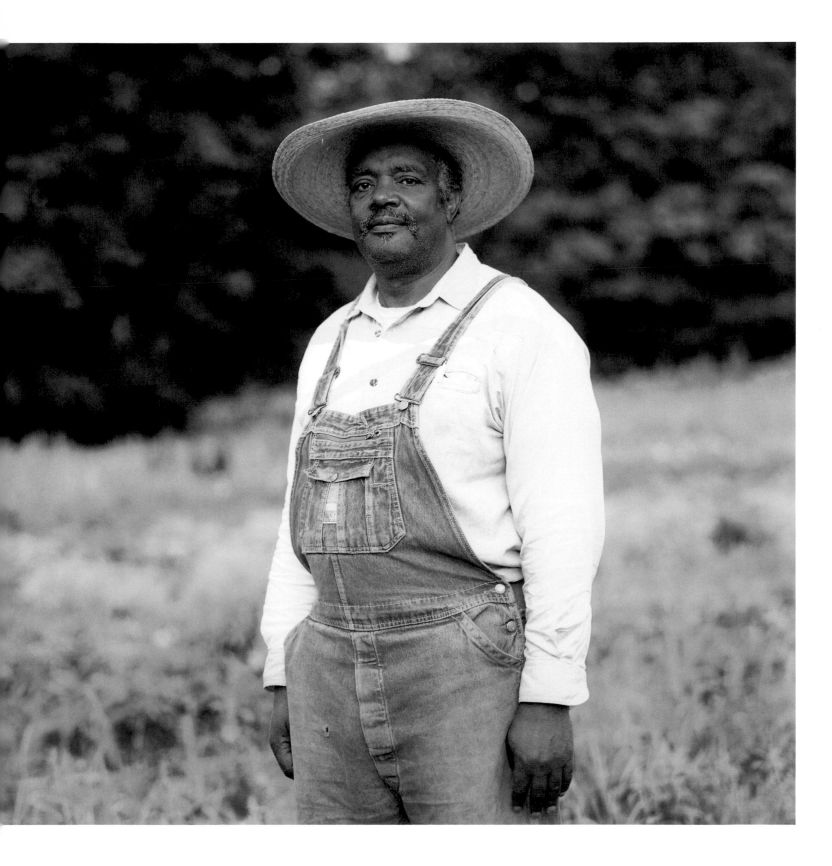

Tom in potato field,
Nature's Last Stand Farm,
Carnation, Washington

Julie with wheel hoe,
Growing Things Farm,
Carnation, Washington

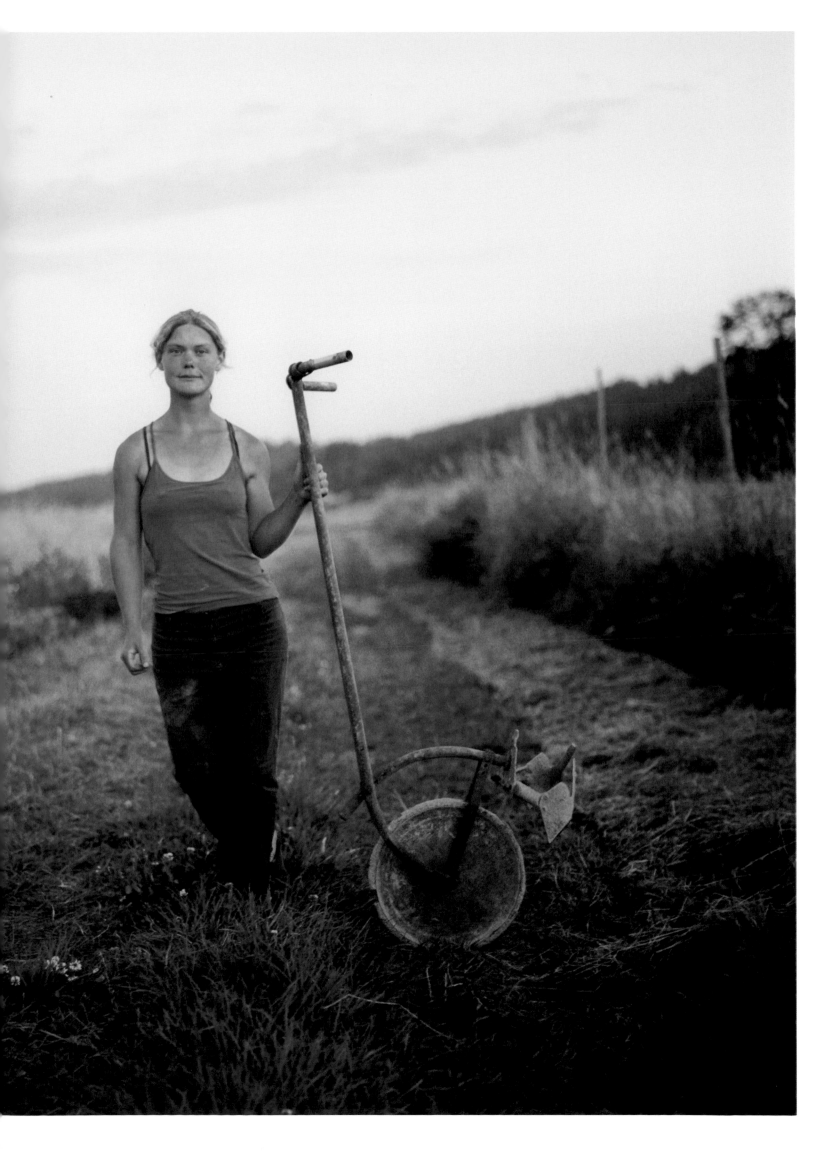

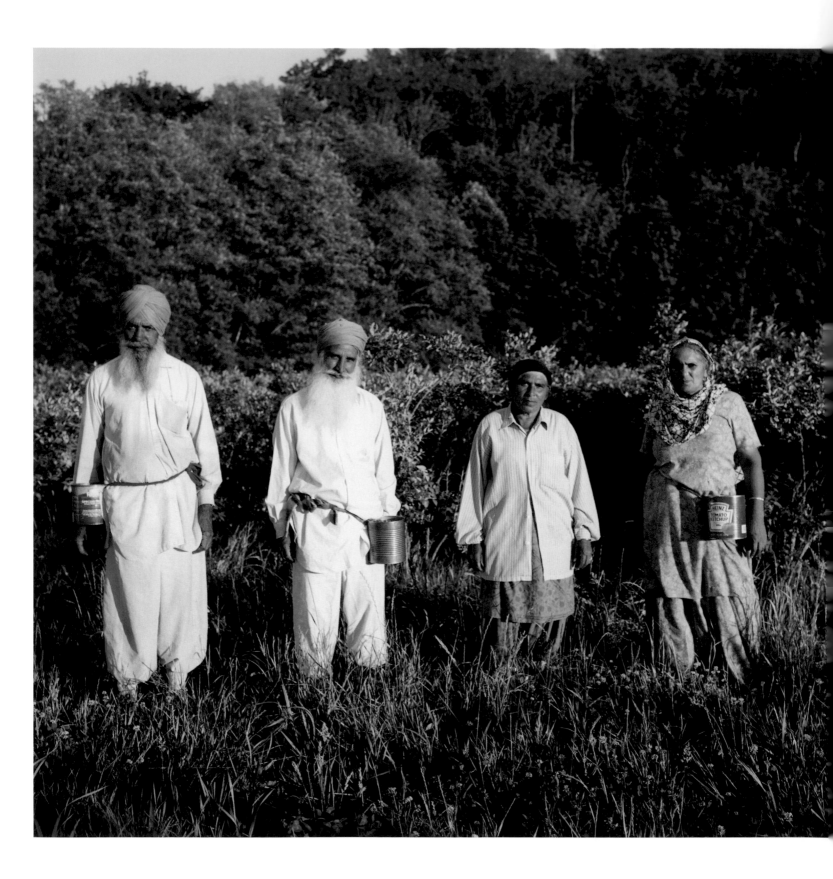

Sidhu berry harvesters,
Sidhu Farm, Puyallup,
Washington

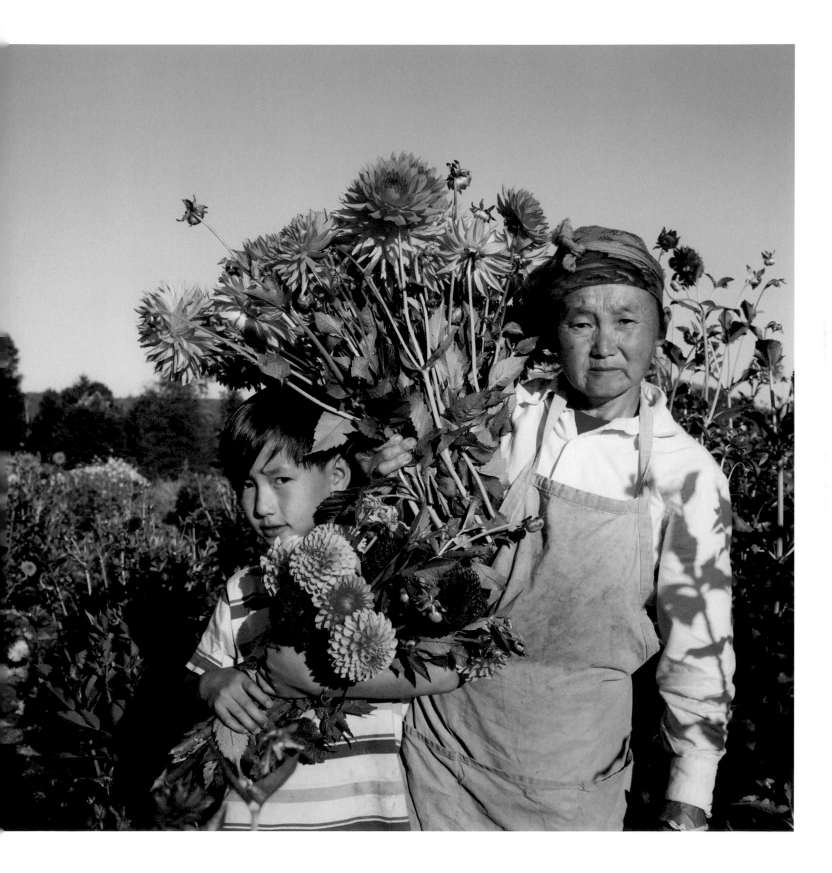

Kong Lor and **Kao Lee Cha**
in flower field, Carnation,
Washington

A. J. in field, Sidhu Farm,
Puyallup, Washington

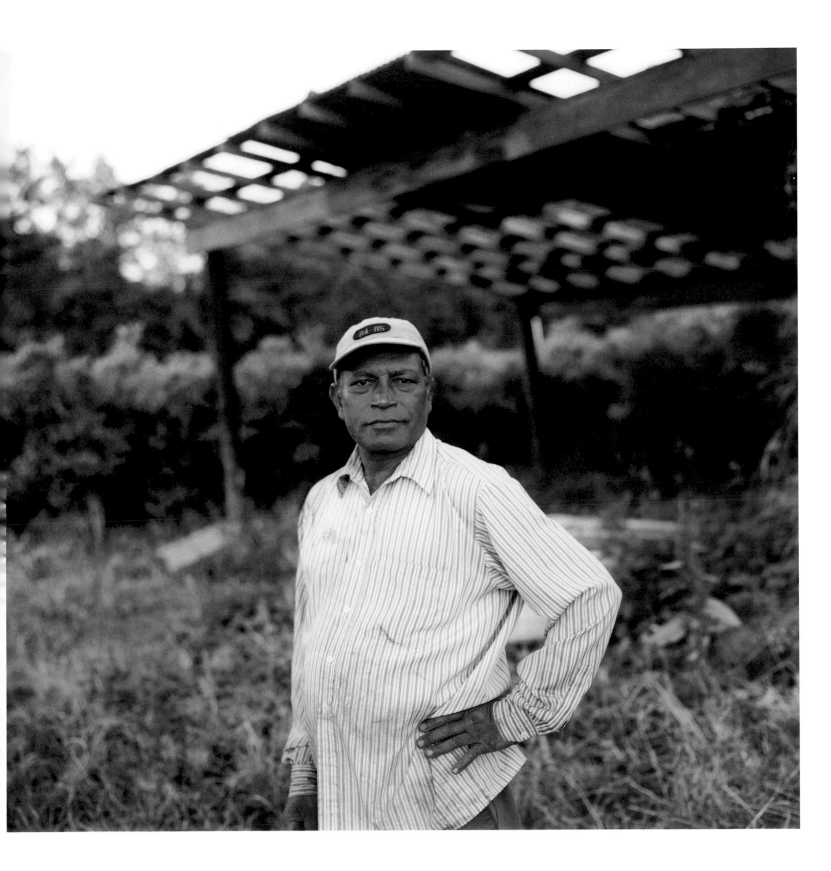

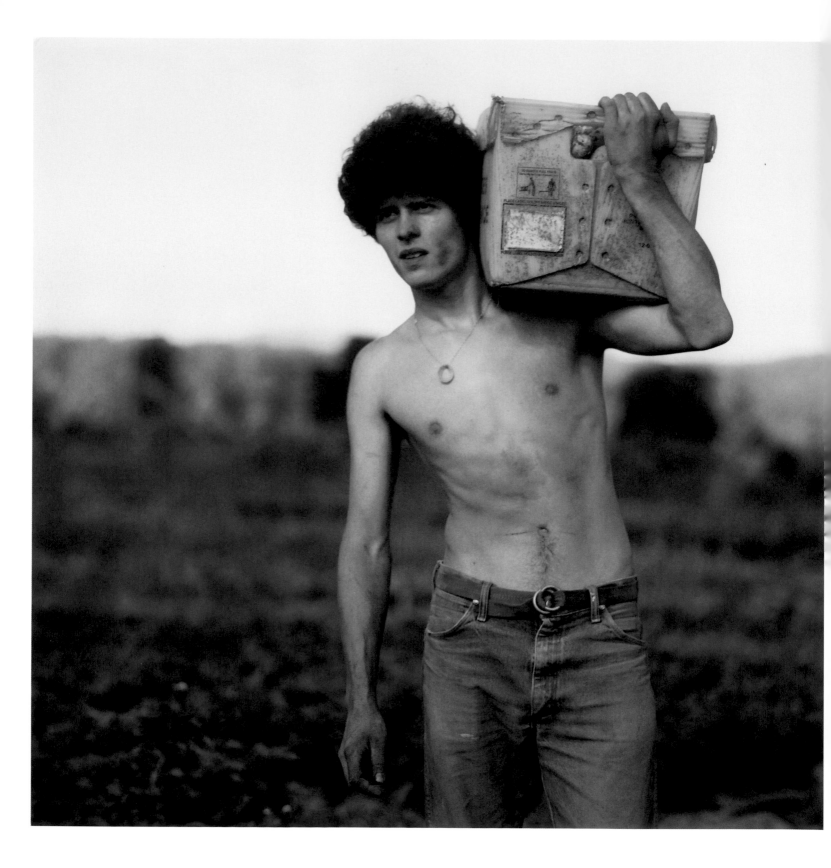

Pierre during potato harvest,
Nature's Last Stand Farm,
Carnation, Washington

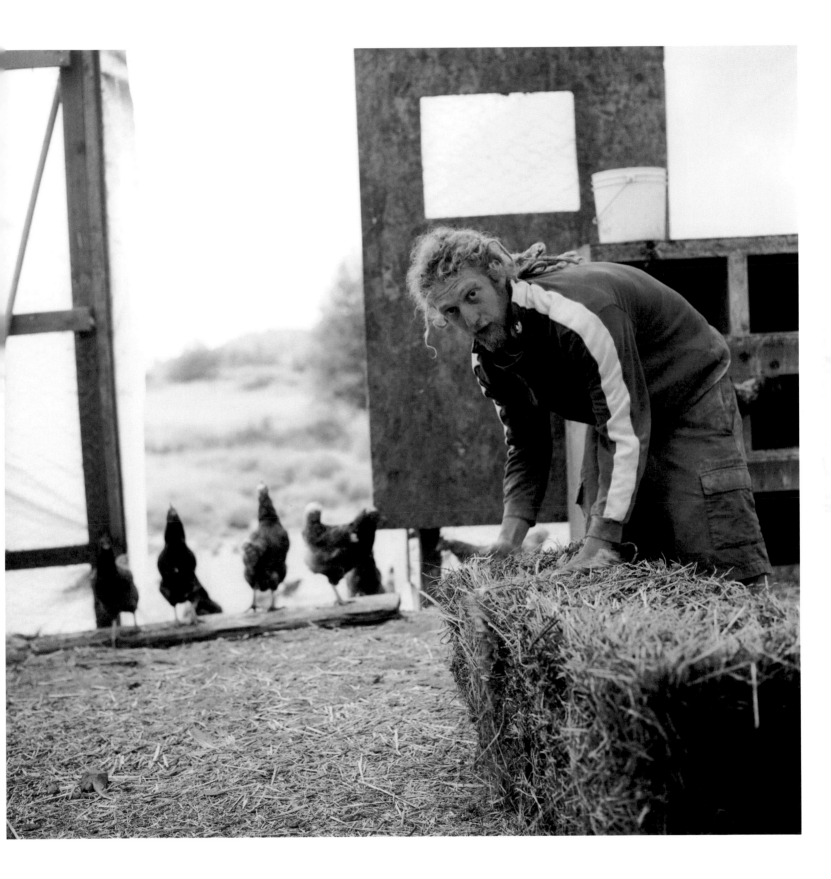

Blake with fresh straw in the henhouse, Growing Things Farm, Carnation, Washington

Oliva with chicken,
Frog's Song Farm,
Skagit Valley, Washington

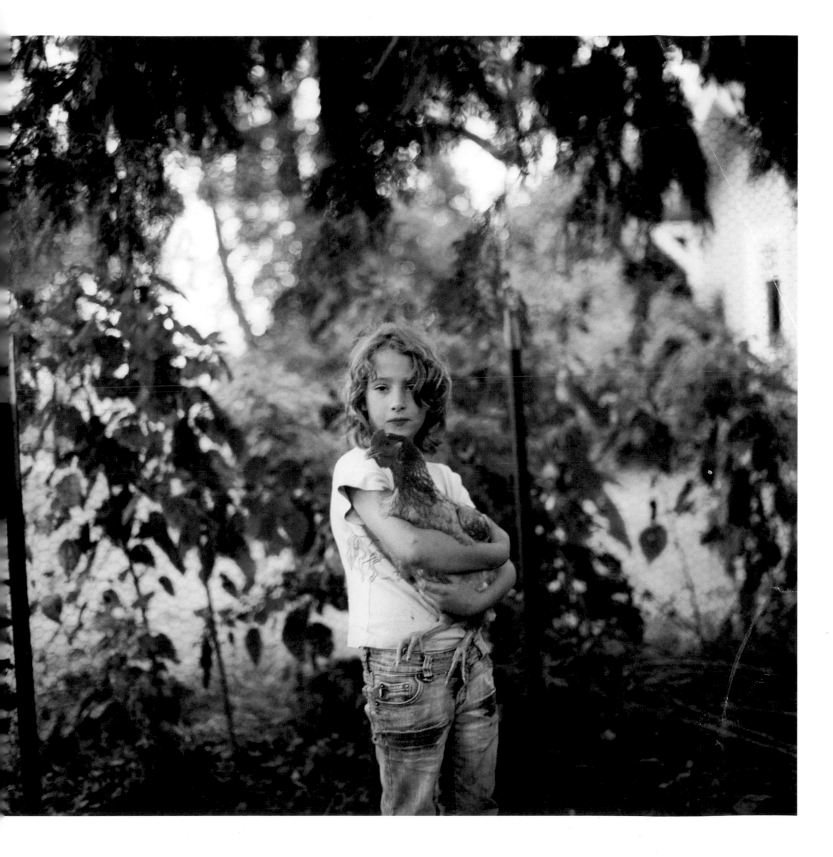

Michigan Music

ERIC
OGDEN

FLINT, MICHIGAN. Sitting on the cracked concrete of a friend's driveway, huddled around a boom box, a cassette by some new band turning its wheels in the deck, we would sprawl out and watch the night sky. The porch light was off. Parents were gone. Yards were dark and empty. And we had no desire to talk, just to listen as a world unfolded.

For those growing up in a small Midwestern town, music was an escape, but it was also an identity. It helped us create ourselves. Surrounded by a landscape of faded strip malls and parking lots, neon diners, and the fluorescent lights of gas stations and convenience stores, kids growing up in Michigan needed a soundtrack to set to the endless nights they spent driving around in their cars. And as often as not, in their boredom they'd strap on a guitar and create the soundtrack themselves. I know that's what my friends and I did, inspired by the shows we'd seen in the basement of the Capitol Theater. Sitting on thrift store couches in rooms heavy with the scent of clove cigarettes, talking to a girl with rings in her nose, we'd watch bands rotate through pounding sets of melody and noise and plot our own band's takeover.

When I was given the opportunity to pitch an idea for Character Project, it was important to me that it be personal. A kind of return to something I knew, a place I'd lived, or people I'd admired. So the idea of celebrating the music that has come out of my home state of Michigan seemed like the perfect opportunity to finally combine my photography with my passion for music. It was also a way to revisit the landscape of my youth, a place where music was life changing. Not to mention the fact that it was an incredible opportunity to work with some of the artists I have long admired.

I set out to create a portfolio of idiosyncratic musicians that would span different genres, from living legends to rising bands just under the radar. In a place that has given birth to a great range of talent, I aimed for the artists just left of center, independents who ride the edge of the mainstream. People grounded with a real strength of character, who often have a vivid sense of the absurd, the bizarre, or who just have their own unique take on the world.

I started with artists I knew, and from there my research expanded, often linking one band to another as I discovered a network of collaborations formed over the years. Sometimes I'd find the odd satellite fully formed at the edges of the map, an artist who'd managed to come out of nowhere and find his own path. But there was a definite core of musicians from Detroit who all knew each other (or knew of each other), and in that way, it was like shooting portraits of as many members of one expansive, eccentric family as I could cram into a few weeks.

Detroit occupies a unique place in music history. It is rich with the legacy of Motown, but also the origins of punk and garage rock, and happens to be the birthplace of techno, too. Why? Maybe it's because of what a friend of mine calls "a Midwest work ethic." Or maybe it's because Detroit is a place with no musical borders. Musicians here aren't averse to mixing styles and genres, bringing history crashing up against the present, or pushing it toward the future.

Every one of the people in these photographs has sent their own unusual vision into the world. Whether they're brash or deceptively quiet, whether they're creating original works or reformatting little-known classics until the songs have taken on a new life, they each capture an independent spirit that drew me to music in my early teens, that sparked the excitement I felt of seeing music played live. No matter how small or dilapidated the venue, the bands of my youth always seemed larger than life. In this portfolio I aimed to show the musicians I photographed in that light.

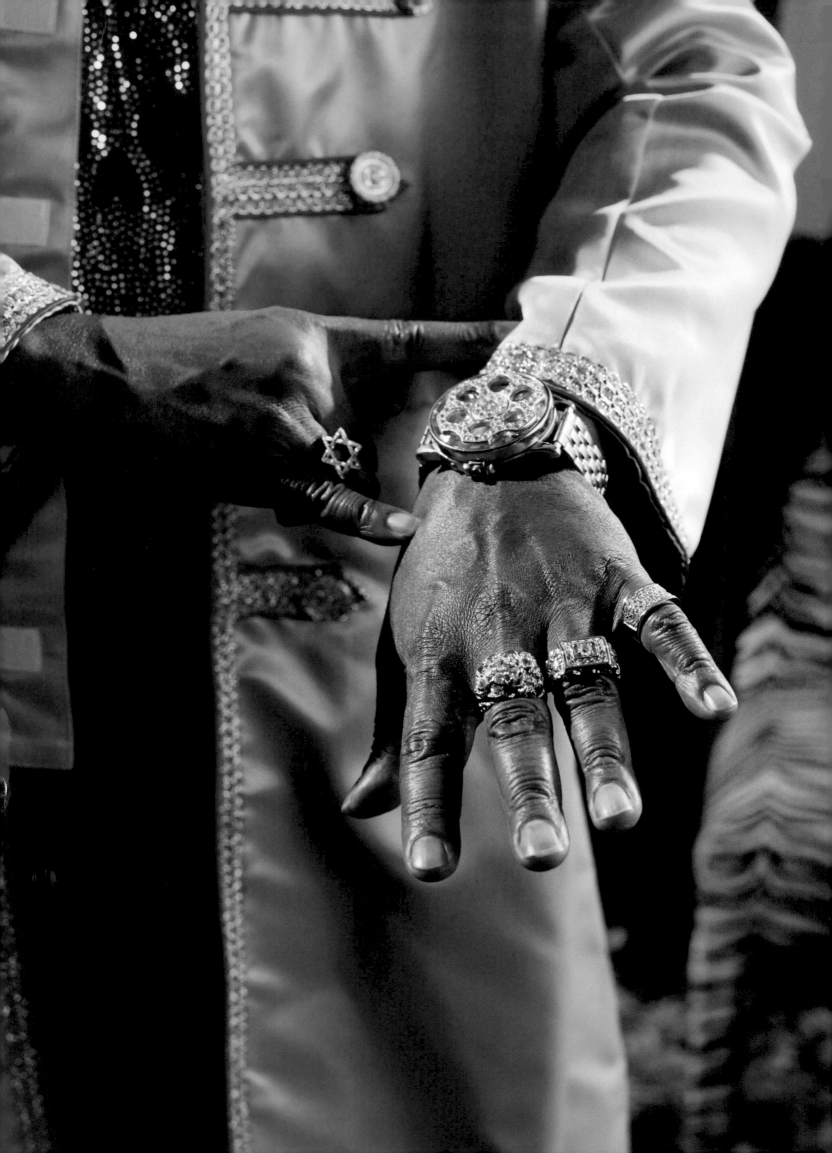

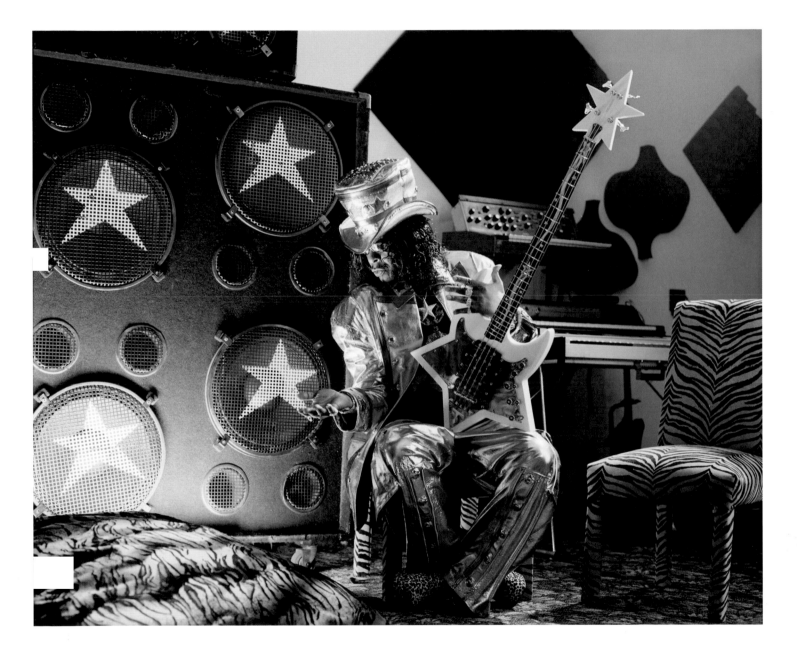

Bootsy Collins at his home
near Cincinnati

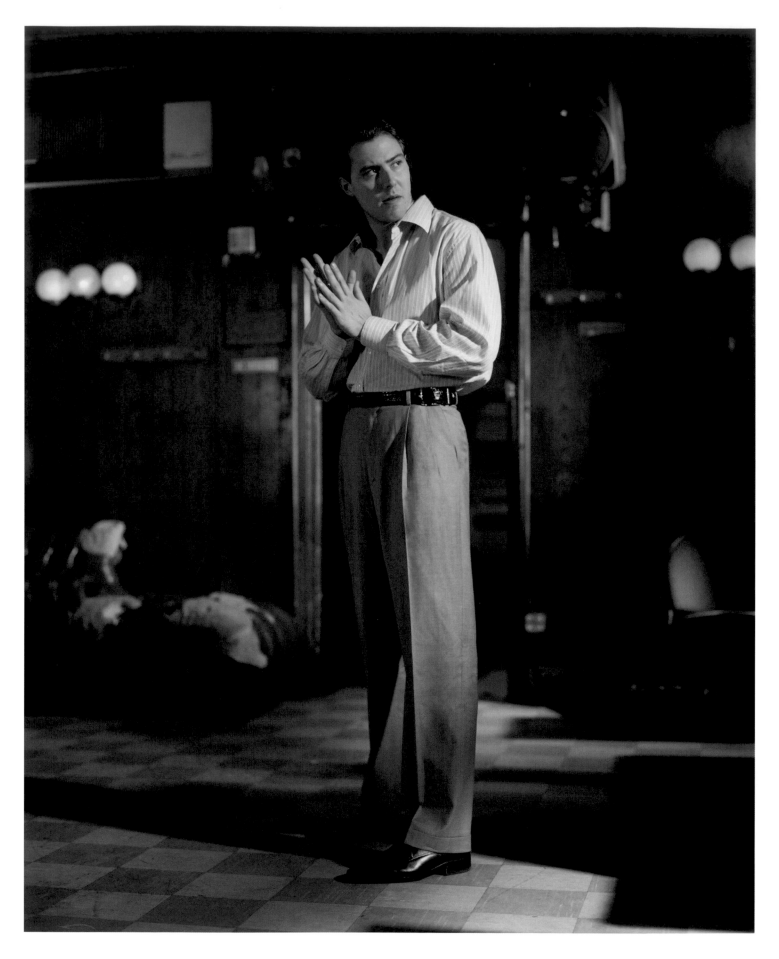

Andrew W. K.,
119 Bar, Manhattan

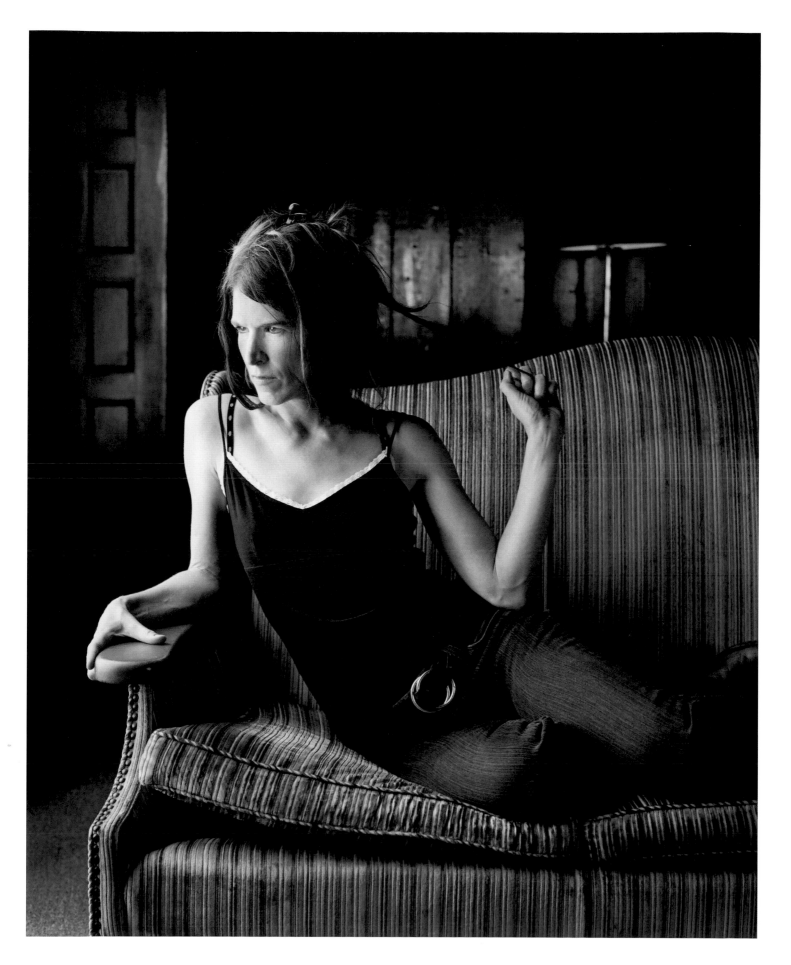

Wendy Case of the Paybacks,
Scarab Club, Detroit

Iggy Pop, Terminal 5,
Manhattan

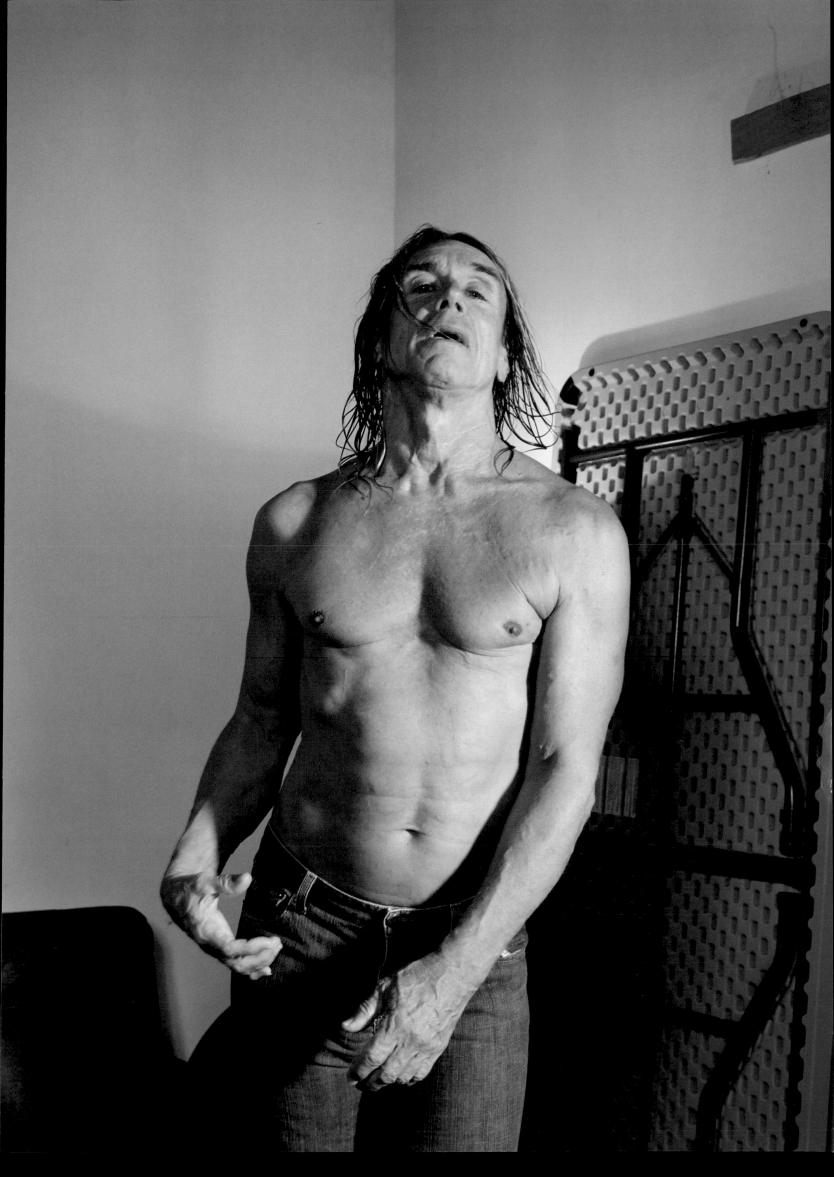

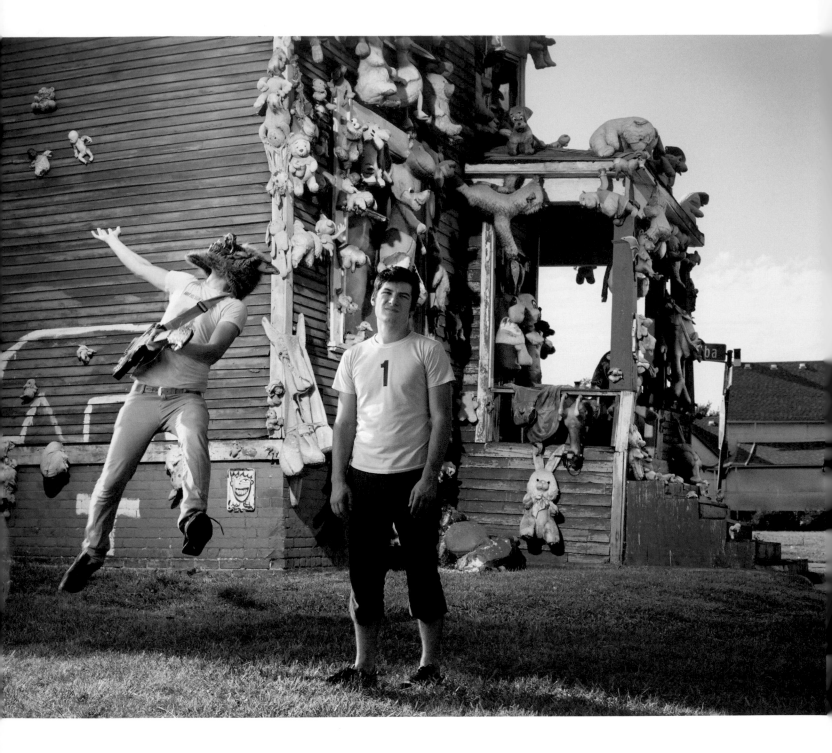

Deastro, Heidelberg Project
Archives, Detroit

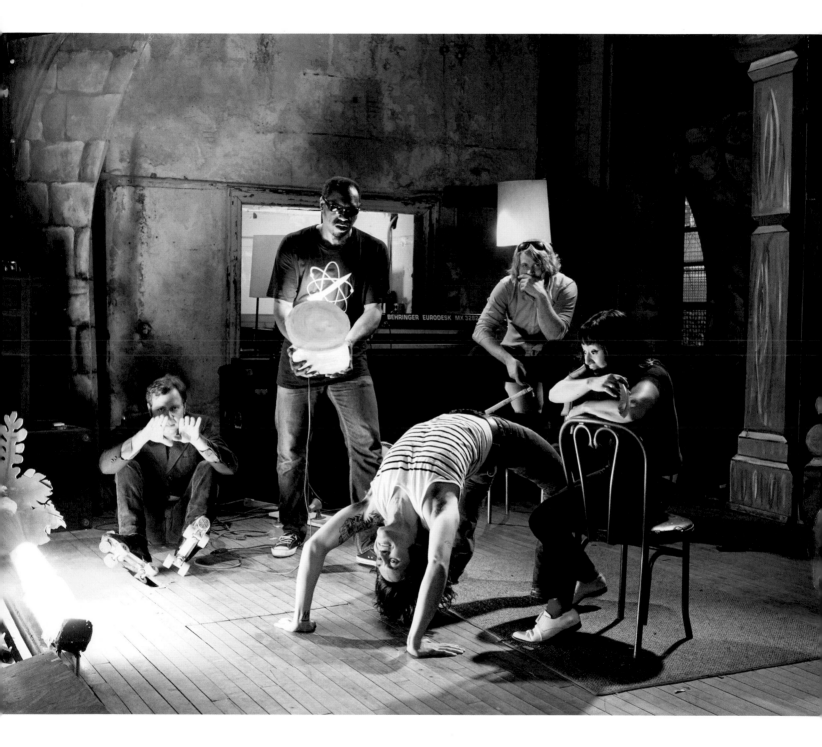

The Dirtbombs, Bohemian
National Home, Detroit

Sufjan Stevens,
Brooklyn

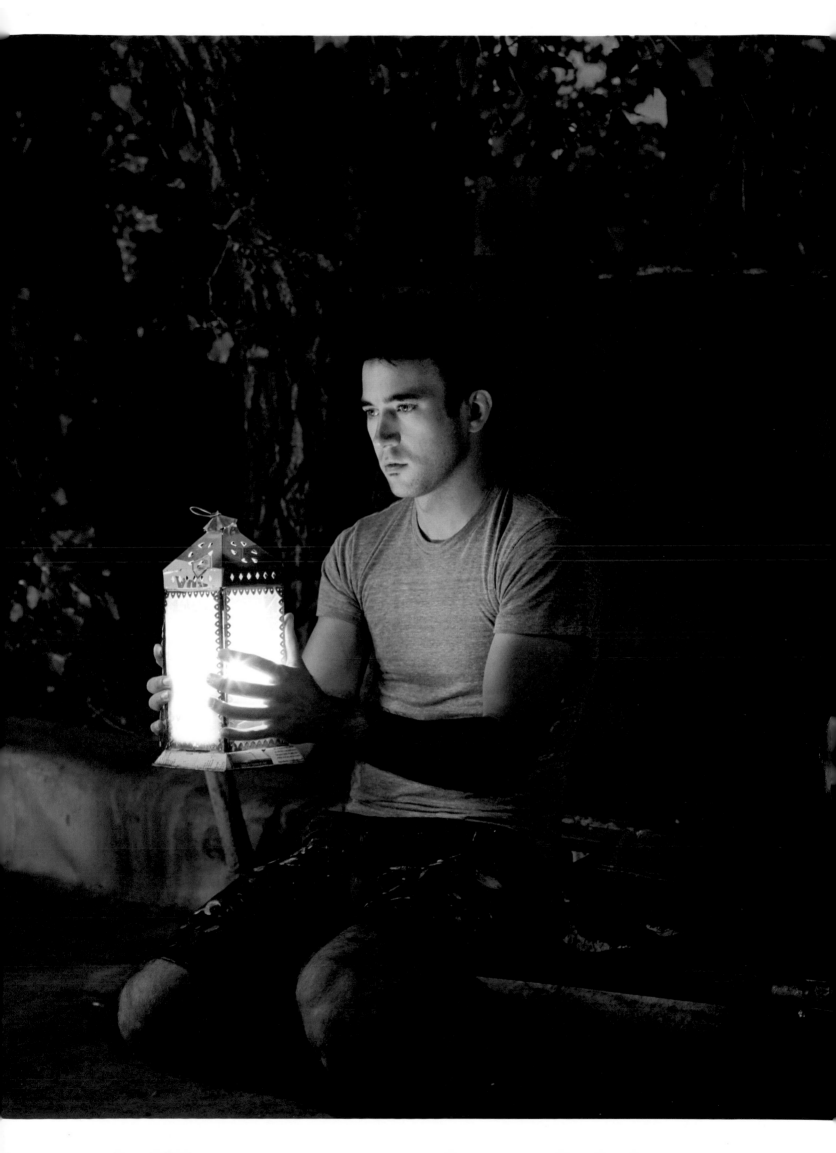

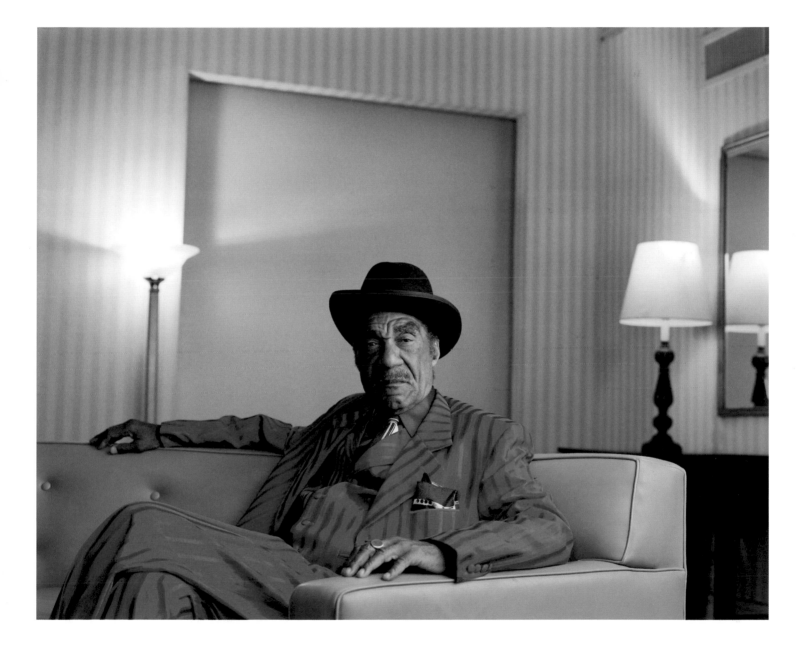

Andre Williams,
Belair Hotel, Chicago

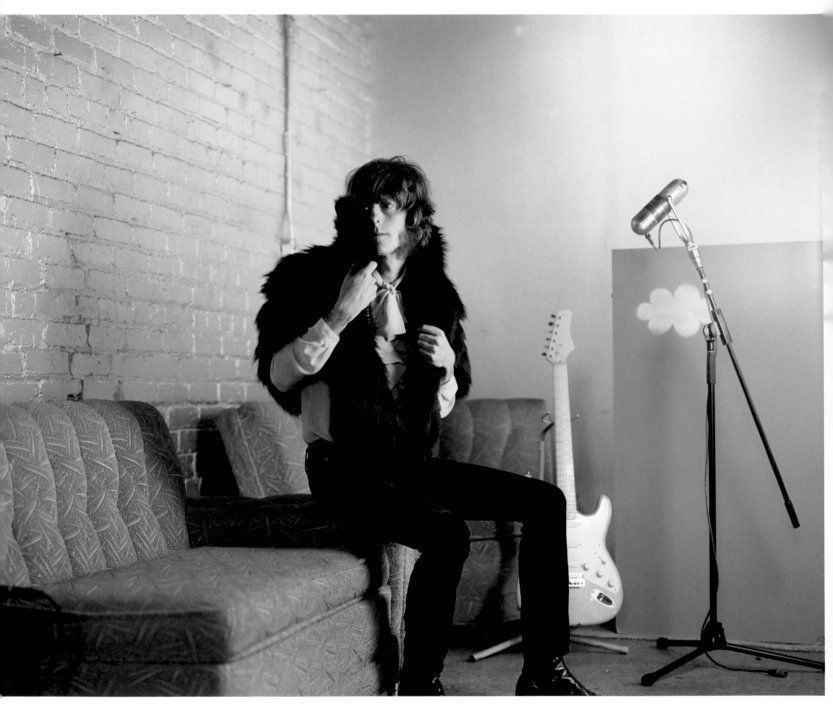

Dan Kroha of Demolition Doll Rods
and the Gories, UFO Factory, Detroit

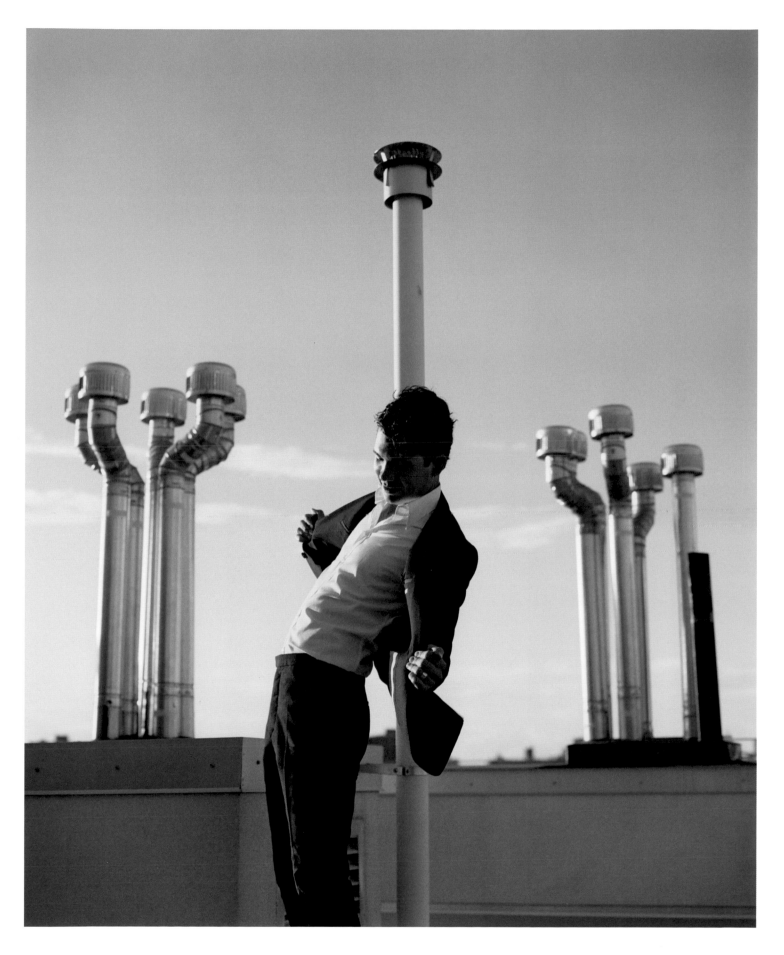

Matthew Dear on his roof, Brooklyn

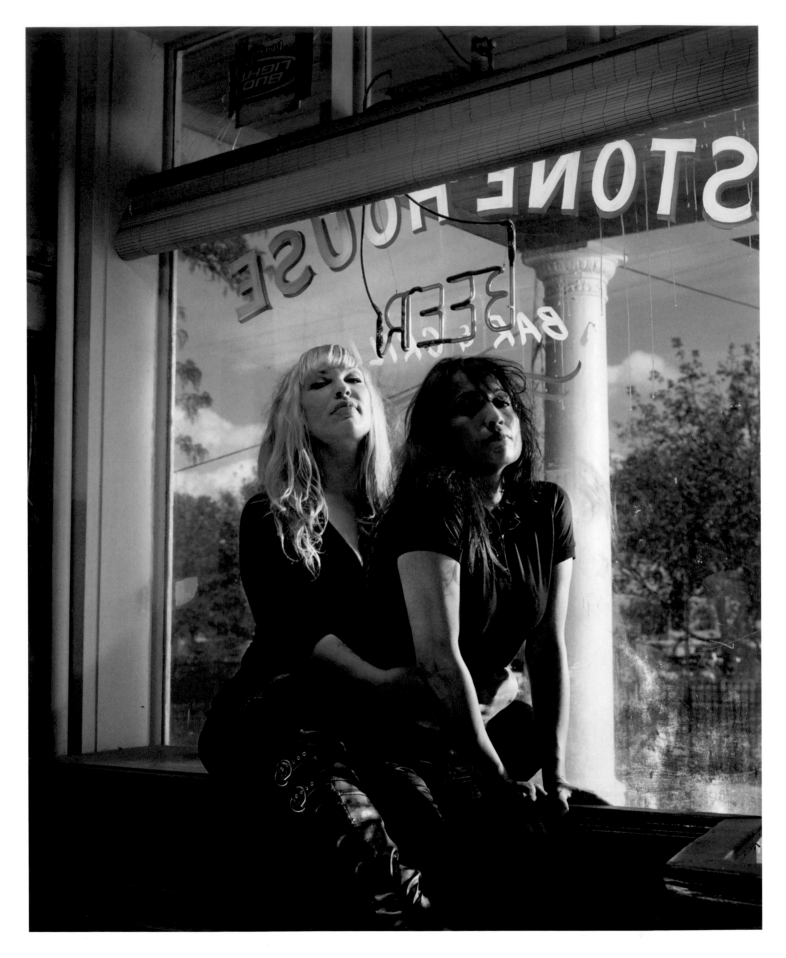

The Detroit Cobras,
Stonehouse Bar, Detroit

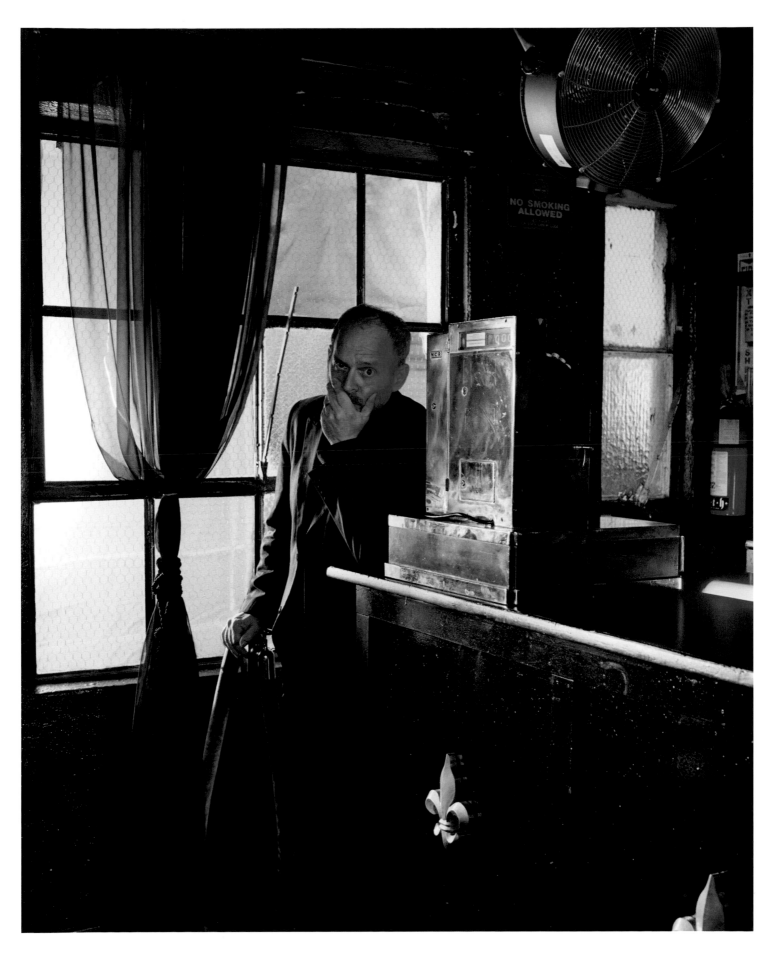

Wayne Kramer of the MC5,
Boardner's, Los Angeles

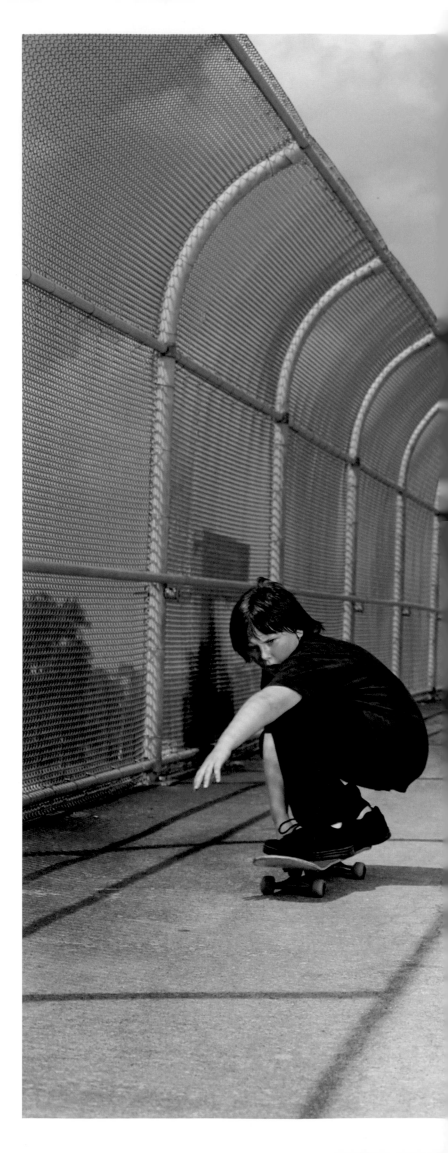

The Muldoons on a freeway overpass near the old Tiger Stadium, Detroit

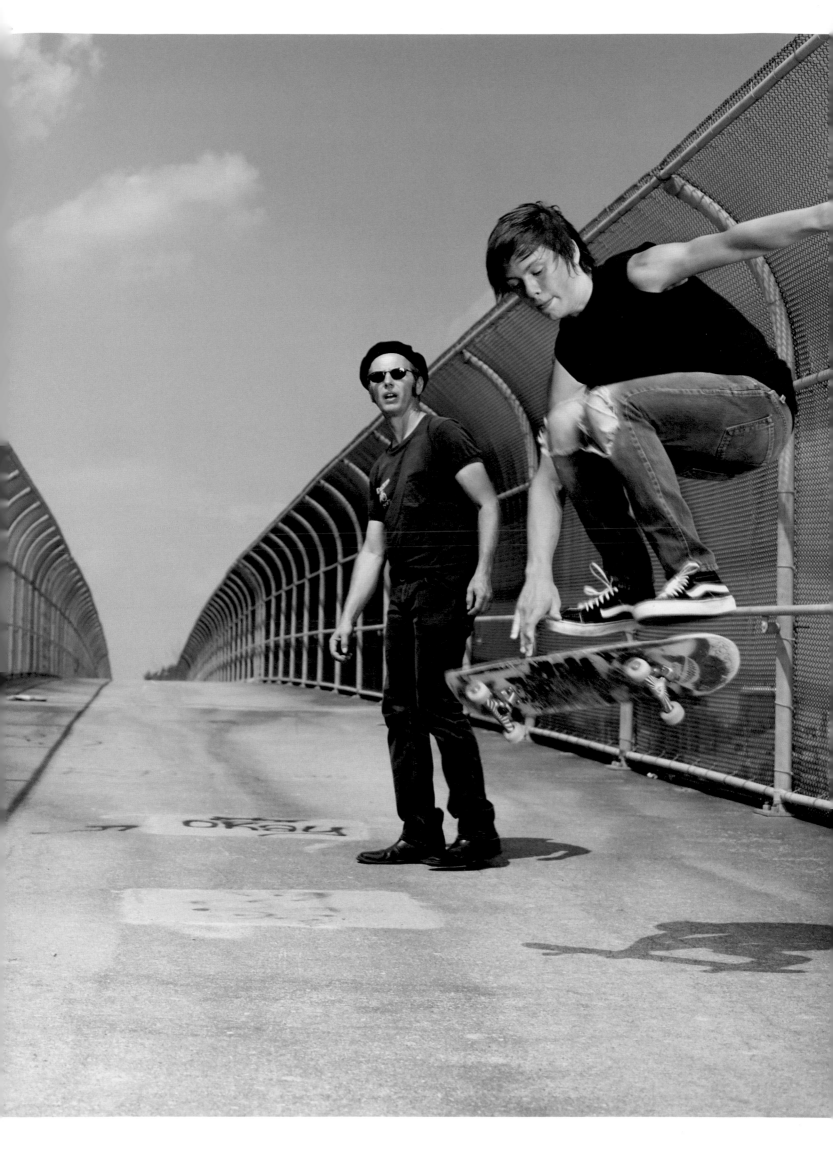

About the Artists

DAWOUD BEY

Dawoud Bey began his career as a photographer with a series of photographs, "Harlem, USA," that was exhibited at the Studio Museum in Harlem in 1979. He has since had numerous exhibitions worldwide, including at the Art Institute of Chicago; the Barbican Centre in London; the Los Angeles County Museum of Art; the Detroit Institute of Arts; the High Museum of Art in Atlanta, Georgia; the National Portrait Gallery in London; and the Whitney Museum of American Art, among many others.

Since 1992 Bey's photographic work has focused on the teenage subject, attempting to describe the essential social, emotional, physical, and psychological aspects of these young people. These large-scale color photographs challenge commonly held notions in favor of a more complex and compelling visual description.

The Walker Art Center organized a mid-career survey of his work, Dawoud Bey: Portraits 1975–1995, that traveled to institutions throughout the United States and Europe. A major publication was also published in conjunction with that exhibition. Aperture Foundation published his latest project, *Class Pictures*, in September 2007, and has organized an accompanying traveling exhibition that will tour museums throughout the United States through 2010.

Bey's works are included in the permanent collections of numerous museums, both in the United States and abroad, including the Addison Gallery of American Art; the Art Institute of Chicago; the Brooklyn Museum; the Detroit Institute of Arts; the Museum of Contemporary Art, Chicago; the Museum of Modern Art, New York City; the Whitney Museum of American Art; and other museums worldwide. He has received numerous fellowships over the course of his career, including the John Simon Guggenheim Memorial Foundation Fellowship and a fellowship from the National Endowment for the Arts.

His critical writings have appeared in publications throughout Europe and the United States, and he has curated exhibitions at museums and galleries internationally as well.

He holds a master of fine arts degree from Yale University and is currently professor of art at Columbia College Chicago, where he has taught since 1998.

ANNA MIA DAVIDSON

For more than two decades, photography has been Anna Mia Davidson's passion as a medium for social change and as a tool to document the lives of diverse cultures. Davidson's connection to Central American cultures began in 1994, while she was working as a solidarity worker in the postwar mountain villages of El Salvador. Over the past several years, she has focused her attention on Cuba for a photographic documentary project sponsored by the Blue Earth Alliance.

Davidson's interest in documenting cultures on the brink of change has taken her to many foreign destinations in addition to Cuba, including Ukraine and Mexico. It was the moment she discovered the world of farmers in Cuba, however, that her interests were brought home again to rural America, specifically, the farming communities of the Pacific Northwest.

In addition to photographing documentary projects, Davidson is a freelance photographer and shoots for many different types of national and international publications. Her photographs have been exhibited in both the United States and Cuba, in such locations as the Farmani Gallery, Los Angeles; Leica Gallery, New York; Benham Gallery, Seattle; Fototecca Gallery, Havana, Cuba; and Lehigh University, Pennsylvania. Images from her "Cuban Maternity" series are included in the Zoelner Art Center's permanent collection. Davidson lives in Seattle, Washington, with her husband and daughter.

JEFF DUNAS

Born in Los Angeles in 1954, Jeff Dunas began his professional photography career in 1971 by contributing photo-essays and portfolios to publications worldwide. He relocated to Paris in 1977 and spent the next decade on a variety of publishing pursuits, including Melrose Publishing Company and Collector's Editions Ltd., a mail-order distributor of fine art photography publications. In 1985 he launched *Collectors Photography Magazine*, which he published and edited, and acquired *Darkroom Photography Magazine* in 1987. For both periodicals he wrote and published over one hundred interviews and profiles with leading photographers such as Helmut Newton, David Bailey, Ralph Gibson, and Robert Mapplethorpe, to name a few.

Dunas moved back to Los Angeles in 1989 and returned to shooting commercial, fashion, beauty, and fine art photography. It was during this period that he began the "American Pictures" series, which documents life in sixty-two small towns along the Oregon Trail; "Legends of the Blues," photographic portraits of famous blues musicians; and photo-essays on Havana and the Mississippi Delta.

Best known for his celebrity portraits, photo-essays, and nude photography, Dunas has garnered international acclaim and awards and was named "People Photographer of the Year" in 2003 by the International Photography Awards. His photographs have appeared in more than thirty group exhibitions and twice as many one-person exhibitions around the globe and are included in many public collections, including the Bibliothèque Nationale, the George Eastman House Museum in Rochester, and the Getty Museum in Los Angeles. His work has been published in nearly every mainstream magazine, including *American Photo*, *Entertainment Weekly*, *Esquire*, *GQ*, *Life*, *People*, *Time*, and *Vibe*. Fourteen monographs of his work, including *State of the Blues* (Aperture, 1998) and *Up Close and Personal* (Merrell, 2003), have been published. He is founder and director of the Palm Springs Photo Festival.

DAVID EUSTACE

David Eustace was born in Glasgow, Scotland, in 1961. Aged twenty-one, Eustace began work as a prison officer in Barlinnie, Scotland's most notorious prison. In 1989 he decided to return to school to undertake a bachelor of arts honors degree course in photography and fine art at Napier University, Edinburgh. He graduated in 1992 with distinction. In his final year, he was awarded the Agfa Student Bursary, and was the sole U.K. representative to be invited to attend the International Student Photo symposium in Poznan, Poland.

His simple and no-nonsense portraits are void of any gimmicks, and seem reflective of his life experience; he takes pride in an honesty and directness to his work.

His highly successful Deutsche Bank–sponsored EGO exhibition (which was the subject of a thirty-minute BBC documentary) in Cork St., London, was described as "beautiful, calm portraiture, and a true rarity these days." This body of portraits was later exhibited in the Glasgow Art Club. This was the first time in the club's 150-year history

at it solely exhibited a photography show.

Eustace's work has been featured in many print shows worldwide, including the main arena at the Groningen Photo Festival in the Netherlands; his work is also found in private collections and in the Deutsche Bank Collection; the National Portrait Gallery, London; and the Glasgow Museum of Modern Art.

He has worked for most major magazines and was a contributing photographer at British GQ magazine from 1993 to 1997.

His list of subjects includes Sir Paul McCartney, Sophia Loren, Sir John Mills, Eve Arnold, Dame Judy Dench, James Earl Jones, Milton Glaser, Ewan McGregor, John Hurt, Alec Baldwin, and Radiohead.

Eustace's photography is not solely restricted to portraiture; his fashion, landscape, and documentary work are also widely recognized, and this versatility has led to him being respected as a "photographer's photographer."

Eustace is working on his first short film, One Mile of Nothing, to be filmed in Arizona and Utah, and is about to finish his first book, Love Letters. He spends his time between New York City and Glasgow.

JOE FORNABAIO

As a first-generation Italian-American born and raised in Brooklyn, Joe Fornabaio was introduced to photography by Brother Clem, a Jesuit teacher at his all-boys Catholic high school. He went on to study photography at the School of Visual Arts in New York City. After graduating from SVA, Fornabaio worked as an assistant to a variety of editorial and advertising photographers. He photographs for the New York Times and the Wall Street Journal, among other publications.

Shooting a wide range of topics has allowed Fornabaio to bring his personal way of seeing the world to a larger audience. His work is an extension of his curiosity about the world. Whether he is shooting his family during Christmas dinner or shooting the Democratic National Convention, his lens gives him the chance to show the rest of us what he sees.

MARY ELLEN MARK

Mary Ellen Mark has achieved worldwide visibility through her numerous books, exhibitions, and editorial magazine work. She is a contributing photographer to the New Yorker and has published photo-essays and portraits in Life, New York Times Magazine, Rolling Stone, and Vanity Fair. For almost three decades, she has traveled extensively to make pictures that reflect a high degree of humanism. Today Mark is recognized as one of our most respected and influential photographers. Her images of our world's diverse cultures have become landmarks in the field of documentary photography. Her portrayals of Mother Teresa, Indian circuses, and brothels in Bombay were the product of many years of work in India. A photo-essay on runaway children in Seattle became the basis of the Academy Award–nominated film Streetwise, directed and photographed by her husband, Martin Bell.

Recently, Mark was presented with the Cornell Capa Award by the International Center of Photography. Among her many awards are the John Simon Guggenheim Fellowship, the Matrix Award for outstanding woman in the field of film/photography, and the Dr. Erich Salomon Award for outstanding merits in the field of journalistic photography. She was also presented with honorary doctor of fine arts degrees from her alma maters, the University of Pennsylvania and the University of the Arts; three fellowships from the National Endowment for the Arts; the World Press Award for Outstanding Body of Work Throughout the Years; the Victor Hasselblad Cover Award; two Robert F. Kennedy Awards; and the Creative Arts Award Citation for Photography at Brandeis University.

Mark's photographs have been exhibited worldwide. Her published books include Passport (Lustrum Press, 1974), Ward 81 (Simon & Schuster, 1979), Falkland Road (Knopf, 1981), Mother Teresa's Mission of Charity in Calcutta (Friends of Photography, 1985), Streetwise (second printing, Aperture, 1992), Mary Ellen Mark: 25 Years (Bulfinch, 1991), Indian Circus (Chronicle Books, 1993, and Takarajimasha Inc., 1993), A Cry for Help (Simon & Schuster, 1996), Mary Ellen Mark: American Odyssey (Aperture, 1999), Twins (Aperture, 2003), Exposure (Phaidon, 2005), and Extraordinary Child (National Museum of Iceland, 2007). Commissioned by the National Museum of Iceland, Extraordinary Child focused on disabled children in Iceland and included a short film by Martin Bell. The exhibition of photographs and the film will travel from Iceland throughout Europe and the United States. Mark's most recent book, Seen Behind the Scene (Phaidon, 2008), is a collection of photographs from her many years of working on films.

In addition to her book and magazine work, Mark has photographed advertising campaigns for such clients as Barnes & Noble, British Levis, Coach Bags, Eileen Fisher, Hasselblad, Heineken, Keds, Mass Mutual, Nissan, and Patek Philippe.

ERIC McNATT

Eric has always considered Austin, Texas, his hometown. He left Texas in 1988 to attend the California College of the Arts in San Francisco, where he graduated with distinction. He has lived in New York since 1996. To date, Eric's work has been published in New York Magazine, Esquire, Vogue, Wired, Interview, Paper, Flaunt, New York Times Style Magazine, Spin, Fortune, and People, as well as many others. His commercial clients range from A&E Entertainment, Sony/Columbia BMG, and Euro SCG to book projects for Galerie Lelong in New York City. In 2005 and 2006 he was included in the American Photography Annual, chaired by Kathy Ryan. He splits his time between his 1970's A-frame deep in Ulster County, surrounded by trees and deer, and his East Village apartment with a garden view and old men arguing on the stoop. Eric will continue to work on his Brownwood, Texas, project.

ERIC OGDEN

Born and raised in Flint, Michigan, Eric Ogden studied at the University of Michigan in Ann Arbor before moving to New York City to pursue work as a photographer. He has lived in Brooklyn, New York, for the last thirteen years, working and traveling frequently on assignment.

His photographs have appeared in the New York Times Magazine, Vanity Fair, Vogue, Rolling Stone, W, the New Yorker, Esquire, Time, Interview, Entertainment Weekly, Teen Vogue, Glamour, and Spin, and on covers of Newsweek, as well as in advertising for ABC, USA, FOX, and the CW television networks; Nike; Sean John; Atlantic Records; Sony Music; Warner Bros. Records; RCA Records; and Miramax and Paramount Pictures.

His images have been awarded publication in the American Photography annuals and his work has been featured in articles in Ameri-

can Photo and Photo District News. Ogden is currently at work on a book of evocative portraits and landscapes of his hometown, Flint, Michigan.

SYLVIA PLACHY

Sylvia Plachy has been a photographer since graduating with a BFA from Pratt Institute in 1965. She has had six photo books published. *Unguided Tour* (Aperture 1990), with a record by Tom Waits, won ICP's Infinity Award for best publication of 1990. *Red Light* (Powerhouse Books, 1996) was a collaboration with writer James Ridgeway about the sex industry. *Signs & Relics* (Monacelli, 2000) includes a foreword by Wim Wenders. *Self Portrait with Cows Going Home* (Aperture, 2004), a personal history of Eastern Europe, won the Golden Light Award for best book of the year. In 2007 Aperture and the *New Yorker* copublished *Goings On About Town: Photographs for the New Yorker. Out of the Corner of My Eye* (De Reojo, 2007) was published in Spain as one of the publications of Madrid's Photo España and copublished by Umbrage Editions in the United States.

Plachy is a Guggenheim Fellow and has received numerous awards, including an Arts and Achievement Award from the Queens Museum.

From 1977 to 2004, Plachy was staff photographer at the *Village Voice*, where for many years she had a weekly column (a picture without words) called "Unguided Tour." In 2005 she had a thirteen-week column (photographs and text), "Vintage," in the *New York Times* Metro section. Her photographs opened the "Goings On About Town" section of the *New Yorker* for more than a year. Her credits include *Dance Ink, Newsweek, Art Forum, GEO, Granta, Grand Street,* the *New York Times Magazine, Double Take, Wired, Metropolis, Fortune, Time* magazine, *People* magazine, and several travel magazines.

Plachy has conducted workshops and lectured at Anderson Ranch; International Center of Photography; New York University; the Maine Photographic Workshop; Friends of Photography; the University of Memphis; Glassel School of Art in Houston; the New York Public Library; Center for Photography at Woodstock; Centro de la Imagen in Mexico City; in Aranjuez, Spain; in Homer, Alaska; at the Arvada Center and the National Arts Club

in New York City; and at the Palm Springs Photo Festival.

Her work is in many private collections, as well as at the George Eastman House, the San Francisco Museum of Modern Art, the Minneapolis Institute of Fine Art, the Queens Museum, the Brooklyn Museum, the Philadelphia Museum of Art, the Museum of Modern Art in New York City, the Bibliothèque National, and the Museum of Fine Arts in Houston, among others.

She has had one-person shows in Penn Station, the Palladium, the Whitney Museum at Philip Morris, the Minneapolis Institute of Fine Arts, the Queens Museum, and in galleries in New York City, Chicago, Philadelphia, Atlanta, Denver, Tokyo, Manchester, San Francisco, Paris, Berlin, Hamburg, Homer, Budapest, Vancouver, and Ljubljana and was invited to exhibit in photo festivals in Arles, Perpingon, and Pingyau, China.

Born in Budapest, she left with her parents after the 1956 Hungarian Revolution and immigrated to the United States in 1958. She lives in Queens with her husband. They have one son.

RICHARD RENALDI

Richard Renaldi graduated from New York University with a bachelor of fine arts degree in photography in 1990. His work on the American West was the subject of a one-person show, Western Lives, at the Nicolaysen Art Museum & Discovery Center in Casper, Wyoming, in 2007. He has also had solo exhibitions at Yossi Milo Gallery and Debs & Co in New York City, and at Western Project in Los Angeles. Renaldi was awarded the Peter S. Reed Foundation Grant in 2004.

Renaldi's work has been included in numerous group shows, including Strangers: The First ICP Triennial of Photography and Video at the International Center of Photography in New York, and in the international traveling exhibition Pandemic: Facing AIDS. His work will be the subject of a solo exhibition at Jackson Fine Art, Atlanta, in February of 2009. In 2006 Renaldi's first monograph, *Figure and Ground*, was published by the Aperture Foundation. His second monograph, *Fall River Boys*, is slated for release in February of 2009 by Charles Lane Press.

MARLA RUTHERFORD

Marla Rutherford graduated from Art Center College of Design in December 2004. Before Art Center, she received her BA at Boston University for psychology in 2000. She applied to graduate school to be a psychologist, but after taking photographs on a trip around the world, she decided to be a photographer.

Her psychology major has definitely had a prominent role in her photography. While a Art Center, she began to photograph people of all sorts, from an ex-convict to a housewife a fetish lady to a grandmother. She brought these worlds together by juxtaposing diverse subjects when displaying them. She photographed everyone with the same lighting—very commercial, bright, and happy, seducing the viewer into believing that this counterculture of individuals is just as commonplace as any other individual walking down the street.

Rutherford's fine art prints have been displayed in galleries all around the world, including Arles; Paris; Milan; Beijing; Lausanne; New York; Washington, D.C.; and Los Angeles. Currently her work is in the traveling museum exhibition and publication Regeneration: 50 Photographers of Tomorrow, organized by the curators at the Musée de l'Elysee in Switzerland. She is represented on the East Coast by Irvine Contemporary, and by Robert Berman Gallery on the West Coast.

Rutherford's commercial clients include *Entertainment Weekly, ESPN Magazine, Life, Los Angeles Magazine, Muscle & Fitness, Newsweek, Time, Village Voice, People,* Fletcher Martin advertising, and others. Her bio and photography have been featured in *Photo* magazine (French), *Phat Photo* (Japanese), *Elegy,* the *Guardian,* and the *New Yorker.*

Rutherford currently resides in Pasadena, California.

SPECIAL THANKS

Dawoud Bey

I'd like to thank Bob Thall, chair of the Photography Department at Columbia College Chicago, as well as dean Eliza Nichols and Steve Kapelke, provost and vice president of Academic Affairs, for their continued support of my work. I'd also like to extend a heartfelt thanks to all of the young people who agreed to be photographed for this project and who momentarily stepped out of their lives to allow me to look at them and to describe them through my camera.

Special thanks to my son, Ramon Alvarez-Smikle, an inspiring artist in his own right.

Anna Mia Davidson

I would like to thank the farmers who graciously opened up their world and their lives to me. I am grateful for their trust and precious time during the busiest part of their season. Thanks also to the Aperture Foundation and USA Network for their exemplary support of photography and for their trust and faith in the power of photography to express a positive vision. I would also like to thank Kodak for their generous film donation and support for the continuation of this project. My optimism has been restored during this volatile political and economic time in our country by being part of Character Project. Lastly, I would like to express my appreciation for the land in which these images were shot, as I am thankful that we still have invaluable farmland in the United States to honor.

Jeff Dunas

I would like to thank Michelle Dunn Marsh, Tracey Shechtman, Crystal Geise, Onno Sweep, Astor Morgan, and Amy Kawadler for their help in making these photographs.

David Eustace

I would like to thank all the subjects for their kindness, time, and trust. A special thank-you goes to Kellie McLaughlin at the Aperture Foundation for believing in my work, and to USA Network for making the trip possible. I am also indebted to the hard work and commitment of others, in particular to Eduardo Fiel, my assistant, traveling companion, and friend. And, finally, I am eternally grateful to my wife, Deirdre, and my daughter, Rachael, who for many years now have sacrificed so much in allowing me to experience so much.

Mary Ellen Mark

Special thanks to Michelle Dunn Marsh for giving me this fascinating assignment and for her wonderful and encouraging nature. You seldom get the chance, especially for a commercial assignment, to do something so inspiring. I will be forever grateful to Michelle for giving me this wonderful opportunity.

Eric McNatt

Special thanks to Kellie McLaughlin, Michelle Dunn Marsh, and Tracey Shechtman. I'd also like to thank the following people for making this project come together: Emily Crawford and Laura Terhune of the Brownwood Chamber of Commerce; Reece Blinco and Coach Steve Freeman for allowing access to the Brownwood Lions; Coach Tino Hernandez and Ryan Reagan of the Little League Baseball Championships; Ronnie Taylor of the Brown County Jr. Rodeo; Paul Shelton, Steve Hackney, and George Heard of the Elm Grove Jr. Rodeo; Eric Evans of Southside Church; Eddie T. Gomez; Don and Debbie Morelock for housing my assistants and for their great suggestions; Steve Puckett and Steve Harris for opening their hearts to a complete stranger; Louise Sharp and the Howard Payne University administration; Coach Josh Prock and Assistant Coach Lindy Hatfield of the Howard Payne Lady Jackets; R. C. and Rebecca Willey of the Traveler's Dance Hall; Dallas Houston; the Excalibur Chapter of the Non-Commissioned Officers Association of Abilene and Ernest Cadenhead for facilitating the World War II vets to be photographed; Mary Stanley for opening my eyes to the new downtown; Adelia Kirk and Hank Hunter of the future Rufus F. Hardin Museum; Ella B. Jones; Beutel Luker; Daniel Graham and Cary Perrin; Walter B. Croft; Frank Sharp and his longhorns; Sheriff Bobby Grubbs; Mary Irving of the Martin & Frances Lehnis Railroad Museum; Mayor Bert V. Massey II; Charles and Bernadette Hays; Patti Jordan; Smith and Ravia McArthur of Smitty's BBQ; Beth Schiffer for taking good care of my film; Robert Dewbre for going the extra mile; my first assistant, Jason Rodgers, who was my backbone; Kevin Kerr; my uncle Logan McNatt; my grandmother Tommie Dewbre; Adam Hetrick; and finally, my mother, who dealt with me, three assistants, and tons of equipment in her house for a month.

Eric Ogden

An extra-special thanks to producer Lydia Andersen-Tarnell and Adam Krause, my first assistant on nearly all the shoots. Special thanks to photo assistants Juel Zamplas, Joel Barhamand, Simon Biswas, Tarik Richards, Amanda Greene, Josh Band, Manjari Sharma, Scott Meyer, Brent Misner, and Zach Callahan; to all of the artists who took time out of their often hectic schedules to make this happen; Kellie McLaughlin at Aperture; Kip McQueen and everyone at Drive InStudios; Kodak; Calumet Chicago; Stacy Fischer; Megan Tully; Joyce Mills; Heather LaForge; Michelle Dunn Marsh; Tracey Shechtman; Boardner's in Hollywood; 119 Bar in New York City; the Heidelberg Project Archives; Andrew Ondrejcak; John at Baker's Keyboard Lounge; Joel Peterson at the Bohemian National Home; "Pops" at the Stonehouse Bar; Warn Defever and the UFO Factory; the Scarab Club; Debbie at Paycheck's Lounge; Dennis Winmiller at the Belair Hotel in Chicago; Eric Novak and Russell Industrial; Patti Willis; Pete Galli; Jason Engstrom and Randy Erwin at ESI Entertainment; Lisa Moran; Sam Valenti and Jeff Owens at Ghostly; Ben Edmonds; Henry McGroggan; Charles Bock; Margaret Saadi Kramer; and Kenn Goodman.

Sylvia Plachy
Mississippi Gulyas

Long before I had the opportunity to visit Mississippi, it was Tennessee Williams whose emotionally complex plays familiarized me with the South. His characters could easily have been eccentric family members or neighbors in my native Hungary. Among the living, I have newfound friends and kind strangers to thank. Birney Imes, photographer, beekeeper, and editor of the *Columbus Dispatch*, and his beautiful family made me feel at home. In McCarley I spent long cozy evenings in the company of Dianne and Thad Wilkes; in Greenwood, I had a book signing at Jamie Kornegay's Turnrow Books, and Edwina and Bill McCain made sure I met everyone they knew. Doris Williams let me hang out in her salon, and I spent time with Leroy Kenter Jr. in Spooney's Bar-Be-Que. I shared a birthday cake with Maude Schuyler Clay, Langdon Clay, and family; Ed "Butch" Meeks and his brother Roy Meeks showed me their special places in Teoc; Terry Stancil took Jane and I and his beagles rabbit-hunting; and Kelvin Scott, the front desk manager at the Alluvian, always had time for me. A most special thanks to USA Network for inviting me to be a part of this project.

Acknowledgments

USA Network is proud and honored to have worked with the eleven photographers who contributed their passion, creativity, and vision to this book—Dawoud Bey, Anna Mia Davidson, Jeff Dunas, David Eustace, Joe Fornabaio, Mary . Ellen Mark, Eric McNatt, Eric Ogden, Sylvia Plachy, Richard Renaldi, and Marla Rutherford. We are equally grateful to Tom Brokaw for sharing his voice and infinite wisdom with us and our audience.

We would also like to thank Kellie McLaughlin and Michelle Dunn Marsh, whose expertise, love of photography, and personal relationships with the artists enabled us to bring our concept to life—without you there would be no book. Thank you to Gary Tooth and Pamela Geismar for their exceptional design; Chelsea Beauchamp, Beth Weber, Mikayla Butchart, Jane Chinn, and Patti Quill at Chronicle for doing all the things we don't know how to do; and the team at Grand Central Marketing— Matthew Glass, Tracey Shechtman, Keith Fernbach, and Sally Campion, whose hard work and patience were invaluable.

Finally, we wish to thank Aperture Foundation for their ongoing mission and their commitment to the artists and to photography as a medium.

We gratefully acknowledge Kodak for their in-kind support for Character Project.

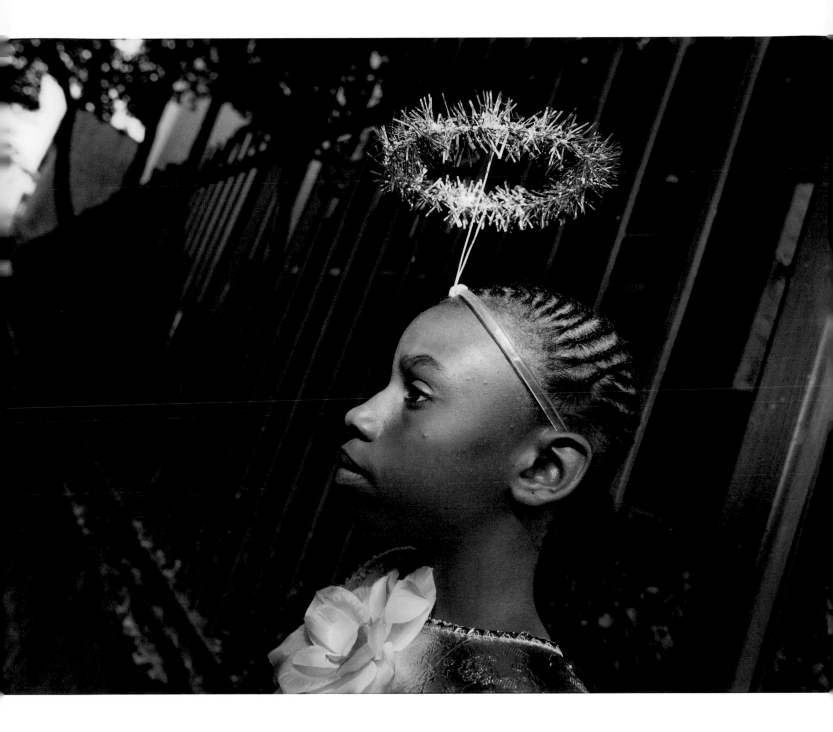

MARY ELLEN MARK,
Jada Birchette,
Children's West Indian
Parade, Brooklyn

About Character Project

American Character: A Photographic Journey
is a celebration of America's characters—the
extraordinary people, from all walks of life, who
make this country what it is. Conceived by USA
Network with the support of Aperture Founda-
tion, this book is an outgrowth of Character
Project, an ongoing artistic initiative inspired by
USA's "Characters Welcome" brand.

During the summer of 2008, USA assembled
a group of eleven photographers and asked them
to capture the character of America. Each artist's
vision was as unique as the people and places
they photographed. From Alaska to New York,
the subjects they encountered are a stunning
reminder of our country's diversity. The musicians
and mothers, fishermen and farmers, athletes
and artists, at home, at work, and at play, are a
true representation of what it means to live in
America today.

USA Network is honored to have collaborated
with the gifted photographers whose work is
collected in these pages. And we're reminded,
once again, that we are all characters. And we're
all welcome.

characters welcome.

usa